SHOOT AN IRAQI

ART, LIFE AND RESISTANCE UNDER THE GUN

SHOOT AN IRAQI

ART, LIFE AND RESISTANCE UNDER THE GUN

By Wafaa Bilal and Kari Lydersen

City Lights · San Francisco

Cover by John Borruso and em-dash
Interior design by John Borruso
Cover photo © Christine Taylor
See p. 179 for additional photo credits

Library of Congress Cataloging-in-Publication Data

Bilal, Wafaa.
 Shoot an Iraqi : life, art and resistance under the gun / by Wafaa Bilal and Kari Lydersen.
 p. cm.
 ISBN-13: 978-0-87286-491-7
 ISBN-10: 0-87286-491-X
 1. Bilal, Wafaa. 2. Artists—Iraq—Biography. 3. Expatriate artists—United States—Biography.
4. Iraq War, 2003—-Art and the war. 5. Computer art—United States.
6. Video art—United States. I. Lydersen, Kari. II. Title.

 N7269.B55A2 2008
 709.2—dc22
 [B]

 2008020487

Visit our website: www.citylights.com

City Lights Books are published at the City Lights Bookstore,
261 Columbus Avenue, San Francisco, CA 94133.

Acknowledgments

First of all I want to thank my brother Alaa
for his unequivocal support throughout my life
and our journey to the United States. He has
been with me every step of the way, helping
make my dreams a reality. He has taught me
so much about giving without asking anything
in return.

I also want to thank the following people for
their invaluable support and encouragement
throughout Domestic Tension:

"The Domestic Tension Team:" Shawn Lawson,
Ben Chang, Sylvia Ruzanka, Jason Potlanski,
Dimitris Michalaros, Dan Miller.

And: Susan Aurinko of FlatFile Galleries,
Aaron Ott, Mark Anderson, Luis Mayorga,
Mark from Discount Paintball, Beverly Wilson,
John S. Thompson.

And throughout the writing of this book:
Maia Ipp, Pat Lydersen, Abbas Kadim, and endless
thanks to Elaine Katzenberger for her tireless
effort, support and enthusiasm in turning this
book into a reality.

For Haji.

A Note on the Writing of *Shoot an Iraqi*
by Kari Lydersen

W HEN I WALKED INTO FLATFILE GALLERIES to interview
Wafaa Bilal for the *Washington Post* on a humid day in May
2007, I was immediately struck not only by the bizarre scene be-
fore me—a paintball gun moving around and firing seemingly of its
own volition and a room soaked in yellow paint—but also by the
exceptionally friendly, warm and incongruously relaxed attitude of
the man sequestered there.

Even in such a strange and stressful circumstance, Wafaa went out
of his way to be a gracious host to me and other visitors who ambled
in. As I visited several more times over the course of the exhibit, I
could see the mental and physical toll the project was taking on him,
but nonetheless his upbeat and caring demeanor remained.

When Wafaa approached me with the idea of helping him write
a book about Domestic Tension*, I was intrigued by the thought of
working with him but skeptical about whether one art project, even
one as multifaceted and unusual as Domestic Tension, could fill an
entire book. Nonetheless I readily agreed to the idea, and as we dove
into the project I realized that along with the fascinating story of
Domestic Tension itself, there was another more amazing story here
—Wafaa's own life, a trajectory he perhaps took for granted or did

* Domestic Tension was the name of Bilal's month-long live installation project, chosen after
his gallery decided that "Shoot an Iraqi" was too provocative to use.

not want to put on display for fear of overshadowing his art work, but a story that had to be told.

Though I had traveled and reported extensively in Latin America and Europe, like most Americans I was shamefully ignorant about the Middle East. With no time for extensive background research, I got a chaotic crash course in Middle Eastern politics and history from Wafaa as details about his own life tumbled out along with his perceptive analysis of the political situation and legacy of US involvement in Iraq. For someone whose country and family had suffered so much because of US intervention and general political aggression, his lack of rancor and his empathy and compassion surprised and impressed me.

Having as I said very minimal background knowledge of Iraq and the Middle East, I was in no way "qualified" to co-write this book. But in that way my experience working with Wafaa mirrors the experience I hope readers of *Shoot an Iraqi* will have—learning about a country, a culture and the impact of the current and previous wars on its people through the eyes of an artist who has forged his own path and stayed true to his ideals.

Our writing process developed on the fly. Chronicling Domestic Tension was relatively straightforward since I had visited the project numerous times and Wafaa has copious video documentation. Telling Wafaa's own life story and painting its political and historical context was a whole different ballgame. With no set plan or framework for how to go about this process, we just started talking at great length about his personal experiences and his country.

Throughout these conversations I always felt incredibly lucky to not only be working on this book, but also to be getting such an education about Iraq and the Middle East, a view that remained uniquely insightful even after I began catching up on my homework and reading more scholarly and historical tomes about the region.

After our conversations I would stay up until the early morning hours writing down what Wafaa had told me, often going out on a limb and adding my own descriptions and interpretations. I am still embarrassed at some of those early forays. Like the time I described his native Kufa as a small sleepy town, oblivious to the

fact that it is an ancient, grand, history-steeped city and one of the holy centers of Shiism worldwide. Even though we were talking about often painful topics and feeling our way in the dark, Wafaa was always patient and gracious.

As I became more familiar with Iraq and with Wafaa himself, I was better able to describe the situations, settings, interactions and emotions he conveyed, wondering about and fleshing out details from an outsider's point of view that he himself was probably too close to the situation to appreciate. Our writing process developed into a highly rewarding collaboration.

After the year-long whirlwind of meeting Wafaa and completing this book together, I will never again be able to glance at headlines of war and destruction with curious detachment like I and so many Americans often do. When hearing about the continuing violence in Iraq, I will always see his face and the faces of those faraway friends and family members I've come to know vicariously through him. By extension, even news of war and conflict in other parts of the world now has a much more human face and visceral impact for me.

I hope after reading Wafaa's story, you will feel the same way.

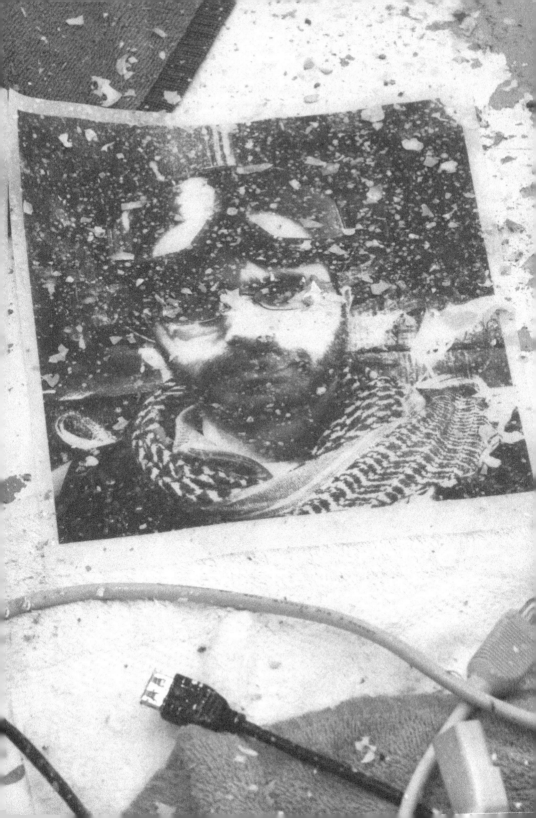

Introduction: Drawing the Line
by Carol Becker

"This isn't a time for art," he said. "This is a time of war."
I said: "It is never a time for war, but it is always a time for art."
Wafaa Bilal

I VISITED WAFAA BILAL several times while he was performing
Domestic Tension at Chicago's FlatFile Galleries in the spring
of 2007. Each time I entered the space, I was brought to tears.
What had once been a spotless, white-cube gallery had become,
over a short time, startlingly chaotic. Wafaa's installation room was
covered in a sticky, slippery, soupy yellow paint, whose fish-oil
smell permeated everything. It seemed impossible to breathe, let
alone sleep, eat, write, or think in such a space. As Wafaa wrote at
the time, "The scene is like some natural disaster—except it's not
natural. It's an entirely manmade disaster. That's what war is." The
chaos certainly startled me, but the most disturbing aspect of all
was the sound of the gun, out of which the paintball bullets flew
with such velocity that at one point they cracked the protective
plexiglas shield behind which Wafaa could retreat to compose his
thoughts and monitor the project's chat room on his computer.
The gun poked its head up out of its armature and roved the room

continuously, commanded by impatient gamers at the other end of the internet.

If Wafaa sat outside the range of the gun for more than a few minutes to speak with friends and visitors, the gun would pivot, trying to locate him. And when the gun would go off, splattering yellow paint on the wall, the floor, the computer, or actually hitting Wafaa, the sound was as loud as a .45 caliber semiautomatic. I had not anticipated this sonic disturbance and how unnerving it would be. On my first visit I wondered aloud and naïvely why anyone would want to shoot Wafaa—one of the sweetest, gentlest people I had ever met.

On my second visit I found Wafaa much more haggard and agitated. "How can you sleep with this gun going off continuously?" I asked. " I can't," he said. The gunshots had unexpectedly triggered an old anxiety in him, associated with his life under Saddam Hussein and time spent in refugee camps in Kuwait and Saudi Arabia, and he was quite obviously sleep-deprived and psychologically pained. On this visit, Wafaa insisted on turning the camera on me to ask for my thoughts about the project. But I sensed he had another motive: he didn't want to step outside the circle of the piece. He had to show me and his "audience" that he was still inside the event. "If I step out of the line of fire for too long, even just a few minutes," he said, "they get upset." They, the ones responsible for the 80 million hits and the 60,000 shots from 128 countries over 30 days, would hurl insults at him if he left the room, accusing him of just having fun, or making fun of them. They would claim that the whole thing was a fraud, and that he was never physically in the space. His absence would trigger their mistrust and paranoia and make them very angry, and then they would write accusatory, racist comments in the chat room.

I have no idea what we talked about on that visit and in that interview; I was too focused on the gun, expecting it to go off at any time. It was like torture schemes where the randomness of the action, the not knowing when the pain would be inflicted, creates intolerable anxiety. Wafaa appeared able to endure it. Whenever it would break down and the firing would stop for a time, however, he also would break down. As he has written, when you are being

shot at you go into "survival mode"; when the shooting stops, one can allow oneself to feel the pain.

On my final visit, the piece was almost over. As I walked into the gallery, I saw Wafaa outside his room for the first time in a month, asleep on the small ledge under the gallery windows. The sun was streaming into the space and he had his keffiyah over his face. The gallery attendant offered to wake him, but I asked him not to. He seemed so peaceful, and by then I understood what a few moments of deep sleep might mean to him. But before I left, I walked around to peer into his room. It was even more chaotic, drenched in inches of paint, the smell permeating everything. That day, said the gallery attendant, they had run out of paint balls since hackers had found a way to turn the gun into a machine gun, and the pellets were flying nonstop and out of control. Friends were reprogramming the gun, and others were taking up a collection to buy more paintballs. But did I want to help buy more ammo with which these aggressive gamers could attack Wafaa? I knew he was adamant that the project should continue, never wanting to appear that he had stopped because it had all simply become too much. And so I left the nuts and dried fruit I had brought for him, along with some cash.

Later, when Wafaa asked if I would write the introduction for a book about the project, I assumed it would be about the project's specificities—the responses from the media, photos, excerpts from the chat room, and so forth. It had not occurred to me, and perhaps had not yet occurred to him, that the book, this book, would become a memoir that wove in and out of the project, telling the story of his life in Iraq, his journey to the United States, and all the heartache and complexity in between. But of course it makes perfect sense that it was his life under Saddam Hussein and his experience of the effects of war in Iraq that were the background for Domestic Tension, and that the past was always in the forefront of his thoughts, along with the present. Nothing short of this intensity would have fully explained the motivation for the performance and installation that had captured the imagination of so many.

When I finished reading this manuscript, I emailed Wafaa to say

that I had a much better sense of all that he'd been through. He replied that it didn't matter what someone had gone through; only what they made of it. What Wafaa has "made of it," over and over again, is art.

PART II

". . . behavior could be judged by moral criteria as right or wrong, but action is judged for neither its motivation nor its aim, only for its performance . . ."
Hannah Arendt

I HAVE ALWAYS VERY MUCH LIKED Hannah Arendt's definition of action, which, when applied to such acts of performative art making, comes closest to explaining Wafaa's intentions. She defined action as a "risk" that takes place in the public arena. In Arendt's sense, art at times can expose the "truth of an event."

This outcome is very much what Wafaa was after. He could not abide that Iraqis were dying every day, that American soldiers were dying every day, that his country had been completely decimated, and yet, for most people in the United States, life was going on routinely, as if nothing was happening, and, worse, that his own life in America could go on as if nothing was happening. This reality was so upsetting to him that he had to create a situation that made him—and us—conscious every moment that our fellow humans were suffering. Wafaa was also aghast to learn that in this war people could die at the hands of those not even in Iraq, soldiers stationed in some unknown location far away from the field of battle, launching missiles that killed real people from an armchair in front of a computer somewhere, as if it were all some kind of video game; these people killed and knew nothing about "the enemy" or the disaster they were creating, and surely did not want to know.

The performative nature of the project is that it simply asked

us to stop and take responsibility for our actions and the actions perpetrated by our government in our name. Wafaa felt he had nothing to lose, or as he has written, "I had already lived and faced death in three other countries." But there are things almost as fearsome as death—the racism and explicit demonizing of all Otherness, the blurring of all that is considered "different." The rage hurled at Wafaa during the course of the piece shocked him to the core.

Wafaa Bilal positioned himself on the literal line of fire and waited. He did nothing but record the process while the world fought over him. In this he became representative of many things during the course of this project, but for most people his identity as an artist was lost even though he positioned himself in a gallery and saw the entire action as performance—a deliberate inactivity of sitting still—while the world took shots at him. Although he was assisted by other artists, he alone was the sitting duck. In the end he was so distraught by the gunfire, the lack of sleep, the randomness of the shots, the sound, the inability to escape, that he experienced post-traumatic stress, as if he had been in an actual war zone. It was surely astounding also that such conditions of war could be replicated in a gallery room while the outer spaces of the gallery housed regular art shows and on weekends were often rented out for weddings. For those guests who came to these events he probably appeared like the Hunger Artist in Kafka's parable, a curiosity engaged in an unnerving performative action of his own instigation. I am certain that the real significance of the piece could never possibly have been understood by those who asked Wafaa—exhausted and completely covered in yellow paint—to stand by them while someone else took their photo.

He created an axis of action to intercept daily life. Yet his actions were modest given the enormity of his concerns—war, reparation, life, death, the passing of time, the development of human consciousness and responsibility. They simply point in the direction of his obsessions, sadness and sense of impotence. At the end of the project Wafaa said, "We silenced one gun today and I hope we will silence all guns in the future." Perhaps without actually

meaning to, he has come to reflect the unique ability of artists to engage the largest questions of life and society in their bodies, and to do so within mundane gestures, in this case sitting—in full consciousness, yet without judgment—while 60,000 people took shots at him. In his metaphoric embodiments and personifications of grave social concerns, he is unwilling to blame. He placed his "body on the line." Nothing could be more dangerous, literal, or metaphoric than this.

Part III

"This project has allowed me to deal with things I had avoided for a long time; the loss of my brother and my father, my family. I miss them terribly. I miss home."

Wafaa Bilal

N

O MATTER WHAT I COULD IMAGINE about Wafaa's life before he came to the United States or his stress during the time I have known him, I could never have reconstructed the complexity of the life he led in Iraq or the degree of loss he has experienced. This is partly due to Wafaa's gentleness. He appears forgiving, even to those responsible for the destruction of his country and the annihilation of his family in Iraq. What he is unable to forgive and, therefore, expends boundless energy trying to counteract, is the silence that continues to surround the war.

The compelling text that follows sets the stage for Domestic Tension by providing Wafaa's history—everything leading up to the project. We come to understand life under Saddam Hussein and in refugee camps in Kuwait and Saudi Arabia, and in the United States as he has experienced it. We are taken into the dynamics of his family and the tragedies of loss that he has suffered in relationship to them: his militant brother, who was killed by American forces; his erratic and often cruel father, who simply wastes away from grief after his son's death; his mother, who tries

to hold the family together; his younger brother who must take over care of the family after Wafaa's departure; all the pain of his childhood and all the pleasure of daily life within his extended family. We are also able to observe Wafaa's lifelong passion to become a serious artist that drives him to continue to make work. He has had to come so far. The paintball project, which was at the center of my original interest, now has taken a back seat to his life. I have become fascinated that anyone could live with such precariousness and still manage to believe that humanity might learn from its mistakes and that social systems might evolve.

Throughout Wafaa's life, no matter how difficult, absurd, tragic or painful his situation, he has always returned to the making of art. This practice sustained him, often helping him to earn a living and to assess his situation. He often traded artistic skills for survival, and his training accounts for his very practical skills as well as those that enable him to give form to his thoughts. His work has always intended to reflect his complex situation. Each action can be understood as part of his life's work, and his life's work was, and is, to engage an audience in serious dialogue. He does not worry if he disrupts or disturbs; he cares only that he asserts his right to articulate his opinion in whatever form is appropriate, so that that which is repressed and unspoken can be revealed and issues he believes significant might be brought into the public arena for debate. For Wafaa, all such interventions are embedded in his practice as an artist and should be acceptable for discussion. But what horrifies and confuses him each time is that the possibility for the debate he so craves is often suppressed in the United States. Were his pieces understood as art manufactured in the spirit of free expression, he is then convinced their manifestations as *art actions* would be allowed to complete themselves. People could then engage and learn from them; the dialogue would be open, and consciousness would result. This is what he expects from a democracy—that it not fear its own contradictions.

Some may see this expectation as naïve; I see it as brave and forever hopeful. But alas, Wafaa has paid dearly for his optimism. Because he puts himself so clearly on the line, there are those who have referred to him as a martyr, but he refuses the term. "I'm not

a martyr," he has written. "I'm not trying to kill myself. I'm just an artist trying to make a point." He makes his points through provocations that break the continuity and demand response. Both the consequences and the rewards of such actions are immense.

Carol Becker is Dean of the School of the Arts, Columbia University. Her most recent book is *Thinking in Place: Art, Action, and Cultural Production.*

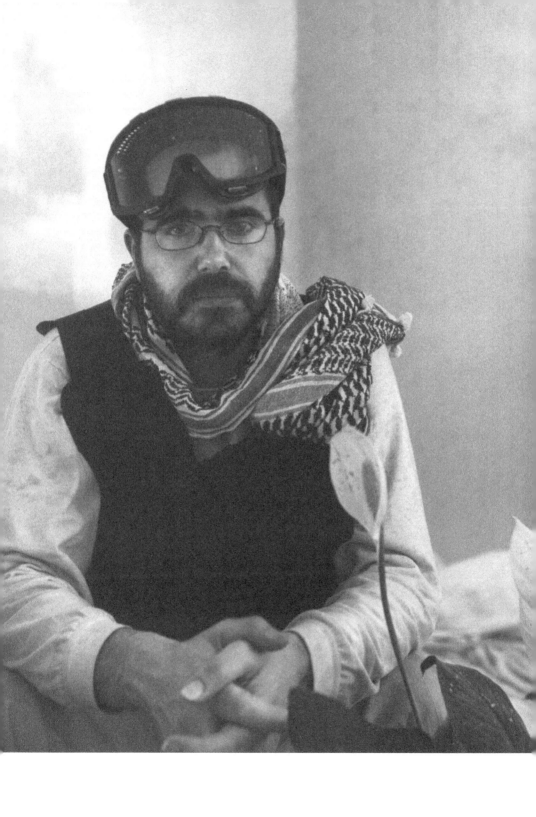

O N MAY 4, 2007, I entered FlatFile Galleries in Chicago for a project called Domestic Tension, a live art installation. For one month I would live in a makeshift room set up in the gallery, going about my daily routine with a robotically controlled paintball gun aimed at me, which people could shoot live and over the internet, 24 hours a day.

I had conceived the project earlier that year, a product of my grief at the deaths of my brother and father in my hometown of Kufa, Iraq (a holy city near Najaf) in 2004, and my intense need to connect my life as an artist in the comfort zone of the United States to the terrors and sorrows of the conflict zone in which my family and so many others were living out their daily lives. Domestic Tension was intended to be a provocative commentary on the nature of modern technological warfare, in which a soldier sitting in comfortable safety at a computer somewhere in the United States can drop a bomb causing death and devastation in remote locales, with absolutely no physical or psychological connection to their target. It was also meant to highlight the dehumanizing effects on the citizens of the United States, who have been mostly shielded from the actual horrors of the government's campaign in Iraq, and whose lives go on as if without a care in the face of the devastation and destruction being perpetrated in their name. What might it be like if one had to actually face down and attempt to "kill" their own Iraqi target? What kind of crisis might that provoke?

What I conceived as an interactive art project turned into a major cyberculture event that garnered extensive international media coverage, bringing together far more people and exposing more complex cultural, political and personal revelations than I had ever

imagined. By the end, more than 65,000 shots from a paintball gun had been fired at me by people from 136 countries, many of them spending hours in the website's chat room. It was a grueling experiment that taxed me to levels I had not fully anticipated, and the results were inspiring, healing and deeply disturbing. This book is my attempt to make sense of that journey.

T his was to be my home for a month. I set up my "bedroom," a 32 x 15 foot space in the back of FlatFile's gallery, complete with a bed, a desk, a computer, a lamp, a coffee table and an exercise bike (which I never used). Several plexiglas screens mounted on garment racks and a mock door frame separated my "room" from the rest of the gallery, with the paintball gun stationed at the threshold.

During my month of confinement I never left the FlatFile building, though I did leave my "room" occasionally to use the bathroom, take a much-needed shower, raid the gallery fridge, give media interviews and sometimes take a desperately needed nap out of range of the gun. Aside from those brief respites, I spent the majority of my time in the range of the gun as an available target, interacting with live visitors and spending hours on the computer, monitoring and participating in the chat room on the project's website. I entered the gallery with no food or drink and no change of clothes. I depended on the community to meet my daily survival needs, and everyone rose to the occasion gallantly.

The paintball gun was outfitted with a custom-designed robotic mechanism that fired in response to the commands of online viewers and gallery visitors; it was positioned about two-thirds of the way between the back wall of my room and the doorway into the gallery's main space. There was a small area where visitors could stand without being in the line of fire and a computer that they could use to shoot at me. In FlatFile's main space, regular life went on—exhibits, gallery hours, even two weddings, which had been arranged months before my project was conceived.

Visitors and online users could aim the gun on a left-right horizontal axis, stationed about shoulder height. When multiple users

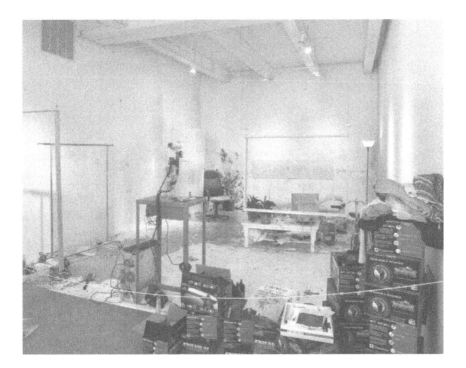

attempted to fire the gun at the same time, their efforts would combat each other, essentially allowing them to fight over the gun. During the course of the month, internet hackers were able to program the gun to fire at me constantly, like a machine gun, and others attempted to come to my rescue by turning the gun away from me.

The entire month was streamed live on the internet via a webcam mounted on the gun. The website interface was grainy and without sound, an intentional decision to heighten the sense of remoteness and detachment that I wanted to explore; visitors to the website who then came to the gallery were shocked to hear just how loud the gun was. Each day I recorded hours of video with my personal camera and edited this footage into a several-minute video diary posted on YouTube. I interviewed my visitors and recorded my own rambling, raw, often painful monologues.

I wore a paintball vest and goggles throughout the exhibit, along with my trademark keffiyah. Paintball experts had recommended I

wear a full helmet and visor, but this proved too cumbersome and alienating, so I took my chances with lighter safety gear. I was hit various times in experiments while preparing for the project, and I soon realized that getting hit at such close range was physically debilitating. While it was certainly not a true representation of life in a conflict zone, where one hit would mean death or serious injury, the stress and manipulation of one's every movement to avoid being hit did characterize both my experience in Domestic Tension and the common experience of those who live under fire.

M Y HEART POUNDS as I run through the narrow, twisting streets of Kufa—ancient alleys that harbor dissidents in a labyrinth of dark corners and basements. The golden afternoon light caresses the crumbling brick buildings with its warm fingers, but I don't have time to appreciate it. He's gaining on me. Our footsteps echo on the cobblestone streets like gunshots. As I turn a corner, running hard, I look quickly over my shoulder. I see the brutality in his cold eyes, the rivulets of sweat running into his famous mustache. A mirror image of the huge face in the mural that I suddenly find myself smack up against, with no route of escape: Saddam Hussein.

Just as the great dictator closes in on me, I jolt out of the dream. I try to sit up, but the belt fastened tightly around my body holds me down in the filthy bedsheets. I am not in Kufa. I am on a disheveled bed in a makeshift bedroom in an art gallery in Chicago. Instead of gentle golden light on ancient brick, I'm surrounded by walls bathed in the oozing yellow slime of thousands of burst paintballs. The bang, bang, bang of the footsteps in my dream continues— it is the sound of the paintball gun. It's fortunate I had the foresight to restrain myself with the belt for the few hours of sleep I've been getting each night—if I had bolted upright in bed, a paintball could have hit me squarely in the head at close range, enough to knock me out or even kill me.

I take a deep breath, the rancid smell of the fish oil paint filling my nostrils and making my lungs ache. Even 15 years after leaving Iraq,

even after Saddam's gruesome public hanging, he still haunts my dreams. The man and all he represents: repression, manipulation, torture.

But Saddam is dead. He's not the reason I'm here in self-imposed imprisonment, living in what has come to resemble a waking nightmare. I'm here to shed light on the destruction and violence of warfare in a language that I hope people who have never experienced conflict can understand. I'm here to create dialogue and build bridges—human being to human being.

And, unbeknownst to myself at first, I'm also here to exorcise my own demons: the loss and tragedy visited on myself, my family and my people by a brutal regime and three oil-fueled wars, and the everyday family and human tragedies that befall us all.

Bang. Bang. Bang.

I stare at the ceiling, immobilized as if in a straitjacket by the paintballs slamming into the wall above me. I close my eyes, though I know sleep won't come again, nor would I want it to, lest I end up face to face with Saddam again. Disjointed memories flit through my brain like an experimental movie: the penetrating eyes of my passionate and cruel father; the welcoming grandeur of the Kufa mosque; the warmth of my grandmother's embrace; the excitement of my first solo art show at the University of Baghdad; the stench of a filthy, deserted gas station in Kuwait; the feel of damp adobe between my fingers in the refugee camp in Saudi Arabia; the bustle of JFK airport as I first set foot in the United States; a lovely, melancholy New Mexico sunset; the taste of a steaming Maxwell Street Polish sausage loaded with onions on a snowy Chicago Sunday; the long, numb train ride to my brother Alaa's house in Detroit after I learned of our brother Haji's death. All the moments that brought me here to this stifling one-room Hell.

I GREW UP IN KUFA, a holy city for Shia Muslims in southwestern Iraq, 10 kilometers from Najaf. My youth was spent playing among the ruins of ancient Islamic civilization, flirting and studying by the lights of the historic Kufa mosque, retreating from the summer heat to the shrine of Imam Ali's house behind it. Sites that drew Shia pilgrims from across the Middle East were the setting for

everyday childhood games, trials and tribulations for my siblings and me.

My family life was characterized by passion for both politics and religion—my mother was a Muslim and my father was a communist. Foreigners might not know that Iraq used to have a strong Communist Party—it was a highly literate, educated country, and wherever you have education, you usually have communists. But even though communist ideology was in many ways similar to the Ba'ath Party ideology, communism itself represented a threat to Saddam Hussein's power, and so he crushed it. For communists like my father, the choices were to flee the country, join the Ba'ath Party or be killed. So my father forfeited his politics and his intellectual and social identity, channeling his impotence and anger inward. That rage and disenchantment smoldered for his whole life, and flared into flame under the pressure of familial obligations. Our family was the place where he would vent his frustration at being stymied in everything he must have dreamed of doing in life.

My father, the self-identified intellectual, hadn't wanted to marry my mother, a devout Muslim with little education. Their parents arranged the wedding, and he never forgave my mother for her supposed role in that. Shortly after their wedding, my dad disappeared with my mother's jewels. He never told anyone where he went, but most likely he sold the glittering stones to buy the fleeting power and euphoria of a week as a Baghdad high roller.

When my father came back to Kufa, my mother accepted him with quiet, resigned devotion. They industriously started producing children, the glue that seemed to hold them together through a tumultuous, epic relationship. First came my sister Rajaa, then my brother Alaa, then me, then my brother Safaa. (Later, after my parents divorced and remarried each other, my brothers, Haji, Ahmed and Asraa were born.) My father initially wanted all our names to rhyme—and mine was a girl's name, so I had no end of teasing. Perhaps that helped make me strong for the battles that lay ahead of me.

My father had a hair-trigger temper. He would hit my mother for the smallest reason, or no reason at all, and she would submit, and then still cook dinner for him. I thought that was what a family was like at the time; I didn't know it wasn't normal to have a home filled with intense violence and anger.

We lived in a two-room brick house in a rough neighborhood, full of crime and prostitution. My dad lived in one room, and the rest of us—up to eight people as the family grew—lived in the other. My father insisted on having the TV in our room, and we had to stay up until he was done watching all the programs featuring pretty girls—gymnastics competitions were one of his favorites. Sometimes he would watch late into the night, even though we had to get up early for school. Everything revolved around his convenience and comfort.

Since he was a teacher, my father made a good salary and the government allotted him a piece of land and some funds to build a house in one of Kufa's most exclusive neighborhoods. He spent several years building a beautiful house for us to live in, designing it himself and hiring a gardener to create the landscaping. When it was nearly completed we had a picnic on the grounds to celebrate, admiring the spacious structure and anticipating our move.

But that fire still burned inside my father, a conflagration of anger, resentment and restlessness that would flare up violently and viciously at the slightest provocation or insult, singeing those close to him and keeping us constantly on edge. When I was about seven years old, shortly after the new house was completed, he impulsively sold it before we moved in and fled with all the money to Baghdad, where he again threw himself and all his money into gambling and women. He sold the house to the gardener who had done the landscaping—who lives in it to this day. When my brother Alaa returned to Iraq in 2003 he tried to buy the house back, but the owner refused.

IT WAS A BUSY WEEK in late spring 2004 when I got the call from an Iraqi friend, now settled in the Chicago suburbs, who had lived through a long stint in a Saudi refugee camp with me. He wanted to come for a visit. I was in the final weeks of teaching my classes at Chicago's School of the Art Institute, and with several projects in the works, I wasn't much in the mood for socializing, but he sounded insistent, so I invited him to come by the next evening.

My friend brought along his young son and another friend. I made tea and we sat down to discuss politics, especially recent news from Iraq. I could tell the small talk was only a prelude, that he had something important to tell me. After an uncomfortable pause he said, "There's something I have to tell you about your brother." I froze. His young son covered his ears. "Your brother Haji was killed." The first question I asked was, "Who killed him? Moqtada[1] or the Americans?" He said it was the Americans.

My brother was 28 years old, and he had gotten married just a year before. He had his entire future in front of him. He was supporting our family with the thriving business he had started with a cousin—selling gravel and sand from our family land in the dry Sea of Najaf. He was a tough, feisty, brave young man. It seemed impossible anyone could kill him.

At first I had no emotional reaction at all. It didn't register. But I was aware of an overwhelming feeling that all of a sudden nothing mattered; all the plans I had for projects and exhibits and my life in general had become totally irrelevant. My world was cloaked in a sweeping, blank silence.

After the guests left I told my roommate Luis about Haji, still feeling as if I were talking about someone else's brother. Then I picked up the phone and called my brother Alaa in Detroit, who already knew but had been too afraid to tell me himself. I said, "When did you hear about Haji?" and Alaa broke down crying. I started crying with him, and then I calmed him down. I said, "You have to control your emotions. I lost one brother, I don't want to lose two." That is actually a saying in our culture, where tragedy is so common.

I packed a suitcase in preparation to head to Alaa's house in the morning and then went to bed. Strangely, I fell into a deep, dreamless sleep, my thoughts characterized only by the deep silence that had suddenly enveloped my whole world. I woke in the morning refreshed, the silence even more profound, and went downtown to

1 Moqtada al-Sadr is the founder and leader of the Shia nationalist militia the Mahdi Army, which formed shortly after the U.S. invasion in 2003 and launched a violent Shia uprising in spring 2004, leading to ongoing conflict with coalition forces. Al Sadr, a young cleric, is the son of respected Shia Ayatollah Mohammed Sadek al Sadr.

catch the train to Detroit. The urban outskirts and farmlands, green and glistening with spring, rolled by outside the scratched Amtrak windows like a strange dream. The few days I spent with Alaa and his wife and children are still a blur. But I know that I told him very clearly not to hide anything from me ever again: "I need to trust you. If something happens, I don't want to hear it from other people."

I didn't call my family in Iraq until I got back home, and then I did not show any emotion. I knew what they were going through, and that crying on the phone, crying with them would only contribute more grief. I had to pretend to be the strong one, even though it hurt me. I reminded my mother of her religious faith, even though it was a faith I didn't share. That helped to soothe her.

I tried to resume my normal life in Chicago, but everything and everyone seemed different, more irritating, more trivial, more pointless. The artistic career I had been building in my 13 years in the United States was focused largely on Iraq—I had gained critical notice from provocative projects such as a photo composite of myself naked and screaming with a mosque tied to my back, and various other ruminations on war and the U.S. intervention. But I saw this work as a matter of fighting for human rights for my country as a whole, commentary and activism on a collective level. With Haji's death, the war and political machinations torturing Iraq had become intensely personal.

Now every report of atrocities, displacements and casualties—of civilians killed by American snipers, of families blown up by roadside bombs, of doors kicked in and prisoners hauled away—hit me like a kick in the stomach. My family's despair and pain were ever present in my mind, and with every new story of death and disaster in Iraq, I could viscerally imagine the pain and loss of countless other families.

The ringing of my phone was a perpetual torment. Each time it rang I became terrified at the thought of what news might be coming to me. The death toll in Iraq was rapidly rising, and I was in constant fear of losing another family member. The evening Saddam was hanged—December 30, 2006—I heard news of a bombing in Kufa. I called my family in Iraq countless times but couldn't get through, and frantically called Alaa in Detroit but got no answer. I was sure our family had been hit by the bombing. As it turned out, Alaa was

out celebrating Saddam's execution all night, and our family was fine, although a piece of a car landed on my brother's house.

I knew that I had to go on with my life, but I stumbled through the days feeling increasingly guilt-ridden and ambivalent about my pleasures and successes, and more and more irritated and disgusted by the seeming cluelessness and callousness about Iraq and the war that I encountered in my fellow Americans every day. My girlfriend gave me a gift certificate for a professional massage for my birthday, but as tense and sore as I was from all the stress, I couldn't bring myself to redeem it—I couldn't imagine letting myself be pampered while my family was suffering and struggling.

In early 2007 I saw a TV interview with a young female American soldier whose job was to drop bombs remotely on Iraqi targets, directing them from a computer console in Colorado. The reporter asked if she had any doubts or remorse about what she was doing. She perkily answered that she trusted the orders and information she got from her superiors. My brother had been killed by explosives dropped from an American helicopter that flew in after an unmanned U.S. drone had scoped out the area. It struck me that Haji's death had been orchestrated by someone just like this young woman, pressing buttons from thousands of miles away, sitting in a comfortable chair in front of a computer, completely oblivious to the terror and destruction they were causing to a family—a whole society—halfway across the world. I was overcome with feelings of intense hatred and anger toward this woman in Colorado and all the other young, fresh-faced U.S. soldiers. But in my heart I knew that wasn't fair; they're mostly just kids caught up in a cycle of greed and power they don't understand, naïve pawns in the age-old game of aggression and warfare. Born and raised in the United States, an encapsulated sphere of privilege and safety, it's not surprising they would be unable to fathom the reality of a distant, foreign society and the ramifications of their actions.

I was struck again by the anguish that has plagued me ever since Haji's death: though my consciousness and memories are forever connected to the conflict zone that is Iraq (and so many other war-torn countries across the globe), my present reality has become the same comfort zone as this young Colorado soldier's. I have a warm

bed in a comfortable apartment, a hot cup of coffee or a pepper-oni pizza at a moment's notice, a health club membership, wine and cheese at Friday art openings. I live in complete comfort and se-curity, even when I am constantly worried about my family and my people.

I realized I had to produce work to address this chasm between the comfort and conflict zones, both to examine the duality in which I exist and to push the limits of understanding of those ensconced purely in the comfort zone. I didn't want the work to be didactic or polarizing—there is enough art and rhetoric like that. It would have to be something interactive and dynamic, where the viewer would become part of the art project. And I wanted to reach well beyond the normal art world, to have an effect on people from all walks of life who would never step into a gallery or go to an anti-war protest, the rest of the American public who remain disengaged and isolated in their comfort zone.

AFTER MY FATHER RETURNED from the Baghdad jaunt where he spent the money from our house, his behavior became in-creasingly strange. He would walk around on his hands and knees with cotton from pillows stuck in his tangled beard, baaing like a sheep, or splay himself out on the floor and moan that he was dying, beseeching us to pray over him. All of us kids would start to cry, while our mother and grandparents would reassure us he was not really dying.

At a doctor's recommendation my father was sent to a mental institution in Baghdad. My mother and her parents thought he was putting on an act, which is very possible. Maybe he was ahead of his time, since a decade later an epidemic of insanity suddenly swept Kufa—this was during the Iran-Iraq war, and Shia men from Kufa were especially likely to be sent to the front lines. Just as during the Vietnam War in the United States, many men of military age tried to convince doctors they were insane to avoid going to war. Kufa residents became experts in all the tricks—defecating in the doctor's office, attacking the doctor, jumping off buildings. My

brother Alaa, who was in the military at the time, was saved from duty at the front lines because of a deftly executed show of insanity. He refused to take shelter, even when the Iranians were firing right at him. He told his commanders he had a great plan to defeat Iran. He would act like he was the highest authority, manically drawing his plans in the sand and commanding the officers to obey. He was declared "unfit to carry a weapon" because of mental instability and given a safer position. I think he learned this behavior from my father, who may or may not have been simulating insanity.

But if it was an act, it was an act born of desperation. When he returned from the institution several months later, he was like a different person—completely calm and placid, moving through the house with a blank stare. I realize now they must have put him on all sorts of medication.

My father was granted disability leave from his teaching job due to his mental instability, and he started doing carpentry work, making decorative cabinets and furniture. Though our relationship was extremely tense, I became his assistant—I wanted to learn the trade.

For a period the government stopped selling lottery tickets, one of my father's weaknesses, and he actually began to save money and pull his life together. But then the lottery tickets were made available again, and my father couldn't resist. Soon he was falling deeper and deeper into debt. In addition to raising the children, my mother sewed clothes to sell in the neighborhood. As my father burned through his income, her labor kept food on the table.

Both of my parents also had strange side jobs having to do with the healing arts practiced by the Fwaili, an ethnic group descended from Kurds. Many of them earned a living practicing a kind of witchcraft. Saudis would come from across the border loaded with money and sheep to pay for advice and cures. My father wrote "spells" for them with orange magic marker on small white pieces of paper, in beautiful script decorated with strange symbols. I delivered the spells concealed in my pants—the government authorities hated this kind of thing, so we had to keep it carefully hidden.

Inspired by the Fwaili, my mother also dabbled in the psychic arts. Her specialty was telling Iraqi women what was happening to their sons on the front lines during the Iran-Iraq war. They'd bring her some of the son's personal items, which she would place under her pillow before going to sleep, and the man's fate or image would appear to her in dreams. She correctly predicted the death of my favorite uncle, a sharp dresser and ladies' man who worked for the government intelligence service.

Though I am not religious, I've always been inspired by my mother's mystical side. When I was young she often told me this story: one day while pregnant with me, she heard a child's plaintive cry, but when she looked around she was alone. She knew that the cry was coming from me, inside her belly. Frightened, she ran to the Kufa mosque and told an imam what had happened. The imam predicted the child she was carrying would be a scientist or do something important in life. My birth was the easiest she ever had—she felt a pain in her abdomen during a family gathering, quietly slipped away to the bathroom and returned holding me a few minutes later, to everyone's amazement.

The intellectual side of me wondered if this tale was even true, but nonetheless it struck a chord and inspired me to fulfill the prophecy, the promise and the belief she felt that I would be someone special. I became obsessed with everything I set my hand to, trying to do my absolute best at it, whether it was soccer or ping-pong or art.

I think my father saw my intelligence and love for learning as an insult and a threat, provoking a kind of jealousy or reminding him of what he had hoped and failed to accomplish. When I graduated from middle school, I ran home with my diploma, excited and proud. When I showed it to my father, he looked at me coldly and said, "Why should I care?" And then he told me a story. Like me, he had run home from school, excited to show his father his diploma. But instead of praising him, his father had slapped him so hard on the side of the head that he lost hearing in one ear for days. Stories like that gave me some insight into my father's own cruelty.

I HAD BEEN AWARE FOR SOME TIME of the ways in which the U.S. military uses video games to recruit youth and glorify war, and that was deeply disturbing to me. The explosion of cybergaming, with its preponderance of simulated military scenarios and blatant ethnic stereotyping, was another frightening and sickening cultural development, one that I felt compelled to confront as an artist whose work had migrated into the realms of technology. I began to toy with the idea of creating a video game where players could shoot an Iraqi—me. Then I read about a place in Texas where one could hunt over the internet. Something clicked. I decided that I would let internet viewers shoot me (with a paintball gun)—in my home, just like so many Iraqis—over the internet. I had a show scheduled that spring at FlatFile Galleries, an innovative artspace in an industrial area just west of downtown Chicago. Maybe I could do it there. It would have to be for a significant amount of time—a month. My mind was running wild, the discontent and vague guilt of the past year melting away as I homed in on my idea.

I called my friend, artistic collaborator and former roommate Shawn Lawson, a freckled farm boy from Ohio whom I'd met in a robotics and virtual reality seminar at the Art Institute of Chicago in 2001, and who now teaches at the Rensselaer Polytechnic Institute. We had collaborated on a number of projects, including our joint master's thesis. When we co-founded an art and technology website, crudeoils.us, we joked about calling it "Crackers and Hummus."

"Mmmmm," Shawn said slowly when I described the project, the way he does when he needs to think about something. He liked the idea, but he tried to convince me to make the duration of the project shorter or to leave the gallery at night. "I don't want you to die or have a serious mental breakdown," he pleaded.

The owner of FlatFile Galleries, Susan Aurinko, was intrigued by my idea. She said there was no way I could call it "Shoot an Iraqi," afraid someone out there would take the title as a literal invitation, but other than that, she was on board.

So it was settled—FlatFile Galleries would become my home for

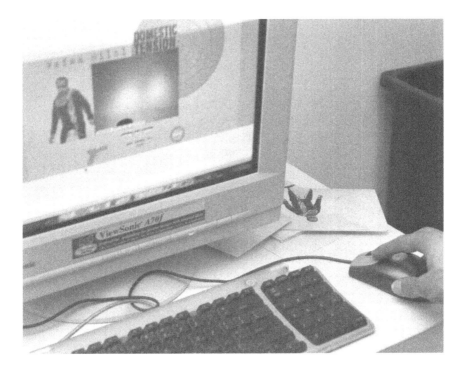

a month. Now I needed to develop the technology. I called the Texas cyber-hunting operation hoping I could borrow their technology, but no luck. The politics of my exhibit most likely didn't jibe with theirs. I researched various commercial robots on the internet, but nothing was quite right.

This project was going to require expertise in more than one medium—robotics, computer programming, viral marketing, internet technology. Throughout my career I have worked in various mediums, and experience has taught me that the project should determine the medium, not the other way around. This project was going to encompass some mediums I had not mastered, and with only a few months to bring my wild idea to fruition, I knew I needed experts in these fields to free myself up to focus on the conceptual aspects.

Luckily, as a professor at the School of the Art Institute of Chicago, I was surrounded by colleagues and friends with a wide range of

talents who relish a challenge and the chance to be provocative and innovative.

Other than Shawn, the person whose dedication and software skills I most trusted was Ben Chang, an Art Institute professor who had worked with me on "Al Qaeda R Us," an interactive video installation about U.S. intervention abroad.

When I told Ben about the project, he laughed and said it was a great idea. Because of his interest in gaming and cybernetics, he was instantly intrigued by the questions and challenges posed by the project. He was especially excited because, as he expressed it, cybergaming usually has no impact on the real world, and there is nothing at stake for the gamer. This project would pose real ethical choices for the participants because of the real-world consequences—the gamers would be shooting at a live human.

Ben's wife Sylvia was also a good friend and a former Art Institute professor; she signed on to write the HTML code for the website. So we had the computer side covered (or so I thought—later, Jason Potlanski, a corporate computer programmer who stumbled upon the project online, would become a life-saving member of the team).

Now we needed to build a robot to shoot the gun, a robot that would take orders from the computer. I immediately thought of Dan Miller, an art and technology professor at the Institute. Dan had already invited me to speak in his class. So I gave my presentation, and at the end of the talk I described the paintball project and asked him—in front of his students—if he would join the team. He probably didn't know what he was getting into, but he agreed.

Dan was attracted to the political nature of the piece, but he had some compunctions about creating a monster. He felt ethically opposed to building a robot, "a beast," he said, that would fire at a human being. And he worried about gallery visitors who might wander in front of the gun and put themselves at serious physical risk.

But the project fell in with the political tack Dan's work had recently taken, and while I was adamant that the piece was not to be didactic or overtly political, Dan felt there was no denying that this was protest art. He liked the timing of the piece—that it would happen while the war was still going on, rather than as a reflection after the fact.

Dan believed that I was taking on the role of target for the armchair warriors of the West. His participation on the robotics side was his way of registering his protest and feelings on the war.

The final key member of our start-up team was Dimitris Michalaros, a graduate student from Greece who did much of the welding and assembly. "In Europe, the war is next door to us, and it affects us, but in this country you can't even feel that there's a war going on," Dimitris said. He told me that he was honestly hoping that this project wouldn't confirm his worst fears about the American people.

FOR MY FATHER, the family was always an inconvenience, a burden standing between him and the desires he felt were his right. He'd often tell us, "I'm sick and tired of you. Go find someone else to take care of you."

My parents divorced three times and separated many times more. According to the Koran, a man must simply say "I divorce you" three times in order for a divorce to be official. If the man later changes his mind, he must kill a chicken and give it to the poor or make an offering to an imam in atonement. A woman can also divorce her husband, though she gives up property rights in the process. A couple is allowed to easily divorce and remarry twice. But after that, the woman must marry another man before she can marry the first husband again. The idea is to punish the man for taking his wife for granted—to make him value her and his family life more. The Iraqi government didn't adhere to Sharia law,[2] but many communities, especially in Shia areas in the south, abided by it in personal and family matters.

My parents first divorced after my younger brother Safaa was born. After seven years they remarried, and celebrated with the birth of my brother Haji. But the old tensions quickly resurfaced, and they

2 The Islamic rules based on the Koran that regulate the relationship between a Muslim and God (worship), the relationships between Muslims and other people (transactions) and, to a large extent, the relationship a Muslim has with himself.

divorced again. Then they remarried yet again, and five years after Haji the twins Ahmed and Asraa were born. Still in a constant state of turmoil, they divorced once again, though without going through the formal process. Surely they knew they were destined to get back together, and they did. Because of the Muslim rules, they asked an imam to certify that the third divorce had not been valid, because there were no witnesses and my father said he had just spoken rashly in anger. The imam agreed, telling them to sacrifice a chicken and God would forgive them.

My mother and father separated a few more times, but they didn't get divorced again. Whenever I asked my mother why she kept going back to my father, she would simply answer that she didn't want her children to grow up without a father. In lighter moments I teased them, saying, "You split up and shop around but no one else will take you, so you end up back together." As much abuse as my father rained on my mother, nothing seemed to shake her inner calm and patience. She dedicated her life to us, loving and protecting her children with a quiet ferocity that belied her humble demeanor.

Once when I was an infant, my mother pushed me into my father's arms as she ran out the door. He had no idea how to care for us, apparently; he left me in the same homemade cloth diaper for several days. Each time she left him, my mother would go to live with her parents near the Kufa Bridge, not far from our house. We kids would usually shuttle between the two houses, which had its benefits—we loved my grandparents' house, and often we'd get two dinners in the bargain.

With my mother gone my father would become miserable and depressed; the unwashed dishes and trash would pile up, roaches would run rampant. Soon my mother would feel guilty and the family would pressure her to go back to him. Each time they got back together we celebrated with a massive house-cleaning, emptying the whole house and courtyard of the residue of my father's sadness and helplessness. We would scrub the walls and floors and breathe life back into the home.

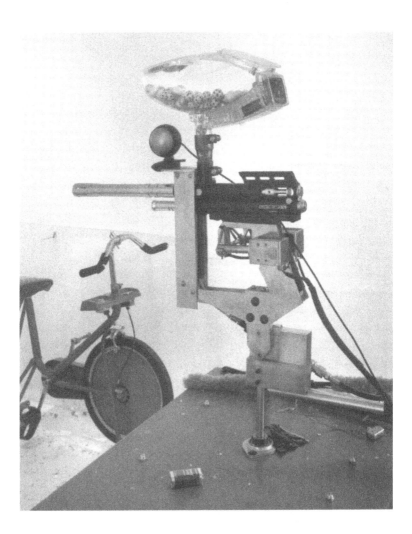

THE SCHOOL OF THE ART INSTITUTE IS KNOWN as a cradle of the relatively young but growing movement known as telepresence, which integrates the internet and robotics to allow remote viewer participation. A crucial component of telepresence pieces—and of my project—is a little green circuit board called an EZIO board, which enables the software to communicate with the hardware, in our case allowing the gun to take orders from the computer.

Most of this hardware was developed by the military and then made available to consumers. Dan noted that Domestic Tension would use the same technology that enables someone sitting in front of a computer to drop a bomb from thousands of miles away. As artists, our goal was to recontextualize and re-purpose that technology.

The team spent about a month in discussion, meeting weekly over Subway sandwiches. That we actually managed to build the mechanism in one month was a somewhat amazing feat. I had gotten a verbal agreement with a company to provide the hardware and web streaming, but once I submitted my proposal and the politics of the piece became more obvious, the firm backed out. We had a similar experience with a paintball company that had agreed to provide free paintballs, then reneged.

We purchased our first paintball gun on sale for $40—one of three that we ended up rotating in and out of the project. The gun, the cases of paintballs and the compressed-air canisters that power the gun all had to be bought in the suburbs, since their sale is illegal in Chicago. Playing paintball is also illegal in Chicago, though luckily the city never shut the project down. We bought a movable camera mount for the gun, but it proved to be too flimsy, so Dan had to build the whole thing from scratch.

A solenoid, an electrically charged metal coil that functions as a switch in many household machines, was attached to the paintball gun's trigger. When an electrical impulse was sent through the solenoid, it contracted and pulled the trigger back, firing a paintball. Dan then installed limit switches to make sure the gun didn't swing too far to the left or right, similar to the mechanism on a computer printer that keeps it printing within the margins.

There were all sorts of technical considerations we learned as we went along. The gun needed to be lubricated and the barrel cleaned out regularly, or else the paintballs would fly in unpredictable and dangerous trajectories. Dan built and tested the gun in the Institute's kinetic lab and his own studio, and he was ultimately able to program it to move smoothly, making barely a sound, only a muted click as it turned. He noted that making machines work silently is usually a goal, but with the gun it had the sinister side effect of creating a stealth weapon.

Ben configured the software, excited to work out all the "geeky little details." Since we were trying to do things on the lowest budget possible, we used Webcam, a low-tech form of video streaming with an open-source program. After the project was up and running we got a call from a company that wanted to offer us high-tech streaming for free, but we decided to stick with what was working at that point.

The entire project was run on open-source technology—a movement of free software created collectively, allowing anyone to suggest improvements and innovations. This was philosophically important to me, since the collective, participatory nature of the open-source movement parallels my devotion to interactive art.

Sylvia wrote the code to build the website I had designed with one of my students. Our original idea was to go for a carnivalesque design, invoking the dunking booth or throw-a-tomato-at-a-clown games you see at state fairs. But we ended up making it more muted and ambiguous, partly because the animated carnival design we envisioned presented technical challenges, but also because the first design was overly skewed toward "fun." We wanted to create more tension and questions for the gamer about whether this game was fun or not.

Aside from the technical problems, I felt that my biggest challenge was how to make the project stand out in an era of image and information overload. One aspect that I thought would make it uniquely appealing was its innate body language. Whenever we see a moving human image we unconsciously associate it with our own body—we are affected on a deeper level than the intellectual, conceptual or emotional; the moving body speaks to the viewer in a corporeal language on a purely physical level of unconscious identification and interactivity.

We decided on a very sparse design for the website, using almost no text. The stripped-down interface was intended to avoid alienating people and overloading their senses. At the start of the project people in the chat room were mocking the site's simple, stripped-down design, but its ambiguity forced visitors to spend extra time figuring out how it worked by communicating with each other—

one of our main goals. We also kept the website devoid of sound, and used grainy, low-resolution imagery to create a heightened sense of detachment—something more akin to the experience of a soldier dropping remote bombs than the usual experience of a high-resolution video game.

We decided to post an IP address log to show where the shots were coming from, using a free program that matched IP addresses with geographic locations. Initially, I thought people might not shoot if they knew their IP address would be made public, but that didn't seem to stop them once we got going. We toyed with the idea of charging people $1 a shot to prevent frivolous overuse, but Ben suggested we leave it wide open to abuse. That way people could police each other and fight over control of the gun, letting cyber–crowd control and some form of direct democracy take over.

Ben explained that the interaction with other internet users is what makes cyber games so attractive. In our case, he was intrigued by the project's element of unpredictability and viewer interaction "breaking the perfect feedback loop," as he described it, and inserting an element of chaos into otherwise perfectly controlled technology. In "normal" cybergames the player controls their own character, whereas in Domestic Tension they could attack me, but not ultimately control me. In other words, they could take shots at me, but they could not become me.

A s I MATURED into my teenage years, with a growing sense of individuality and morality, I became less and less willing to suffer my father's abuse quietly. I often asked him why he was so cruel to us, and I warned him that we wouldn't always be young and forced to take the abuse.

When I was 13 years old, I made my stand against him. He was in a particularly foul mood that day, and had been hitting my mother and my sister Rajaa. In the evening as he was sitting in the open-air kitchen eating a kabob, we got into an argument. He slowly finished his kabob, eyeing me like an adversary in a

boxing ring. Then, with cold and calculated precision, he threw the plate at me. It hit me squarely on the forehead and shattered on the floor. With a throbbing bruise already swelling, I grabbed the sharp ceramic shards and charged him. He jumped up, startled, kabob remnants cascading off his lap, and ran out onto the street. I chased him to the threshold and then locked the door behind him. We both knew something cataclysmic had occurred, the timeless saga of the son rising up against the father. He lost a lot of power that day. He learned that the kids had grown up, and we wouldn't blindly bow to his authority anymore. Soon after, in an attempt to get some of that power back, he bought a gun.

After that day my relationship with my father was characterized mostly by avoidance. He no longer dared confront me physically, and I preferred not to further humiliate or challenge him. So when he was unhappy with me, he would banish me from the house, and I would stoically comply.

When this happened I would usually walk to the Muslim bin Aqeel shrine adjacent to the Kufa mosque. It was beautiful and peaceful, an oasis of cool and calm in a tumultuous world, with its high dome, mirrors and chandeliers—and air conditioning. I would just sit there and think. Or I would go to my grandparents' house, which was a haven of kindness and peace.

Later, my grandparents died during the embargo, the devastating 12-year UN-sanctioned ban on trade with Iraq, imposed after Saddam's invasion of Kuwait. My grandmother died unable to buy the medicine that could have prolonged her life. Her six daughters, including my mother, were struggling just to feed their families, and after my grandfather died they sold the house for what they could get, which was next to nothing. Having to sell that home out of the family was like a betrayal of all the memories, warmth and family togetherness it had come to symbolize, and that is just one example of the ways in which the embargo tore apart so many families.

B Y MID-APRIL WE HAD THE HARDWARE and software all set to go. I had come up with a list of alternative names for the exhibit, since Susan, the gallery owner, did not like "Shoot an Iraqi." We settled on Domestic Tension, which in retrospect was a superior name because it made the piece even more ambiguous and forced the viewer to think harder about what was going on.

The first test shot, without a paintball in the gun, was fired by Dimitris's friend in London through our temporary website on the Art Institute's server. It worked. It worked! We jumped up and down in relief and excitement.

Now it was time for me to feel what it would be like to get hit. Paintball guns are meant to be fired from 200 feet away. Our gun would be firing at me from a distance of only 20 feet. In the kinetic art lab at the School of the Art Institute, Dan fired a paintball at a piece of cardboard, and the paint bullet went right through it. I suddenly realized this was going to be brutal.

A day or two before the exhibit opened, we arranged for Dan to take a shot at me in the gallery. He fired, and hit me in the ribs. It hurt so much that tears came to my eyes. When he asked if I was OK. I bit my lip and said yes. There was no backing out now.

T HE KUFA MOSQUE IS A DESTINATION of vast and ancient importance to Shias, who make pilgrimages from all over the world. Some travel for days to pray there, but it was practically in my backyard, and I often retreated there in times of stress.

The annual Ashura celebration, the most important Shia holiday, would take place in Kufa as a massive, citywide festival—before it was banned and forced underground by Saddam. Those celebrations are some of the defining memories of my youth—thrilling, passionate, and a little bit frightening; the unleashing of a collective, ancient sadness and pride, a visual and palpable demonstration of our inexorable historical link to melodramas of centuries past. People would walk miles and miles from across the region to celebrate Ashura in the holy cities of Kufa, Najaf or Karbala.

Ashura commemorates the Battle of Karbala in 680 AD, when the prophet Mohammad's grandsons, Imam Hussein and Imam Abbas, were slain while valiantly leading their army of 72 men against thousands of the caliphate troops from Syria. Hussein and Abbas are the heroes of Iraqi Shias, and this battle and the Ashura festival are sacred to the Shia community. Even today, in mosques and basements in Iraqi communities in the United States, men initiate their sons into the Ashura rituals much as a Christian family would have their children baptized—a way to cement their identity and ensconce them in a long cultural and spiritual history.

The reenactment of the legendary battle that is the focal point of the holiday took place at the Kufa soccer field. People from all walks of life would participate, dressed up as the different characters with horses and swords. Imam Hussein, the hero, would bravely battle the caliphate soldiers dressed in yellow with peaked metal helmets and swords, shields glinting in the sun. The person costumed as Hussein would fight so valiantly that it always seemed he might triumph, even though we knew the outcome was predetermined. Some of the spectators would get so caught up in the drama that they'd try to join the battle themselves, throwing stones at the "soldiers" or lunging at them with fists flying, even days after the reenactment.

Then came the Ashura procession, men with shaved heads dressed in white robes marching through the streets of Kufa. They beat out a booming, solemn dirge on huge drums, and every third beat they would triumphantly shout "Hussein!" Others would rhythmically strike their shaved heads with their swords, drawing a small spring of blood with each stroke, causing themselves pain to commemorate Hussein's sacrifice for his people. Now and then an errantly swung sword would lop off an ear or chunk of scalp. Ambulances waited on side streets for participants overcome by the heat or blood loss, passing out and crumpling to the ground. The procession went right by my grandparents' house near the Kufa Bridge, and we would hand out water to the marchers. One year when my grandfather participated, he drew blood from his shaven head and wiped it in a bright streak across the chest of my

terrified brother Alaa. He was preparing to lightly nick Alaa's scalp with the sword, initiating him into the ancient ritual, but Alaa dashed away screaming.

Then, when I was six or seven, the government banned the Ashura celebration. As a sacred and highly visible symbol of Shia pride and unity, Saddam saw it as a direct threat to his power and hegemony. But the event was too popular to suppress, and people would still enact the commemoration secretly. Or they would have processions going down the remote side streets or through rural farmyards. Around this time police would canvas the city arresting men with shaved heads or scalp wounds, sure tip-offs of illicit Ashura celebrations. At the youth Ba'ath Party meetings I attended as a teenager, we were told we should educate our families to stop this ritual, and that instead of spilling blood on Ashura, we should donate it to Palestine.

For centuries now, Sunni-Shia relations, power dynamics and geographic distributions have comprised a shifting mosaic of religious, spiritual and social issues overlaying and heavily influencing wars, politics, alliances and philosophical and cultural trends in the Middle East. Shia make up about 10 to 15 percent of the world's at least 1.4 billion Muslims, concentrated mostly in Iran, southern Iraq, Lebanon, Azerbaijan, Bahrain and parts of India and Pakistan.

Situations vary by country, but in much of the Arab world Shias tend to be dispossessed, impoverished and discriminated against, even if, as in Iraq, they constitute a majority of the population. Shia movements are therefore often advocates for the poor and marginalized, hence the frequent intersection of Shia and leftist movements, despite Shiism's religious conservatism; Iraq's Communist Party has always been almost entirely Shia.

Though I've never been a religious person, I'm sure Shia identity and history has shaped my being and outlook on life. My father's communism and intellectualism are typical of Shiism. My instinctive identification with the underdog and my outrage at abuses of power and authority are likewise emblematic of the position and ideology of Shia populations throughout the Arab world. Even my identity as an artist—my taste for provoking,

commemorating and educating through images—could be seen in the Shia tradition of lush art and imagery. Shia homes and businesses are often blanketed with scenes of the Battle of Karbala and other historic moments, similar in some ways to Catholic images of the saints. This has earned Shias the condemnation and repression of Sunnis, who see such displays as forbidden idolatry.

Since a de facto civil war has erupted between Shias and Sunnis in Iraq, you hear a lot of contradictory analysis and descriptions of everyday relations before the U.S. invasion. On one hand, as in many multicultural societies, Sunni and Shia have a history of constant and mostly harmonious interaction. There has always been intermarriage, and within families good-natured joking would usually be more common than tension regarding religious differences. But in my experience, discrimination and hatred between Shias and Sunnis was also a part of everyday life.

Even in majority Shia states, Sunnis held almost every position of authority, from the local police chief to the governor. It was like the Sunnis didn't trust us to govern. Shia children would grow up being told they were superior to Sunnis, since Sunnis betrayed Mohammad's prophecies. Meanwhile Sunnis always let us know they were the ones in power, and they considered us inferior. The Koran was taught in school, but the textbooks always gave the Sunni interpretation, so Shia parents told their kids not to believe what they were being taught.

Even though my family was generally open-minded and kept aloof from sectarian strife, as a community we were all brainwashed early on. The seed must be planted in children to hate and feel superior to another culture or sect. When my tough little brother Safaa wanted to fight someone, he would call them a Sunni, pronouncing it in a way that also meant the word for "teeth," an insult. Things like this were a part of the culture. Shias have felt repressed by Sunnis for centuries, and sectarian hatred has been a form of resistance for many.

M AY 4, 2007—THE OPENING NIGHT of Domestic Tension. I had hosted many openings before, but this was going to be something completely different.

We had distributed flyers featuring a photo of me in an all-white room with a lone yellow paintball splotch on the wall. The gun's barrel aims at my crotch like a giant phallus—the sexual metaphor of power and vulnerability that was a subtext to the project, one I would ruminate on at great length in sleep-deprived states of near delirium later on. In the photo I have a goofy, befuddled expression on my face to make people think, "This silly guy is a terrorist?"

My friends and I hung flyers at local colleges and coffeeshops and sent out email invites to the opening to our usual lists of contacts, and FlatFile issued its usual press release, but other than that I did very little media or public outreach. The publicity for the month-long project would mostly be word-of-mouth and viral.

At a few minutes before 5 p.m.—the time listed on the invitation—everything was set to go. Then I plugged in the cheap table lamp next to my computer and heard a pop. The whole gallery went dark and quiet—off went the lights, the computer screen, the whirring of the paintball gun's motor. I couldn't believe it. I was afraid the systems had been blown, everything ruined. I thought I would have a heart attack. All the work to prepare, and now we might not even have an opening night. Luckily, when Susan replaced the fuse and we turned things back on, everything worked.

As people trickled in and started to fill up on wine, I stepped in front of the gun. I was wearing a paintball vest, a keffiyah and a black bicycle helmet we had modified with a big clear visor to protect my face. I stood awkwardly in my "room" as my friends and other visitors tentatively took some shots at me. I was trying to laugh and talk with them, but I was tense—I knew how much a direct hit would hurt, and it felt strange to be standing in front of a gun waiting to be shot. Along with visitors in the gallery taking shots at me from a computer in the room, there were also shooters already online. My roommate Luis was working late, so he took a shot over his cell phone internet connection.

When the paintballs hit my vest they bounced off without splattering.

28

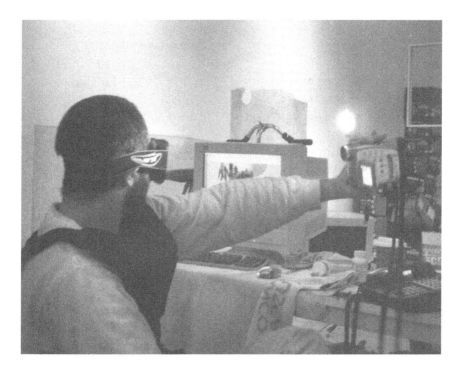

That made one visitor angry, an older man with thick muscles and a military haircut who was getting drunk fast. He decided he wanted to go in front of the gun. He stripped off his shirt and swaggered into the room—after signing a liability release. I kept warning him not to turn his back to the gun, since it could hurt his spine, but he didn't listen. He was enjoying showing off. When a paintball splattered right at his navel, he rejoined the crowd and displayed the sticky stain like a badge of honor.

The atmosphere was partly the usual festive mood of an opening night, with visitors making small talk, laughing and drinking wine. But there was an obvious element of awkwardness; people wanted to enjoy the night and support my work as usual, but they felt conflicted about whether it was appropriate to be smiling and joking as I was being shot at. As for me, I was separated from the crowd by the paintball gun; I tried to be a good host while also being the object of the art. I shuffled around my "bedroom" in front

of the gun aimlessly, smiling gingerly at jokes and trying to partic-
ipate in conversations with guests 15 feet away on the other side of
the gun.

Then Ben joined me in my "room" in front of the gun for a dis-
cussion about digital art. We leafed through the pages of the book
Digital Art by Christiane Paul and tried to have a philosophical talk
as the gun fired with increasing frequency.

It was like my family's everyday life in Iraq—trying to go about
your business, working, talking, thinking, studying—with gunshots
and the threat of violence hanging over you the whole time. Ben was
shielded by a plexiglas panel and I had my helmet, vest and a small
plexi shield, but we still felt on edge and vulnerable. I was reminded
of the power of the paintball gun when one shot blew a jagged hole
in the plexiglas shield I was holding, sending plexi-shrapnel flying.

Giving up on our conversation, we decided to go ahead and kill
Digital Art. Ben held the book out from behind the plexi panel.
Someone hit it, sopping the cover with the slimy yellow paint.

Friends tried to pass me wine and beer, but I knew I couldn't
risk drinking; I was in a conflict zone. One paintball hit hard right
on one of the openings in the bike helmet. The impact jarred my
skull, and yellow paint dripped down my face behind the visor, stink-
ing of the fish-oil base. I felt woozy for a moment; watching myself
on video later I could see I was visibly swaying.

One person was shooting constantly from Shabbona, Illinois. "I
hope he's not an adult," I thought. "What would make one person
shoot so much?" Little did I know that this was nothing compared
to what was to come.

Even with the pain and anxiety, there was still a party atmosphere.
All parties have to end however, and finally I found myself alone
with the gun. As the reality of what I was getting myself into fully
dawned on me, I began to feel incredibly lonely and vulnerable.
There was no way to escape the ticking noise of the gun when some-
one moved it, which was the worst part. I found myself wishing I
could sneak away somewhere to paint, like I used to do when the
abuse from my father became unbearable.

LIKE MOST IRAQIS my family would sleep wrapped in blankets on the roof, in the fresh cool night air, waking at dawn to face the day. I created a little studio of my own under the stairs that led to the roof, so tiny you couldn't stand up in it, but it was a private little place for me to paint. In the summer it was stifling, so I built a crude homemade air conditioner from an old radiator, an air pump, a fan and a tin can I'd fill with water and ice. I like to think of it as my first foray into technological art. When tensions escalated with my father or the bustle of family life became too much, I would slip away to paint and dream there, in my own little world.

I spent almost all my free time reading, writing and painting, studying at night by the lights of the Kufa mosque on the empty street. I never smoked a cigarette or drank until years later—alcohol wasn't sold in the holy cities of Kufa or Najaf—but like the other boys I did find time to chase girls, which was especially challenging in an Islamic city. The mosque was the big meeting place, especially on Thursday nights, since Friday is the weekend day in Iraq. Like malls or movie theaters in the United States, it was the place for young people to see and be seen. The girls would arrive with their families, their hair covered. The boys would go in groups, dressed to kill. The boys and girls would slowly parade past each other on their way to buy food outside the mosque, casting long, coy looks. It was so crowded that it was easy for the girls to sneak away from their families to talk to us. The Ba'athist government officials actually encouraged this kind of thing in mosques—it was a way of making the atmosphere more secular and diminishing Shia religious power. The imams hated all the flirting in the mosque, but there was nothing they could do about it.

As with boys the world over, catching the attention of girls was an endless source of intrigue and fascination for us. We would pour our hearts out in love letters, or hint at our attraction in enigmatic notes and wrap them around rocks to toss into a girl's yard—sometimes breaking a window in the process. In the summer we'd jump from rooftop to rooftop to catch glimpses of these strange and compelling creatures. And we would buy little electronic kits which you could use to make small radios. We would tell a girl what frequency to listen to, and we'd play her favorite songs, mostly Egyptian hits, about love lost, love gained, love this, love that.

However, in those teen years that were similar in many ways to those of an American teenager, there existed at least one major difference: I was engaged to my cousin, which was a common arrangement in Iraq. My fiancée was the daughter of my favorite aunt, Mahdiyya. The story goes that when I was about twelve and she was about seven we were playing in my grandfather's yard, and they asked my little cousin whom she liked the most. She said innocently, "I like Wafaa." And that was that. Throughout my teenage years we remained engaged, and my aunt always wanted to buy me a ring. My cousin looked forward to getting married. Sometimes I liked the idea of it, sometimes I pushed it to the back of my mind. Finally, when I was in college, I fell in love with a different woman and broke off the engagement with my cousin. My mother and Mahdiyya were furious; Mahdiyya didn't talk to me for a year. My cousin was crestfallen—she had grown to believe in the fable of our impending marriage, and would often proudly tell her girlfriends about it. She was the envy of the other girls, since her future was set and she didn't have to worry about an arranged marriage with an unappealing stranger. The few times I saw her after breaking the engagement, things were very awkward. But, as I found out years later, she eventually got over it. She ended up marrying my younger brother Safaa.

DOMESTIC TENSION DIARY

DAY 7

I'VE BEEN HERE A WEEK. It's been alternately frightening and exhilarating, but most of all it's been mundane. The gun is shooting at a slow pace, though I must be constantly aware. I haven't had the level of personal interaction I was expecting, and the hours drag on. This afternoon Susan brought some towels to help in the endless ritual of sopping up the paintball residue. It makes me think of how in Iraq, in a war zone, you must constantly be cleaning up and repairing the damage done, even though you know your work will likely just be destroyed again. There's something wrong with the gun—air is leaking out of the canister that powers it. I tried

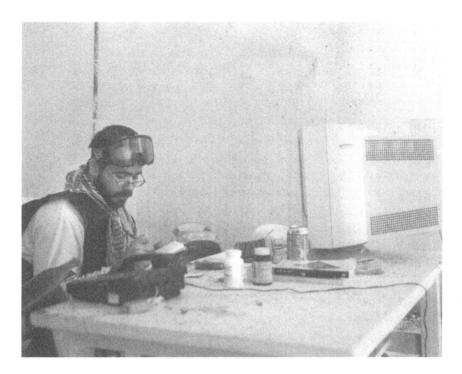

fixing it but ended up removing it from the robot and installing a replacement gun. It's odd to be gently monitoring and repairing the machine that is shooting at me.

DAY 8

TODAY MY CLASS CAME TO THE GALLERY for their final critique of the year. These periodic sessions are crucial days for art students, when they put their work up for public scrutiny and criticism from the professor and their fellow students. Emotions run high during these all-day sessions. Students often end up in tears or storm out of the room, only to return for hours' more soul-searching dialogue and raw back-and-forth with their peers. I do my best to provoke, brutally questioning the very basis of the students' work, pushing them to stand up for their ideas and skills. I don't believe

in separating life from art; I think this real-life interaction and emotion enriches their artistic vision.

Holding a critique in the paintball gallery with the sound of the gun constantly in the background added another layer of intensity to the experience. I had mentally prepared the students before the project started, and I was grateful they were all willing to venture to FlatFile for the class. This was also a way to see how they would respond to the project and to this window into my personal life and history. As a teacher I never want to push politics or my beliefs on my students; I don't think it's right or effective. Belief needs to come from within. But I relish the chance to push my students to stretch their limits of empathy and understanding.

Yesterday, the *Chicago Tribune* published a story on me. That has led to a media storm today. I was pulled away from my students constantly by local reporters stopping by and phone calls from international media, including the BBC and CNN. I hated not giving the class my full attention; but they got a firsthand example of the way art can break out of the gallery and generate widespread attention and dialogue beyond the art world, and I hope it inspired them to think more about that.

M Y CHILDHOOD COINCIDED with Saddam's rise to power. I was two years old at the time of the coup that brought the Ba'ath Party to power, with Ahmed Hassan al-Bakr as president and Saddam as his head of security and vice president. As vice president, Saddam was both modernizing the country at a rapid pace and quietly laying the groundwork for his reign of terror. In 1979, he grabbed the reins from al-Bakr, taking the presidency in a secretive bloodless coup, a political maneuver that many Iraqis thought was assisted by the CIA to counter Ayatollah Khomeini's revolution in Iran.

In 1972 and 1973, when I was six and seven, there was a serial killer on the loose in Baghdad—or so we thought. Many mornings there would be news of another prominent family hacked to pieces by Abu Tubar—"the one with the axe." We didn't learn until later that "Abu Tubar" was actually Saddam's security service, killing

communists, educated people, dissidents, anyone who might stand in Saddam's way. Once the killings were finished they made a big display of Abu Tubar's capture, parading him before TV cameras wearing a white lab coat splattered with blood. His wife confessed that she would see him come home every day covered in blood. Even as a child I found it ridiculous—if you were an axe murderer, why would you put on a white medical coat?

But it took people a while to catch on to who Saddam really was. He wisely solidified his support by improving the quality of life for much of the populace—his motto was that people with full bellies don't make revolutions. As part of his campaign to win hearts and minds, Saddam built houses for all the Shias living in the slum that is now called Sadr City in Baghdad. He had a mission to get electricity to every Iraqi, and would travel to villages followed by trucks carrying televisions. Hours and hours of TV footage showed him going from town to town, a benevolent bearer of gifts. He also ensured virtually everyone learned to read and write, sending literacy teachers out across the country and boosting the nation's literacy rate to one of the highest in the world. He even passed a law that everyone between the ages of 15 and 45 must learn to read and write, or risk imprisonment. My mother and aunts joined the local evening literacy classes. I would help my mother study; it was touching to see her reading for the first time in her life. But the books they would assign were ridiculous tomes extolling the heroism of Saddam and the Ba'ath Party.

There was no end to Saddam's paranoia. Every neighborhood had a "mukhtar." Traditionally the mukhtar was a respected elder who looked out for the neighborhood. But Saddam perverted this position into the local snitch. Usually it was an older man. If there was anything strange or suspicious going on, he would report it to Saddam's authorities. And if anyone new moved into the neighborhood he had the authority to knock on their door and demand they fill out a form giving personal information, then he would cross-check the information with the government. In addition to the usually obvious mukhtar, there were also many undercover informants. After Saddam was toppled, people could acquire the files the government had on them. My family found a file on me—to their surprise, it revealed that the local barber had been informing on the neighborhood.

Saddam's popularity plummeted during the embargo imposed after the Kuwait invasion. With the embargo, he no longer had boundless wealth to bestow favors and gifts so freely; only his most powerful and loyal devotees could be coddled. So Saddam turned to his tried-and-true tactic of flaunting his advocacy for Palestine. Even while Iraqis were starving to death under the embargo, Saddam was giving $25,000 to the families of Palestinian suicide bombers. Palestine has long served as a pressure valve in the Arab world, a noble cause for oppressive rulers to rally behind to distract from their misdeeds and brutality at home. When I came to the United States, I met Palestinians who thought we were traitors for fighting against Saddam. I tell Palestinians and anyone else that you can never judge Saddam unless you actually lived under his regime.

Saddam also turned to religion to salvage his image. During the height of his power Saddam had been solidly secular, frowning on displays of religion, especially when identified with Shia tradition. But in a transparent attempt to win over disenfranchised Shias and the rest of the Arab world in the wake of the failed Kuwait invasion, he became a whole new Saddam, with a Koran always at hand. He banned alcohol and called for the construction of more mosques. Government officials took to enforcing conservative Muslim gender roles and morals. In 1991 he revised the Iraqi flag to bear the words "Allahu Akbar" ("God is Great") inscribed in his own handwriting.

Saddam recast Muslim spirituality in the context of modern warfare and his own cult of personality by building the megalomaniacal Mother of All Battles mosque in Baghdad to commemorate the Kuwait invasion and Gulf War. The bizarrely pretentious structure boasted minarets shaped like AK-47s and Scud missiles and held a copy of the Koran written in Saddam's own blood. The dome was emblazoned with the word "La"—"No" in Arabic—Saddam's answer to Western imperialism.

Monolithic and flamboyant buildings like the Mother of All Battles Mosque were one of Saddam's favorite ways to enshrine himself in history. It wasn't enough that his visage leered from murals on nearly every block; he had to be memorialized in marble, brick, gold and stone. More than being loved or respected, Saddam wanted to be remembered.

In this he was hardly alone. Iraqis are obsessed with the notion of our place in history. Iraq is steeped in history; we are raised to believe it is the cradle of civilization, and we pass on the stories of our ancestors, heroes and tribes from one generation to the next. Living in the very setting of legendary battles and kingdoms, we are always looking back to the past.

But the young Iraqi generation—the generation of satellite TV and the internet—is not the same. (Saddam didn't allow satellite TV, but Iraqis soon became adept in building and hooking up their own illicit satellite dishes, opening up a broader world of information and culture.) This new generation wants to live unburdened by all this history.

There's a split between the old and new generations in any culture, but especially in the Arab world. I'm not sure exactly where I stand in this generational continuum. I'm rebellious, but not against tradition—I'm very respectful of tradition. I'm rebellious against stagnant tradition, and authoritarian control used to keep that tradition in place. If push comes to shove I will always place myself on the side of the new generation, because if a culture can't keep renewing itself, it will eventually die.

To help pay the bills and "breathe life into the gallery," as she says, Susan often rents FlatFile out for weddings. The weddings are arranged a year or more in advance, and it just so happened there were two weddings scheduled during the month of my project. Luckily the couples were understanding about the situation, if confused by my project, and didn't object to my presence.

In the United States, weddings seem to be largely about alcohol. In Iraq, weddings are about blood. After the massive community celebration, the man's male friends and neighbors will all cluster outside the house where the bride is waiting for him. After he goes in the crowd waits eagerly for the brandishing of the handkerchief stained with blood—to prove the bride is a virgin. In the Western world women have recently begun having surgery to re-create the hymen for their anniversary or husband's birthday. In the Middle East, midwives have been doing this "surgery" for decades or even centuries, saving young brides from a horrible fate. When the bloody handkerchief waves, a cheer goes up.

I hated being part of those wedding crowds. And now I find myself, absurdly, party to a stranger's wedding while being shot at by a paintball gun. The gallery rings with the din of clinking glasses, lively conversation and a mediocre cover band, punctuated by the sound of gunshots. I lie on my bed, under bombardment, exhausted and pale, I need to get some sleep. I try to ignore the obnoxious male guest taunting me: "Are you sleepy?" And another loud guest is apparently explaining the exhibit to someone else—over the mishmash of voices I keep hearing the word "Iraqi . . . Iraqi . . . Iraqi."

A smile plays across my lips as I hear the song "Hit the Road, Jack"—it's one of my favorites. Most of the music isn't very good. It makes me think of the American torture-interrogation method of barraging subjects with bad rock music. A woman says over a loudspeaker, "Ladies and gentlemen, if I can direct your attention to the cake. . . ." Right then, a gunshot. The strains of one of the songs drifts through the muddled noise: "I ain't got nobody. . . ."

I close my eyes again and start to drift off, until I'm jolted awake by a woman's voice right next to me. It's one of the caterers, apparently mistaking me for a drunken guest, asking, "Sir, are you all right, sir?" I leap up, without my goggles, and push her out of the way, yelling. She is right in front of the paintball gun; if a shot were fired she could be killed. As she apologizes, still clueless, a paintball speeds by my head. I dive back onto the bed, shaking.

Soon the bride and the man she appears to be spending the whole evening with—not the groom—stumble over to the doorway of my room. I meet them there to make sure they don't accidentally get in front of the gun. She has some supportive, if drunken, words for me.

"We've seen how hard it is, how tough it is, this is a really disturbing thing . . . and people live like this every day."

She fingers her veil and continues.

"We're so fortunate . . . I'm a bride, I'm getting married, I'm so happy for me. Yet people live in this situation where you can't eat, you can't live, it's beautiful."

A pause.

"I mean, it's not beautiful, but what you're doing is beautiful," she continued.

"I remember when it first started," the man says, and I assume

he's referring to the current war. "It seemed like a hangover from 15 years ago . . . but the hangover always lasts longer than the night before," and he lifts his drink to me.

I've heard enough. "Thank you, thank you," I say. "I wish you all the happiness in the world," and I bid them goodnight.

Later the bride comes back and tries to kiss me, while the groom appears to be flirting with the male flower arranger. One of the last songs they play is "I Will Survive." Probably appropriate for all of us.

I N SEPTEMBER OF 1980, Saddam invaded Iran.
He felt threatened by the Iranian revolution that had brought Ayatollah Khomeini to power in 1979, overthrowing the U.S.-backed Shah. The Islamic revolution in Iraq's Shia neighbor state presented a direct threat to Saddam's Sunni-dominated, secular regime, and Khomeini made no secret of his ambitions to export the revolution throughout the Arab world. Saddam also wanted control over Iran's oil-rich Khuzistan-Arabistan province and over the disputed Shatt al-Arab waterway—the confluence of the Tigris and Euphrates rivers that forms part of the Iran-Iraq border and is Iraq's access to the Persian Gulf. With the U.S.-Iran hostage crisis at its peak and massive oil wealth at stake, Saddam knew he would have the United States' support in challenging Khomeini.

Saddam sent his troops in with reckless abandon, hoping to overwhelm his adversary with sheer ferocity and determination. As his way of supporting the war, King Fahd of Saudi Arabia offered to pay Saddam $10,000 for each Iraqi soldier killed, since the Sunni Saudis hated the Shia Iranians. Hence, Saddam was essentially getting paid to send his citizens to their death on the front lines—primarily Shia soldiers, since Saddam would deploy them to the front lines and spare his favored Sunnis. But the victory Saddam envisioned was not to be; the Iraqi soldiers—mostly Shias—were slaughtered by the Iranians.

Soon the bodies started arriving back in Iraq. Najaf is the largest cemetery in the world, with Shias from around the world buried there—it is believed that one's passage to the afterlife will be quicker if your remains are interred in Najaf.

Before the bodies could be buried in Najaf, Islamic tradition

dictated that they had to be washed, and the main washhouse was in Kufa, right next to our childhood playground. Long lines of cars and taxis with flag-draped coffins on top snaked through the narrow Kufa streets, waiting to deliver the bodies. To this day, when I see a car with a box or container on top, I do a double take.

Kids would sneak into the washhouse to see the bodies. It was horrific—bodies with missing heads, guts spilled out, two left legs because someone threw the wrong body parts together. I only went a few times, and I was revolted by it. But many others loved the scene, drawn by morbid curiosity, numb to the pain and grotesqueness. In keeping with tradition, mourning girls and women would tear at their hair and clothes, wailing and clawing at themselves until their garb hung in rags and they were nearly naked. Desperately curious boys would climb on the roof of the washhouse and peer into the courtyard just to see the naked women; some would lie there on the roof with their hands in their pants, masturbating.

One person's tragedy is another person's pleasure.

I often felt that way during the paintball project, when I was exhausted, stressed out and in pain, and the shooters were getting such a thrill from targeting me—I wouldn't be surprised if some of them were masturbating, too.

Day 9

THE NEW LAMPSHADE I WAS GIVEN yesterday is already mangled and completely soaked in yellow paint. As shots whiz by, the lamp trembles, but it doesn't fall over. Susan, the gallery owner, comes in and tells me firmly that I have to unplug it. She's afraid the bulb is going to be hit and that it could start a fire.

Since she lives in the apartment upstairs, Susan is always checking in on me. When she hears the gun firing nonstop, she'll come down or call on the phone line she installed for me to make sure I'm OK. She's even started washing the towels I use to sop up the paint on the floor each day, saying she never imagined she'd do laundry for one of her artists, and I'd better not tell anyone.

Dazed and apathetic, I ignore her as the lamp trembles and sparks.

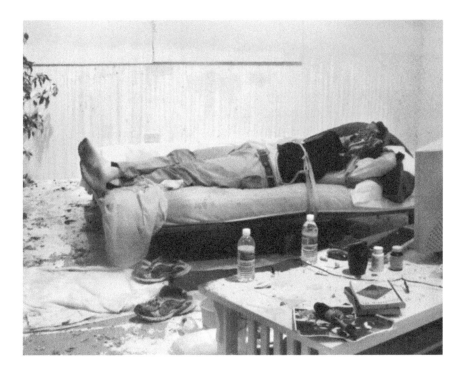

"Oh my god!" she yells, and I unplug it.

I glance at the chat room: "Estonia, good job, you killed the lamp."

"I hope you regret this act," I tell the video camera.

Why is the lamp of such significance? Years of war in Iraq and constant danger in the refugee camps have left me with post-traumatic stress disorder (PTSD)—I can no longer sleep with any light or sound, and at home I sleep in total darkness with earplugs and a cloth over my eyes. But in the gallery I can't let myself fall into a deep sleep, or else I might forget where I am and sit up, putting my head in the line of fire. So in order to remind myself I'm in a dangerous place, I've been leaving the lamp on at all times.

When Estonia killed the lamp, I cried. Another sign of how frayed my nerves have become, how easily I get agitated.

When I think about what I've gone through with PTSD, it reminds me of all the effects of the Iraq war that we haven't even seen yet. I remember sitting in a Dunkin' Donuts where my brother Alaa worked in Albuquerque, drinking a cup of very hot coffee, and

suddenly I had an inexplicable urge to dump the coffee over the head of the man sitting next to me. That incident marked the beginning of years of inner conflict. I felt like there was one voice in my head telling me to do one thing, and another voice telling me not to. When I first got to Chicago, I would have urges to either jump in front of the train or to push someone else in front of it. (Luckily those urges subsided.) One time my girlfriend woke me up as I was pinning her down violently with both hands—I was having a nightmare that I was fighting a soldier. When you have such traumatic memories, your past and present realities bleed into each other, until sometimes you can't differentiate where one ends and the other begins.

As an artist my work is driven by my emotion—I can't survive without it. But I didn't anticipate the emotional roller coaster this project would become. Usually my artwork is a reaction, sculpted by the feelings and thoughts unleashed by an event. This time the event itself is the artwork, and the emotions it releases become a direct part of the work.

As a young teenager I could see the cracks in Saddam's heroic façade—the dangerous rigidity and hints of buffoonery in his carefully cultivated larger-than-life persona. But I was nonetheless an aspiring young Ba'athist, attracted by the opportunities and activities the party offered and motivated by the challenge of moving up through the junior Ba'athist ranks.

I attended weekly Ba'ath Party meetings. I liked the structure and hierarchy, and advanced quickly up to the third-highest level for youth. I was small and short for my age, and I still remember the mix of pride and frustration I felt on hearing one of the higher-up boys praising my loyalty and intelligence but saying they couldn't promote me to the next level because I was too small.

The Ba'ath Party youth centers and camps were a staple of our lives, and indeed provided a wealth of social, athletic and intellectual opportunities. We'd go to school from 8 a.m. to noon three days a week, and 1 p.m. to 5 p.m. three days a week, leaving hours each day to spend in the centers, participating in various classes and programs—sports, art, poetry, music. I was most interested in art and sports; the centers pro-

vided oil paint, canvases, brushes, all manner of supplies. And it was a place to interact with girls. During the summer we'd go to camps in the city parks where we'd sleep in tents and get up early every morning to do chores and train. It was very militaristic. But during the day we'd have movies and lectures, and girls would join in, so we loved it.

Kids weren't required to go to party meetings, but if you didn't you would be denied some opportunities, and party officials would be watching you and your family. This was all part of Saddam's master plan to turn people's loyalty away from religion, family and the tribal system and replace it with loyalty to the State. And in the beginning it worked well, so well that many youth would inform on their own parents.

But once the Iran-Iraq war began to claim so many lives, Iraqis increasingly hated and feared the Ba'ath Party. Students no longer saw it as a glowing opportunity; rather they endeavored to avoid party officials without seeming disloyal.

Ba'ath officers began rounding up high school students on the street in the summer or even seeking them out in their homes, then forcing them to sign up for summer military training programs. These students were usually sent to the north where Saddam was repressing the Kurds. I actually volunteered to go, just to get away from my father. I wanted to go to the north, where the action was. But since I was so small, they sent me to guard the oil pipelines at the Saudi border instead.

I was disappointed, but the tales I later heard from friends returning from the north made me realize how lucky I was to have avoided it. The Kurdish region, full of beautiful waterfalls and picturesque land formations, was also cold and dangerous. The Kurds would frequently ambush Saddam's forces, and the area was strewn with land mines; people would send dogs or mules ahead to find a safe path.

Stuck for weeks on end in a desolate outpost by the Saudi border, standing guard over the buried pipelines that transported the viscous blood of our country, I discovered my lasting love for the desert. There you realize how small you are, a speck on the vastness of this planet.

The slow pace of the work and the expansive landscape at the border outpost gave me the mental space and time to get to know myself, to explore the corners of my mind without constantly having to look over my shoulder for the next attack from my father. I would take long walks into the sunset with my AK-47 slung over my back,

walking until my legs ached deliciously and I could no longer see the guard post, only sand and shimmering heat in every direction.

About 15 students and teachers serving as guards were stationed there at a time, and we would rotate out every 21 days. One time the arriving party was late and, against orders, the group whose time was up left on schedule anyway—except for me. Wanting more time to myself and loath to face my father at home, I volunteered to stay on alone and wait for our relief group. So I had the desert all to myself, and all the time in the world to read, write, draw and think. As I was lost in thought, sitting idly in the outpost, I suddenly heard an approaching truckload of Bedouins. These nomads would often travel through the area with their sheep, sometimes smuggling liquor. They were only allowed to cross at designated places, for fear their trucks could break the pipelines buried under the sand. It was my job to block their path and redirect them. I was all alone, just a scrawny kid, and I didn't have any bullets in my Kalashnikov—we were instructed to keep our guns empty since a young guard had been killed accidentally when his friend was firing his gun for a photo. As a nervous lone teenager confronting a truckload of approaching men, I felt sure the mercenary Bedouins would shoot me and steal the guns and ammunition stored at the outpost.

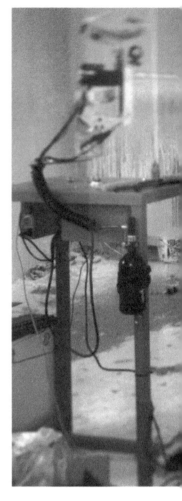

So I put on an act of going inside to check with my commander, quickly loaded my Kalashnikov, and then gave them my supposed commander's orders to keep moving on down the border, giving them directions that would lead them to another guard post. Luckily, they complied, and the silence of the desert closed around me again.

Later, I learned that the next commander they encountered let them cross over the pipeline we were supposed to be guarding after they bribed him with liquor and cigarettes.

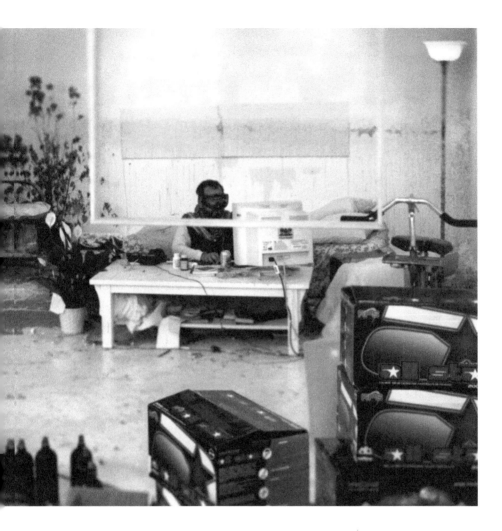

Day 10

I AM ENGAGED IN MY DAILY SISYPHEAN RITUAL of cleaning.
I've had to cover the floor vent with duct tape, since the paint
was dripping into the basement where artwork is stored. So now
there is little air flow, and the atmosphere is suffocating.

The gun is silent; I'm not sure why. I bask in the silence, repeat-
ing my mantra, "I hope this gun stays silent, and all guns become

silent." But the silence quickly becomes disturbing. What's wrong? Has the server gone down? Has the program developed a bug? What will the people online think? I have to get it running again.

It turns out the server is so flooded with traffic that it has frozen. I call Ben and Mark, my comrades from the School of the Art Institute. They promise to head over to help me out. As I wait in the silent room I come to a strange realization: As much as I curse the gun, it has become my companion, and once it falls silent I feel alone and abandoned.

Now I understand the old woman back home in Kufa who was always tormented by kids following her, shouting at her and pulling at her dress. Then one day no kids were there, and she said sadly, "Where are all those little bastards!"

Now Sylvia and Ben are here, and we cluster around the computer and router trying to figure things out. Ben and Sylvia are the picture of geek chic with their matching black T-shirts and Buddy Holly glasses, staring intently at the screen and tapping away on the keyboard. I try to stay out of their way.

"No matter what we do, the server can't keep up with the demand," says Ben.

I try to stay calm, but I'm worried, anxious, terrified, even. Could this be the end of the project? As we sit there stumped as to what to do, a young man strides in. None of us has ever seen him before, but he has such an air of assurance, it's like he owns the place. He says his name is Jason Potlanski, and it turns out he's the hotshot computer whiz who contacted Ben after reading the *Chicago Tribune* story.

I ask Jason to introduce himself to my video camera, out of range of the gun and webcam.

"Hello everybody on YouTube, my name is Jason Potlanski and I'm a technical lead for Citizendium[3]," he says with rapid, no-nonsense confidence. "Since I'm in Chicago, I figured I'd give these guys a hand and see what we can do so you can shoot Wafaa 24/7."

I ask Jason why he's decided to help me. He says he's not into art, or the anti-war movement or politics. He just likes the idea of helping famous people, and apparently now I am "sorta famous."

3 A collaborative on-line encyclopedia headed by Wikipedia co-founder Larry Sanger, which aims to "catch up to" and "do better than" Wikipedia.

Jason promises to get us a dedicated server; he says it will be the answer to our woes. He calls his former employer, a company that hosts servers for large companies and government agencies out of a maximum-security, climate-controlled warehouse near the city's lakefront convention center. As he swirls in the chair with the phone to his ear, he purses his lips and places a finger on his cheek with an air of seriousness belying his baby face.

"No, I don't have an *issue*—is Carl available?" he asks officiously. "I do need something urgently, but it's quite different from what you would think. Have you heard of the Domestic Tension website in the news? There's an artist in Chicago who's hooked a paintball cannon up to a server. It's been on CNN and Slashdot and all that."

He asks to be connected to the CEO and leans back in the chair, giving me a breezy thumbs-up.

He tells the CEO to call me at the gallery. "His name's Wafal, Mr. Wafal, W-A-F-A-L," he says without giving me a chance to correct him. "I appreciate it a lot, Kevin, and while you're at it, if you have a little spare time, Google the words 'Domestic Tension' and you'll see what it's about."

Soon we are back up and running!

But the dedicated server means we lose our old IP address and the users who were linking to it. That is upsetting to me, but to soften the blow Jason contacts an art website in Canada, Art Threat, which has directed a lot of the traffic to the site, and makes sure they post the new address.

Though we increased the bandwidth as a temporary fix until we get the dedicated server, after Jason leaves the server overloads again, and again the gun falls silent.

So many times I've cursed the constant noise of the gun, repeating my mantra about longing for the silence of this gun and all guns. But today, I find the silence torturous.

My attention no longer absorbed by just trying to avoid being shot, I now have time to think, to feel, to remember. In the silence, I think of the deaths of my father and my brother Haji. I try to keep these thoughts at bay, but in my state of exhaustion it's impossible. With a wave of despair, I realize I will truly never see them

again. I crawl over to the desk behind a paint-splattered plexiglas screen so I can cry without being seen over the webcam. I set my video camera on top of the desk aimed at my face, determined to document myself even as I sink into a black hole of grief. My defenses and my pride drop away, and a raw, primal emotion overcomes me. I sob. Tears stream down my face and small, childlike moans issue from my twisted lips. I haven't cried like this since they died.

I want to document my state of mind, but I can't allow the web viewers to see me at this level of vulnerability, I'm too fragile. So I turn to my video camera, my trusty portable confession booth. "This project has allowed me to deal with things I have avoided for a long time, the loss of my brother and my father, my family," I say to the camera. "I miss them terribly. I miss home!"

J ASON BECAME MY TECHIE GUARDIAN ANGEL. I called him at all times of day and night, and he always picked up the phone, even if he was already asleep at 2 a.m. His girlfriend said he was obsessed.

On the day he first visited the gallery, Jason had interviewed for a position at a high-end real estate firm. When he got the job, he immediately told his boss that his devotion to Domestic Tension could become a conflict of interest. Along with fielding my calls for help, he was constantly monitoring the chat room, and he visited the gallery three or four times a week, drinking beer and eating pizza with me under the gun. Once he was in a bar telling his friends about the project. To prove the paintball gun actually worked, he took a shot at me over his cell phone, which had internet access. And then he felt deeply guilty.

Jason's involvement was exactly what I was looking for—I had reached someone who would not otherwise have been drawn to an art exhibit or political debate.

Jason boasted that the project wouldn't have survived more than 10 days without him, and he's right. I had no idea at the beginning how many people would take shots at me, but Jason knew the cyber and gaming communities well, and he knew this would be a magnet for the aggression and curiosity of the online hordes. He also knew how malicious and cruel people could become in the anonymous world of the internet, and he took it upon himself to monitor my mental state. When he saw a YouTube posting where I was distraught, depressed or drained, he would call me immediately to try to lift my spirits.

A T THE END OF MY LAST YEAR of high school, I studied around the clock for final exams. In Iraq, high school was extremely rigorous and all students had to take baccalaureate exams at the same time. College was free, but you had to pass these high school finals to go. For many students admittance to college was a chance to get out of poverty, a pathway to a new existence. And with the Iran-Iraq war still raging, it was also a matter of life or death. If I didn't go to college, I would be conscripted into the military.

I was especially concerned about the English exam. Though I loved the language, I had failed English class almost every year. I excelled at literature, art and math. English and science were my stumbling blocks.

We had a month off from classes to study for the exams, and we threw ourselves into it as if nothing else mattered in the world. For that month, I hardly slept at all. Homes were always too busy, bustling and distracting to study in, so every morning we students would pack up our books and a thermos of tea and head out to the farmland on the outskirts of Kufa, where we'd sit under the date palms to study. We'd go home around 2 p.m. for lunch and a short nap, then back to the palms to study. In the evening we'd have dinner with our families, then head to the Kufa Mosque to study by its light. The mosque was always well lit, with big stadium lights spreading a milky glow across the ruins of old Kufa and the city parks that encircled it. At the end of the street were kabob stands that stayed open late. We'd bring blankets, tea and food with us; I loved leaning my back against the brick wall in the soft night air and burying my head in my books. When I tired of sitting, I would stroll down the street holding the book up, still reading. If I had a question or sudden revelation, I would share it with my classmates, who were also encamped around the mosque with their thermoses and books.

The exams were spread out over the course of two and a half weeks, each one three hours long with a day off in between. As the time approached, I felt ready, almost tingling with anticipation of the new life—college, freedom, travel—that would open up before me if I did well.

The first three exams went smoothly. I sailed through two of

them; the third, English, I believed I had passed, thanks in part to an elaborate collective system of cheating that the student body had developed specifically for that test.

Like me, many students struggled with English. And during the Iran-Iraq war, failure in the English test could send you to the front lines. The exams were held in a large auditorium, the doors guarded by soldiers but the windows open to the street. One student would leave the exam early, taking the test with him. A car or motorcycle would be waiting to take him to the home of a fluent English speaker—sometimes a sympathetic teacher—who would quickly read the test and ascertain the answers to the multiple choice questions. Then another messenger would approach the window of the auditorium and shout out a long string of numbers, a code corresponding to the letter answers for the multiple choice questions. That messenger would dash away on foot or jump on a motorcycle, leaving hundreds of grateful students with a head start on the exam. This system couldn't help with the fill-in-the-blank or essay questions, but since you needed only 50 percent to pass, it was usually enough of a lifeline to get you over the top.

With three more exams to go, I thought I had it made. But then my momentum was interrupted by an event I never could have predicted.

I was huddled with a group of students studying outside the mosque when an acquaintance came by and interrupted our work with a horrible story about a fight that had just happened, where someone's throat was slit. When I got home late that night, I could tell something strange was going on. The door was locked and my family took a long time opening it. When I got inside, everyone was strangely quiet and my mother told me something terrible had happened. My 17-year-old brother, Safaa, had killed someone. It turned out it was a man who had befriended him months earlier, then had taken him out to the desert and raped him. Safaa had kept the attack a secret. When this same man tried to force him into a car that night, Safaa fought back with a knife he had in his pocket, and accidentally slit his throat. My poor brother was so terrified that he had run 10 kilometers through the night, all the way to our aunt's house in Najaf, with dried blood caked on his clothes.

My uncle Salim was based in Najaf, working for the government intelligence service, so my family called him and Safaa turned himself in. My family decided we had to leave Kufa. Revenge killings were common, and since Safaa was now locked up and my older brother Alaa was in the military, I would become the target. Early the next morning we all headed to my aunt's house in Najaf. My parents didn't want me to go back to Kufa for the last three exams, but I was determined. The government wouldn't give me a pass from the military because of the threat I was under, and I wasn't going to let Safaa's terrible ordeal ruin my life by keeping me out of college and hence doomed to the military.

My aunt's house was full of people coming to visit my mother, so the only place to study was on the roof, in the 120-degree heat. Early on the morning of the next exam I sneaked out of the house and ran two miles to get a cab to Kufa. It took me right to the door of the school, and I dashed into the auditorium. There were about 400 students there who all knew what had happened and had seen my empty chair. Now all eyes were on me. The principal came up and told me they would take care of me. A friend of the family agreed to be my bodyguard and driver to help me get to the next two exams. The day I finished the last exam, my family shipped me to my aunt's house in Baghdad.

Waiting for the results was like hanging on the edge of a precipice. On one side was the military—a hellish and most likely fatal experience. On the other was college—escape from the military, my brother's crime and the oppression at home, heaven! After a few weeks of anxious waiting, my mother and youngest brother, Ahmed arrived at my aunt's door with the exam results. They said they had good news—I had passed five subjects. And bad news—I had failed English, the thorn in my side! As I started babbling desperately, my mother and brother began to laugh. They'd been playing a joke—I had actually passed all the exams. In fact, I had averaged 89 percent. My aunt didn't let me out of the house, even in Baghdad, because of the risk of revenge killing. But I wanted to thank my mother and brother for driving out to give me the results, so I gave my cousin money to buy Pepsis for them.

I was thrilled that I was going to college, but my joy wasn't com-

plete, since I was also devastated because my little brother was still locked up.

That summer while Safaa's trial played out, I was a virtual prisoner in my aunt's house, able to peek at the outside world only from the roof. During the trial, my father exhibited his strange penchant for seesawing between cruel contempt and fierce loyalty toward his family. He spoke out bravely and boldly to the judge throughout the process, and he helped bring another young man who had participated in Safaa's earlier rape to trial. That man's family tried to claim he was a juvenile, even creating a fake ID card, but my father pushed the prosecutor to demand physical tests, which revealed he was indeed an adult.

Meanwhile my father met the threat of the revenge killing head on. He went straight to the powerful leader of the tribe of Safaa's rapist, and brandishing his gun, said that if anything happened to his sons, he would hold this man directly responsible. Perhaps my father's reputation for insanity came in handy; no one wanted to tangle with him. Thanks to my father's advocacy, judicial and public sympathy swung to my brother's side, and he was only sentenced to three years in juvenile detention. With the trial over and the tribal leader properly warned, my family felt the threat had subsided. I remained in Baghdad, but now I could move about the city, and even joined a local soccer team.

In the juvenile detention center in Sadr City, Safaa became deeply involved in religion, influenced by the fundamentalists he encountered there. As in many U.S. prisons, one was likely to come out either a hardened criminal or a religious fanatic. I figured it was better for my brother to become religious than criminal, but the transformation was still disturbing to witness. He had been a talented flute player, and now he gave up the instrument, convinced that music distracts from proper attention to God.

Thankfully, Safaa was smart at working the system. He was allowed to leave the jail during the day to finish his vocational degree in car mechanics, and during his brief furloughs he would buy cigarettes and other sundries to sell to fellow detainees at a handsome markup. When I visited him in jail, he would be the one giving me money, not the other way around.

DAY 11

A TALL, FRESH-FACED YOUNG MAN with a crew cut ambles into the gallery. His name is Matt Schmidt, and he tells me that until recently he was a U.S. Marine. He saw the YouTube video where Estonia killed the lamp, and how upset I had become. He holds out a plastic bag. "I got you a new lamp and some light bulbs," he tells me. "I figured you can use all the help you can get."

Matt says he never thought much about the consequences of shooting another person in war. He says he and his fellow Marines were always too busy trying to survive to be worried about their targets. But the paintball project has made him see things in a different light, enabled him to see his adversaries as human beings. He wishes his Marine buddies could visit the gallery.

Matt explains that he intentionally got a tall lamp so the shade and bulb will be above the line of fire. The apartment depicted on the lamp's box is a pristine snowy white—the way the gallery looked on opening night before the paintballs started flying.

Matt's visit warms my heart. I take a short walk over to the gallery's front window and gaze out at the sheets of summer rain pouring down, biting my lip, overcome with emotion.

I had been having doubts about whether I could go on. But then Matt walked in and gave me the lamp. It was a simple act, but a brave one, and hugely significant. Moments like this keep me going, restore my faith in humanity.

DAY 12

I GET A SURPRISE VISITOR—Mark, the owner of Discount Paintball, the suburban outlet where I get my supplies. He had taken a real interest in the project when I visited the store to stock up. After seeing all the media the project was generating, he knew I had grossly underestimated the quantity of paintballs and air canisters I would

need. So now he has driven for an hour into the city to bring me eight free air canisters and a cache of free paintballs.

When I visited his shop, Mark schooled me on politically correct paintball nomenclature: you're supposed to call the guns "markers," in reference to their original use by foresters and farmers to mark livestock and trees from a distance. This is apparently an effort by the industry to disassociate the guns from real violence. However, this public relations effort is belied by the macho names

of the equipment on the market—"Evil Autococker Super Tail," "Dangerous Power G3."

And YouTube features plenty of videos of paintball enthusiasts in military garb darting through the woods to the sound of heavy metal music. The military also uses paintball guns for training, as highlighted in a video from Camp Pendleton showing Marines sniping at each other with red paintballs.

"You have a lot of fun!" enthuses one of the Marines. Another says it teaches you to keep your extremities in tight, close to your body, since getting hit gives you a "pain-induced memory."

I greatly appreciate Mark's generous gesture, not only for the free materials but also, more importantly, because it's another instance of the project reaching someone I wouldn't immediately have expected to sympathize with the Iraqis' plight or take an interest in conceptual art.

I WANTED MORE THAN ANYTHING TO STUDY ART in college. Every student lists preferences for what to study at the University of Baghdad, and depending on your score on the high school final exams, you are assigned one of your choices.

To major in art or physical education, a student also had to pass special exams—the art exam consisted of sketching various objects and models. One of the professors administering the test loved my work and told me, "You're in. I'll see you when school starts."

So I was shocked and crestfallen when I saw the list of those who had been admitted to study art, and my name wasn't on it. I had thought it was guaranteed. Instead, I was assigned to study geology and geography, which I had marked as my next choice without even thinking about it, so certain I'd be studying art.

Now I learned that art and physical education majors were treated differently because the government understood the power of those fields—in those professions one could influence other people. There was an arbitrary policy that if one of your family members was a dissident, you could not study in those fields.

My downfall was a cousin in Kufa who had been accused of being

in the Dawa Party, a militant Shia religious party hated by the Ba'athists. He was arrested, and later his body was returned to the family along with a bill for 72 dinars for the bullets used to execute him. He had been an only son, and his parents, wracked with grief and despair, died soon after. At the time of his death I was still a loyal young Ba'ath Party member, but the execution—which took place when I was in high school—had torn the scales from my eyes and initiated my rapid fall from grace with the party. Later, the government sent my cousin's family a letter saying the accusation had been a mistake, and apologizing for the wrongful execution.

Though I wasn't allowed to study art, luckily there were art studios with free supplies at the university that anyone could use. The catch was you were always being watched. The walls had eyes and ears, as did the ceiling and the floor.

Saddam wanted to foster the illusion of democracy and freedom of speech, and the university sanctioned a "Free Wall" where students were allowed to post leaflets and fliers. But it was a trap. Spies would lurk around the wall, watching whoever posted there. A friend of mine tacked up a note addressed to "Mr. President," opposing the summer training camps that students were forced to attend. "Many of us have poor families," he wrote, "and when we're forced to go to training camps in the summer, we can't help earn money to feed our families." He asked Saddam to end this practice. A security official came up to him and said, "Looks like some people have extra fat to burn," which was a way of threatening torture, a reference to cooking a kabob for an especially long time to burn off the excess fat. Dissident students would regularly disappear from the campus, leaving behind lovers and friends too afraid to ask questions. Sometimes the students would return looking like ghosts, with haunted eyes and gaunt frames, terrified. They would never tell anyone where they'd been, but they were a walking reminder that the regime would suffer no critics.

While I was at the university, Saddam named a loyal Ba'ath Party member, Samir al-Sheikhly, head of the ministry of education, even though he hadn't finished high school himself. He had previously been head of sanitation in Baghdad, in charge of cleaning up the city and enforcing the "laws of God." He would go out on the

streets himself at 4 a.m. when the sanitation workers were just starting work, and if he saw any of them not doing their jobs he would personally beat them. He was renowned for his brutality and pettiness.

Al-Sheikhly was so uneducated and unsophisticated that when he found out the University of Baghdad didn't have bells to start and end each class, he was scandalized. He couldn't understand that this was university, not grammar or high school, and we students had the responsibility to make it to class on our own; he mandated there must be a bell ringing every hour. Once he had the bells ringing, he was infuriated that there were still students hanging around outside on campus. People tried to explain to him that every student didn't have lectures at every hour of the day, but he didn't buy it. More time for talking and socializing meant more time for students to organize and share their dissent. So he increased the number of subjects in each major from seven to thirteen, to be sure we were in class at all times and so overwhelmed with work that we would have no time or energy for stirring up trouble.

DAY 13

MY HAIR, BEARD AND NAILS ARE GETTING LONG; I will let them grow for the duration of the project. And like the rest of me, my hair and beard don't just lie down peaceably. They insist on sticking out and making themselves known, engulfing me in a bushy mane. I'm looking progressively wilder and more unkempt.

The shooters have figured out that they can fire the gun multiple times in quick succession if they open multiple browser windows on their computer. They're loving it. Someone in Milwaukee opens 19 browsers and starts firing away; he tells me he's giving me a "19-gun salute."

I get a visit from my Iraqi friend Aqeel, who has been a war photojournalist for 11 years. Unlike most visitors to the gallery, he has seen war firsthand, and lots of it. He says he could feel the fear the moment he walked in the gallery. He'd been watching his co-worker shooting me online for three days, but he is astonished to feel the

palpable tension in the gallery. It reminds him of various conflict situations he's seen.

He tells me, "A lot of people ask me about war because I've seen so much of it, but most of the time I cannot tell them what war is. This project shows exactly what it is. It's not a video game. I see you sitting there in fear; you are a human being."

ALL COLLEGE STUDENTS WERE FORCED TO SPEND one month in a military training camp during the summer. Saddam wanted to make sure we were kept busy; he feared students in general and especially idle students, with time for getting together and stirring up trouble. The student training camps were even more grueling than training for regular soldiers. We got up at 4:30 a.m. and by 5 we were doing physical exercises—running, calisthenics and mock military maneuvers. After "breakfast," standing around a table wolfing down tea and small rations of food, we were sent out for more exercises. The evenings were filled with lectures about the virtues of the Ba'ath Party. I remember returning from the camp one year with my back so sunburnt the slightest touch of a shirt or hand was excruciating. The scorching Iraqi sun was so brutal it burned right through the military jackets we wore.

I truly hated the camps, the fact that I was being forced to learn skills I didn't want, that I was being trained to kill, against my will, and also that my time was being taken away from reading and art. And I hated the constant, systematic abuse from the officers. I spent much of the time physically sick—I had suffered a serious concussion playing soccer as a kid, and the head injury left me with paralyzing bouts of nausea and vomiting when I became dehydrated or exhausted. I remember being doubled over on the ground throwing up, with a camp officer shouting angrily in my face. Some days I was too sick to perform the physical exercises, which was terrifying since perceived disobedience on my part could mean not only being put in jail but even being kicked out of college and sent to the front lines of the war.

I was in a summer training camp outside Mosul when the Iran-Iraq war ended, the summer after my third year of college.

When the officers at our training camp got the news of the cease-fire, they dropped everything and headed back to their homes to celebrate—stranding the students in that harsh desert outpost with no transportation or extra food or water. We were ecstatic to hear the war was finally over, but faced with finding a way home before our supplies ran out. Some hitched rides on passing trucks, celebrating in the open truck beds as they sped down the highway. We heard that one truck flipped over from the momentum of students rocking it in exultation, crushing some of them to death. After a few days the government sent a convoy to collect us and take us back to Baghdad.

Back in Kufa, my whole family was celebrating the end of the Iran-Iraq war. But my grandfather put a damper on things with a strange prophecy—he kept direly repeating, "This is nothing, wait until the big one comes." His daughters snapped at him not to say such things.

One summer during college, after my hellish month of military camp, my artist friend Qasim and I escaped from the rest of the world for a few weeks and dedicated ourselves to painting, living in a friend's vacant apartment in Baghdad. We had an idyllic schedule, painting through the night, going to sleep when we heard the roosters crowing just before dawn, then waking up mid-morning and taking a bus to the university to work in art studios that were open to students during the summer. After the necessary afternoon siesta—when the temperature is scorching—we would roam the streets of Baghdad looking for art and inspiration. We were idealistic and determined to dedicate our lives to art.

Like young bohemians the world over, we were always scrambling for spare change and cheap food. Qasim was a talented painter of realistic landscapes and city scenes, so he could sell his work. I could never sell anything because I was doing abstract work that didn't interest tourists or mainstream Iraqis. We used to go to Al-Karrada, a neighborhood in Baghdad that even during the war was always full of tourists from Europe and the Gulf states. The Europeans loved paintings of the marshes, markets and alleyways.

One day we saw a new gallery, in a place that had previously

housed a stand selling *pachah*, a popular Iraqi meal involving every part of the sheep—the head, feet, intestines all stewed with spices and onion and sopped up with flatbread. People were especially fond of it after a night of drinking. The shopkeeper told us the *pachah* business hadn't been going well, so he'd decided to sell art instead, even though he didn't know the first thing about it. Qasim promised me that if this man bought his work, he would buy me a quarter chicken—a luxury for us at the time. Qasim did indeed sell a painting, so we headed out for the feast.

There was a new rule in Baghdad mandating that people were only to cross streets on recently installed pedestrian bridges, above the hopelessly snarled and chaotic traffic. I obeyed the law, but Qasim called me a coward and crossed on the road. An officer grabbed him and wanted to arrest him. To make matters worse, Qasim had washed his shirt with his student ID card in the pocket, and it was ruined. I ran down to the officer and begged him not to arrest Qasim.

It turned out the officer was a friendly, open-minded sort, and he began to banter with us. And so, not seeing any real risk of going to jail, Qasim began to comically plead with the officer to incarcerate him, while at the same time I was saying, "Whatever you do, don't take him to jail!"

The officer dramatically promised to let Qasim go if I would explain what was going on here. The truth, which I told him, was that if Qasim went to jail, he would get a free meal but then I wouldn't get my quarter chicken. The officer let us both go, with a cautious smile. He knew the regime would not approve of such lighthearted banter, but his humanity and sense of humor broke through his authoritarian mantle that one time.

I N IRAQ, YOU NEVER EAT ALONE. The family spreads a sheet on the floor and eats together, each with our own plate of rice, and sharing communal platters of meat, stew, greens and flatbread. Guests are always welcome. People eat until the food is gone or until they

can't eat anymore, sitting cross-legged on the floor, a symbolic way of honoring the earth and God who gave us this food.

When I stepped into the paintball gallery for my month of captivity, I intentionally did not bring any food with me. I wanted to leave my fate, my well-being in the hands of the community, to take a leap of faith and hope they would take care of me.

And on the food front, they not only took care of me but—with the exception of a few lean days late in the project—lavished me with all the diversity of Chicago's famous ethnic cuisine, which arrived regularly on my doorstep.

For longtime friends and sympathetic strangers, food was a form of physical connection and sustenance, one of the few comforts they could offer me.

During the project I became good friends with the owner of Baba Pita, a restaurant across the street from FlatFile. He was a Morroccan immigrant about my age who got his business degree in Canada and then took on the challenge of saving this struggling Middle Eastern restaurant in Chicago. When his business was slow, he would come over and talk to me for hours, telling me what a great job I was doing, thanking me for raising awareness of Middle Eastern culture. He would often get customers on their way to or from seeing me at FlatFile, and if someone came in who didn't know about my project, he gave them my card and told them to check it out.

I do like Middle Eastern food, and appreciated the countless meals of falafel, pita and lentil soup people brought. But what I most craved during the paintball project, as I do in everyday life, was pizza. On a really rough day midway through the project, my roommate Luis and friend Mark could see on the webcam that I was losing it. They showed up with pizza and beer and convinced me to leave the gun to eat with them. They took turns dressing up as me to go before the gun so I could enjoy my pizza in relative peace. No one online noticed the difference. Another time, after a lively interview with PRI's Fair Game, host Faith Salie asked me what my favorite food was. Pizza, I told her. Half an hour later a pizza arrived at the gallery door. The reporter logged into the chat room to ask how the pizza was. I told her honestly it was the best one I had ever eaten.

When visitors brought food I always wanted to eat with them, usually in front of the gun if they were willing, an experience that made many people too jittery to eat much.

Once Susan, Shawn Lawson's wife, called from New York asking what my favorite restaurant was. Baba Palace, a Pakistani spot in downtown Chicago, I told her. She called Baba Palace to order a meal for me. They don't deliver, but the restaurant is a hang-out for cabdrivers, and they arranged for one to bring the food to me. He pulled up outside FlatFile and motioned impatiently for me to come get the food. Since it was a Sunday I was there alone. Standing in the FlatFile doorway, I pleaded with him to bring it to me. It was only a matter of a few steps. He couldn't understand why I would not go out to his cab for the food. There was no way I could explain the whole project to him, shouting across the noise of traffic as he sat there increasingly impatient in his cab. Luckily my friend at Baba Pita across the street saw the drama and stepped in to ferry the food to me.

With all this rich food and very little exercise, along with stress and depression, I gained 20 pounds in 30 days, the reverse of those miracle diet plans advertised on late-night TV. But along with the crucial social aspect, food became the only way I could reward my poor suffering body, to offer some indulgence and comfort for all the stress I was putting it through.

T HE YEAR I ENTERED COLLEGE, Saddam closed the dorms to new students, since he viewed the communal housing as a breeding ground for discontent and resistance. He wanted to prevent students from gathering and stirring up trouble, and at the same time make it harder for them to study so they would be more likely to flunk out of college and be forced into the military. I had been so excited at the prospect of life in the modern, comfortable dorms, on my own and away from my father at last. Now I found myself with the prospect of being homeless in Baghdad.

So my first year of college I lived in a filthy hotel called the Algier, with stained sheets and musty, cracked walls. I would walk around Baghdad late into the night just to avoid going back there. Later I

rented an apartment with about 10 other students. But soon, my friends and I figured out how to pose as upperclassmen to get a space in the dorms. Our success depended on good fake ID cards, which we created using the same technique I would use a few years later to get my brother out of a Saudi Arabian refugee camp. We copied the stamp from a valid ID onto transparent paper with India ink and an engineer's pen; then we boiled and peeled an egg and pressed it carefully against the copy. It would transfer the ink perfectly, just like a rubber stamp, onto the fake ID card we'd made with our name and picture. Then we'd laminate it with an iron. In addition to getting us in the dorms, this ruse gave us the satisfaction of fooling the authorities—gratifying in any context, and especially in regard to such a repressive regime.

Later I lived with my sister Rajaa, who had moved to Baghdad while her husband was away in the military. They lived in Gazalia Village, an area given to officers by Saddam; Rajaa and her husband Kamel ended up there thanks to Rajaa's brother-in-law, who was a military helicopter pilot. When Kamel came back from the war, he drove a taxi. The embargo had started, and food was rationed by the government based on how many people lived in a home, but I didn't officially live there. They shared their meager portions with me, and I remember being doubled over with hunger pangs, counting the minutes until Kamel would return from his late shift and we could eat our paltry repast. I spent some of these hungry hours making paintings that mocked the government. One showed an officer at the hated military training camp haranguing a group of students. But on his uniformed shoulders was a mule's head. Rajaa was furious at me for doing these paintings, since she knew what would happen if they were ever discovered. Without her knowledge, I rolled the canvases up and stowed them away in the hollow bed posts.

THE BA'ATH PARTY INSERTED ITSELF into every facet of college life. There was a mandate that every class, no matter what subject, had to integrate the philosophy and achievements of the party. As a reaction to this policy, a joke started to circulate about Party officials

telling a geography professor he must integrate party philosophy into his lessons. He said, "How? I teach geography." They insisted. So he told his students, "Iraq used to have a cold, wet climate in the winter and a hot, dry climate in the summer, without a drop of rain," which is the reality, "but," he'd continue, "thanks to the Ba'ath Party, it's nice all year round now."

You couldn't turn around without seeing Saddam's image. His thick, arrogant visage peered down from every tall building—huge murals reminding you that the system was always watching. There were people in Iraq who made a living just painting Saddam's image. As my talent for painting developed, Ba'ath Party members came to me asking me to paint portraits or murals of Saddam. I talked my way out of it by insulting myself, saying I was an awful painter, that they didn't want me representing the president. Even my friend Qasim often badgered me to paint Saddam's portrait, because each year on his birthday Saddam would judge his portraits and give a big award for his favorite one. Qasim would enter two of his paintings, one with his name and one with mine, so if one of us won we could share the award. I remember taking a taxi to the palace to drop off the paintings, the driver sweating nervously just from being so close to the presence of the dictator. "My" painting never won.

Though the political situation was extreme, I was in many ways like a college student anywhere in the world, a young man finding my identity and my voice and glorying in my newfound personal freedom. Exhilarated by the chance to express myself through art, I churned out provocative political pieces, full of self-righteousness and cynicism. I mocked Western culture and created Dada-esque anti-art, fighting everything and everybody. Then I started photographing poor people in Baghdad's indigent neighborhoods and painting them in a realistic style. This was something the regime did not want to see. One of my shows was closed down. Some of my paintings were seized and I was questioned and harangued by security officials. I veered into abstract art, so I could create more subtle images and claim the art wasn't anti-government. But after an art show at the end of my third year, they hauled me off to the security office and questioned me for hours. The piece that most upset them was a canvas

wrapped in chains. They made me sign a document saying that I would not create art critical of the regime and that I would also report other artists who were dissidents. I never reported anyone, and I would alert other artists if I thought they were being watched.

The government was terrified of the students. Officers were stationed in each classroom, easy to recognize as non-students because they were older men who sat in the back and never did homework, yet no professor would dare challenge them. There were also undercover spies who were genuine students turned informers. Not many students had cars, so you could tell some of the student spies because they would shamelessly flaunt their vehicles and wealth. Most spies were pure opportunists, in it for the power and money. They were also largely from Ramadi and Tikrit, Saddam's ancestral turf. But others, including some Shias, were spies out of true loyalty to the Ba'ath Party. Those were the most dangerous.

In a gesture toward false democracy, like the not-so-free "Free Wall," the university let the students elect class leaders. I was elected leader of my class, beating out a student spy, which made the Ba'athist students really hate me. They threatened me to my face, approaching me between classes and saying things like, "You better be careful, there are a lot of cars on the street and it would be really easy to have an accident."

One day one of the obvious spies, a perpetual student in his 40s named Abu Umar, asked me where I was from. When I said Najaf, he put his repulsive face close to mine and hissed the words, "Shia Shani'a"—which basically means "Intolerable Shia."

I didn't really care: I had long ago decided that you only have one life to live and there's no point living it in submission or fear. So I kept breaking the rules.

There was a rule that all students had to shave, since a beard was seen as a symbol of alliance with Shias in Iran. But this was during the embargo—times were rough, and I hardly had money for food—and as a point of principle, I decided I wasn't going to spend money on a razor. My human geography professor was a politically connected Ba'athist who cared little about his subject matter—the migration of peoples and ethnicities—but he was obsessed with getting me to shave. One day, when I refused his demand that I shave, he

marked me absent. The same exchange was repeated the next day, and he marked me absent again.

Meanwhile the government had figured out that students were failing their classes intentionally so they could remain in college and stay out of the military. New rules were put in place: if you had three absences, you failed the class, and if you failed out of school your first year, you were automatically sent to the military. Also, you had to complete your studies in five years—you couldn't keep failing and stay in eight or ten years, the way some students had been doing.

(Years later, after I had spent almost a decade in college in the United States pursuing my bachelor's and master's degrees, my brother jokingly asked, "Don't you know that here you won't be forced into the military when you leave college?")

So if I was marked absent again in the human geography class, it would be a step down the road to the military. I refused to let the professor count me absent. I wrote down every single thing he said in the lectures, rambling about his wife's makeup and the beans they ate for dinner, so I could prove I was there. My unruly beard and attitude annoying him more than ever, he demanded I leave the classroom. I refused, saying, "I'm not leaving—you can leave if you don't like it." And he did, stalking out in a huff.

Iraq invaded Kuwait on August 2, 1990—just two years after the end of the Iran-Iraq war. I was about to start my fifth and final year of college. Saddam accused Kuwait of participating in an "imperialist-Zionist conspiracy" against Iraq by driving down oil prices through overproduction and supposedly stealing billions of dollars worth of Iraqi oil by drilling horizontally under the border to tap Iraq's Rumaila oil field. Saddam also wanted Kuwait to forgive the massive loans it had advanced Iraq for the war against Iran, which Saddam saw as a war on behalf of the whole Sunni Arab world. Kuwaiti officials countered that Iraq was drilling for oil inside Kuwaiti borders, and refused to let the loans slide.

Saddam had swelled with pride at "winning" the Iran-Iraq war—he held a rally at "Victory Square" in Baghdad dressed in his traditional white dishdasha and his keffiyah, regally brandishing his sword. But the Iraqi people didn't see it as a victory—they hated Saddam

with a passion. His personal victory had cost almost a million lives and destroyed the economy. And now there were more than a million young Iraqi men coming back from the front lines without jobs to support them.

Meanwhile the United States was starting to feel threatened by its erstwhile protégé—Saddam's demonstration of military might had shown he might be too strong for his masters. The Kuwait invasion played perfectly into U.S. hands as a needed excuse to destroy the war machine it had created. Saddam was led to believe the United States wouldn't interfere with his aggression against Kuwait. During his July 25, 1990 meeting with U.S. Ambassador April Glaspie, she told him the United States had no opinion in this regional "Arab-Arab conflict," adding that President George H.W. Bush wanted "better and deeper relations" with Iraq. Saddam thought he had a green light.

Ba'athist military officers started coming to the university asking students to volunteer. They claimed it was just "symbolic," that we wouldn't really have to go to war. Since I was the elected class leader, a Ba'athist professor wanted me to volunteer in front of everyone, to make a point. He asked me, "Wafaa, will you volunteer?" My heart was in my throat, but keeping my voice strong and steady, I stood and said, "No, I don't believe in it." He sneered, told me to sit down and called me a coward. He said I'd see the other heroes volunteer. But no one else volunteered. You could hear a pin drop. The officers left, and in front of everyone, the professor told me I would get my punishment.

I didn't want to be one of those people who vanished and then returned a broken man, an example for others. Or I could be one who simply "disappeared." It happened all the time. I realized, sadly, that my time at the university was over.

DAY 14

POSTING NEWS OF MY PROJECT on the message board at Paintball Nation's website—a popular venue for paintball fans —seemed like a perfect idea. But for some reason, they banned me. The administrators said I could not post anything on the site

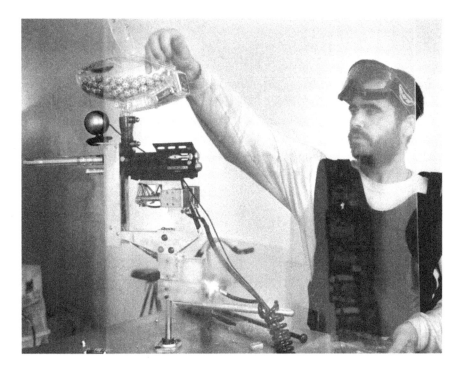

or even visit it. So on my YouTube video, I make a plea to people to tell Paintball Nation to lift the ban. "Shame on you, Paintball Nation!" I say into the camera.

The plexiglas shields have been shattered. So the associate director of FlatFile Galleries, Aaron Ott, and I install new ones on movable racks I bought from a clothing store before the project started. (When they inquired what I would use them for, I had laughed to myself and said aloud, "Don't ask!")

This time we're using 1/4″ thick shields, as opposed to the 1/8″ ones that have all shattered and splintered.

We put a "Don't Shoot" sign up while we do maintenance. Aaron didn't want to turn the gun off; he wanted to experience being in the line of fire. But the sign doesn't stop the shooting. This must be what it feels like to prepare for a hurricane—you don't know exactly what will happen, but you know it's going to be rough.

D ETERMINED TO KEEP A STEP AHEAD of the Ba'ath executioners I was sure would be coming for me, I silently said my goodbyes to my studies, the art studio and my friends and classmates. I didn't dare actually tell anyone I was leaving; I didn't want to tip off the student spies. My instincts proved right—later on I heard that a list of "expelled students" had been posted, my name among them. We all knew "expelled" was a code for something much worse.

I gathered up some sparse belongings and got on a bus to Kufa, where my family was startled but pleased to see me back.

People were in motion all over the country—the road from Baghdad to Kufa was jammed with bumper-to-bumper traffic—because the January 15, 1991, United Nations–sanctioned deadline for Saddam to leave Kuwait was looming. Saddam had no intention of backing down, and we knew the wrath of the U.S. military would soon be upon us. Days after I fled Baghdad, the university was closed.

On January 16, 1991, the United States began bombing Iraq. In Operation Desert Storm large swaths of Baghdad were decimated, historical monuments were obliterated and university buildings I had studied in just a month earlier were reduced to rubble. The communications infrastructure across the country was destroyed, which worked to my benefit—there could be no government intelligence sharing between Kufa and Baghdad. A UN report would later describe the effects of the bombing as "near apocalyptic," driving the country back to a "pre-industrial age."

My family hunkered down into survival mode in Kufa, not knowing how things would pan out. I had not been able to bring any of my art with me from Baghdad, but I threw myself into creating new works—realistic pieces criticizing the government, which angered and terrified my family. One was a ghostly image of a man's hunched, tired back, his thin, translucent skin barely covering his bones, showing the brutality of the regime through the physical effects of poverty, imprisonment, torture.

I would go to a friend's house and paint all night, then slip home at dawn—the way young Americans sneak out to drink and party

hidden from their parents, except I was sneaking out to paint.

My family's and my grandparents' homes were surrounded by potential bombing targets—a government building, an air raid siren, a gas station, the Kufa Bridge and a communications tower. So they all went to my aunt Mahdiyya's house in Najaf, which was in a purely residential area away from any targets. I decided to stay in Kufa in my other aunt's empty house. There would be so many people in Mahdiyya's house; I wanted time to be by myself, to paint and read and think.

Solitude was such sweetness to me that it was worth risking my life for some time alone. I gathered up a camping lantern and all my canvases and whiled away the hours painting in my aunt Razeeqah's empty house to the sound of bombs dropping in the distance. I listened to the radio—usually *Voice of America*—to hear news of the outside world falling apart around me while I was ensconced in this little sphere of my own. Even though I wasn't religious, every night when I lay my head on the pillow I would say a short prayer in case it was to be my last. First I would curse myself if I were to die, feeling that death even in such circumstances would be a sign of weakness or failure. Sometimes when we find ourselves in such horrible circumstances, we illogically blame ourselves. But eventually I accepted that the situation was out of my control, and instead of cursing myself each night I said a tearful round of goodbyes to my family, one by one, each by name.

Aunt Razeeqah, whose house I was staying in, had been pregnant with her second child when her husband Adel was sent to the front lines of the Iran-Iraq war. He never came back. When a soldier disappeared in that war, unless the body was returned, people always figured there was a possibility they had been captured by the Iranians. Families would listen to the radio constantly, because Iran and Iraq would both broadcast interviews with their prisoners of war. It was a way of flaunting victory—"look how many prisoners we have"—and also of trying to show each government's supposed benevolence toward prisoners, urging enemy soldiers to defect and turn themselves in. Someone told Razeeqah they heard Adel's voice on the radio, but we doubted that was true since we always listened to the radio to see if anyone we knew had been taken prisoner, and we hadn't heard him ourselves.

But sometimes people would tell the family of missing soldiers that they had heard their loved ones on the radio just to give them hope and calm them down, and Razeeqah latched onto the idea that her husband wasn't dead but rather a prisoner of war. However, after the war ended and Iran released its prisoners, he still didn't come back. So Razeeqah convinced herself that since her husband was deeply religious, he had decided to stay in Iran under the revolutionary government. Even though she never received a letter or any news of him, her hope remained high that Adel would return after the toppling of Saddam. Of course, he never did. Adel's son never met his father, and Adel died without ever seeing his son. He probably ended up in a mass grave, another anonymous body leaving a legacy of pain and false hope behind.

Kufa's telecommunications tower, which rose over the city like the Eiffel Tower, was a major bombing target, so Kufa's citizens volunteered to take it apart piece by piece, scaling it with their wrenches in their belts, dismantling a section and climbing back down like a parade of industrious ants. They stored each piece carefully so they could put it back together later.

Sometimes I would go to Najaf to visit the family, and it was amazing to see just how many people were crammed into the house, living with no electricity or running water, only candlelight. There was little food; the adults would eat first and then give the kids the pot to fight over. There was too little to distribute on plates, so my young siblings and cousins would dive into the pot, the fastest kid getting the spoils. My brother Alaa loved the dry crust of rice that would form on the bottom, so much so that even though he was an adult, he would fight the little kids for it.

Incongruously, there was much laughing and joking in that house. Iraqis have always been big on humor, even in the most stressful and dangerous of times. I think you have to be able to laugh in order to stay alive and sane in the face of atrocities, violence and fear that you are helpless to stop. The adults started acting like children to pass the time—my adult brothers would be out in the street with the little kids playing marbles. This resilient, playful attitude was a form not only of survival but of resistance. We were powerless to oppose the regime, but at least we could mock it. However,

recently I hear that Iraqis are no longer making jokes, no longer laughing in the face of disaster. This is deeply disturbing. When Iraqis can no longer laugh, it means they've entered a mode of complete hopelessness.

I became anxious to leave Iraq. I longed to go to Europe; I had heard so much about enlightened people who appreciated art and other cultures. I pondered escaping into Iran through the Kurdish area in the north. But that would mean I'd have to go back through Baghdad. And there were almost no cars on the street—any vehicle would have been attacked. So I stayed in Kufa through weeks of U.S. bombing that destroyed the whole city's infrastructure, and most of the country's; electricity generation, communications and bridges. My favorite spot to paint was the Kufa Bridge—until it was bombed, killing scores of people including a wedding party. I was painting at my aunt's house at the time, it was just luck that I had decided not to go to the bridge that day. The reverberations shook the house and all the surrounding buildings, sending tremors through my bones. I raced toward the bridge with my heart pounding, joining a screaming, wailing crowd converging on the site of the explosion. There were pieces of flesh and twisted metal everywhere. Staggering through the destruction in a state of collective shock, we gathered up the bits of flesh and torn clothing and threw them in the river, my eyes smarting and my throat swelling from the horrific smells and sights.

DAY 15

I WAKE UP FEELING GOOD about the four hours sleep I've gotten—a luxury by recent standards. Aaron is coming over to help me clean up the room, which is filthy.

In fact, the filth is one of the hardships I hadn't anticipated going into the project. It really takes a toll on my mood. Imagine living in a pit of yellow slime and piles of shrapnel (the rubbery bullet coating) and the sickening smell of fish oil from the paint. I am itching like crazy. I had hung an 8½ x 11″ black-and-white photo of myself on a string to create a target for the shooters. Now it's lying

on the floor, torn up and half-submerged in yellow paint. The scene is like some natural disaster—except it's not natural, it's an entirely manmade disaster. Like war.

We scrub the floor inch by inch on our hands and knees, under the line of the gun. Aaron remarks that being on your hands and knees because you can't stand up is an amazing condition—I'm not sure if he means it metaphorically or not, but that's how I understand it. Under a dictatorship, one cannot stand tall.

People keep firing at us as we rub the slippery floor even though we are only four feet away, as opposed to the usual 15 or 20 feet between me and the gun. Predators with no mercy.

We get the room relatively clean, and Aaron leaves. I log in to the chat room. For the past two nights three young women from the UK who heard me on the BBC had been online until 4 a.m., teasing me, telling cute jokes and talking about flying to Chicago for a visit. They were all in different towns, but they were having a party together in my chat room. One of them was crazy or maybe drunk. She kept saying, "KILL KILL KILL MAIM KILL." Then "Yr a handsome bloke! Don't b coy." I wanted to cut through the ridiculous banter and talk to her as a normal human being. Finally, when I told her about my brother's and father's deaths, I was able to engage her in real conversation.

One of them said she was sorry for my losses and years of exile. "This is only an example of the loss of human life in Iraq," I told her. She asked if the project was helping me deal with my brother's death. I said it was, but it was also bringing up difficult emotions.

"So it's causing u harm, there must be a better way," she said. "Shootin seemed really fun at the time. We all feel real bad now!"

Most of the young women will shoot once and then want to talk. The guys never want to have a conversation. Maybe because talking humanizes people, both me and them.

Now the UK gals are not online, but I meet (in the cyber sense) a woman studying printmaking at Yale and an Iranian guy who "was born into the Iran-Iraq war," as he describes it. They think I should let myself get hit.

"The project in a sense collapses because the artist is no

longer willing to suffer," says the Iranian. "It might as well be a computer game where we shoot images of individuals. I thought the point was to shoot you, and based on your YouTube entries I think you were initially not as averted to the idea of being shot. Until you realized it REALLY does hurt. That's why you are now just avoiding every shot. But shouldn't your suffering and endurance be a part of the project?"

They want me to be a martyr and sacrifice myself to make a point.

That makes me furious, because I didn't do this to take orders from people. I didn't do this to be turned into a joke or a game. And I'm not a martyr—I'm not trying to kill myself, I'm just an artist trying to make a point. I hate the idea of martyrdom in general; I believe in surviving. The day of the opening I was still confused. I performed for the people in the gallery, letting myself get hit over and over again. But that was not what the project was about.

The point is, in Iraq, in a war zone, you don't jump in front of a gun asking to be shot. You go into survival mode, and that survival mode is what changes your entire life and saps your energy and attention. On a daily basis, Iraqis are shaping their whole lives and routines just to avoid getting hit—taking different routes to work, only going out at certain times of day, always staying alert.

I think the Yale student and the Iranian are trying to make a logical argument about something completely illogical, entering a discussion just because they want to win an argument, trying to hijack someone else's platform just so they can show off their intellect, but not contributing anything.

I can feel myself getting more and more irritable; I'm on an emotional roller coaster.

DURING THE IRAN-IRAQ WAR, Saddam claimed all the Iraqi dead were martyrs. Iran used the same tactic, but it was especially cynical for a secular leader like Saddam to invoke the religious connotations of martyrdom to try to keep his people from questioning that pointless war.

My favorite uncle, Salim, my father's younger brother who worked

for the government intelligence service, was one of the many so-called martyrs.

One day during college, the head of the geography department interrupted my class to call me into his office. I knew something serious was up; he wouldn't do that for no reason. "Sit down, son," he said. Then he told me my family had called to tell me that Salim had been injured. I knew they probably would not have pulled me out of class if he was really only injured, so I suspected the worst.

I jumped on a bus from Baghdad back to Kufa. As I got off the bus in front of my grandfather's house, I was met by a swarm of young relatives, the kids of my various aunts and cousins all playing in the yard.

So many relatives here ... the sinking feeling in my stomach got worse. I walked into the house, where I saw Salim's wife draped in black surrounded by other grieving women. At that moment any attempts at denial were stamped out, and I fainted, literally dropping to the floor.

The next thing I knew, people were clustered around trying to wake me up. I started to cry violently, convulsing in sobs. My brothers and sisters crouched on the floor around me, also crying uncontrollably. I wailed until I had no energy or tears left, then I slumped limply as relatives picked me up off the ground and dusted me off.

We all loved Salim. He wasn't much older than I was, and there was nothing authoritarian about him. My brothers and sisters and I would all escape to his house for relief from the fear and oppression of our father. He could dance like Elvis Presley, he wore the hippest clothes and had the best books and records, he even owned a 16mm movie projector. Women loved him. He loved life.

I found out later how Salim died—since he worked for the government intelligence service, part of his job was hunting down war deserters and forcing them back to the front lines. He went into a house in Sumawa where a deserter was hiding. This man met him with guns blazing and shot Salim down.

If in the abstract I sympathized with the war deserters rather than government officials, at times such political stances can be overshadowed or even negated by familial and personal ties. I'd loved Salim, and I also knew that under this twisted regime, both he and the deserter were victims.

I went to the mosque where I knew Salim's coffin would be. The

```
50:::74.114.119.220:::
54:::74.114.119.220:::
59:::74.114.119.220:::
12:::74.114.119.220:::
20:::74.114.119.220:::
24:::74.114.119.220:::
29:::74.114.119.220:::
36:::74.114.119.220:::
40:::74.114.119.220:::
45:::74.114.119.220:::
38:::68.106.137.10:::hi
```

coffins of war casualties are always draped in an Iraqi flag and held in the local mosque until burial, which for Muslims is supposed to be the same day. I crept into the mosque and saw so many coffins all draped in flags. I chose one at random and hunched over it, crying. Then my dad came up beside me, in one of his more tender moments, saying, "Son, that's not your uncle."

"Does it really matter?" I remember thinking to myself. So many "martyrs," so many dead for no reason at all.

DAY 15 (LATER THAT DAY)

SOMEONE FROM COLUMBUS, OHIO has been shooting nonstop for more than four hours now. Other people in the chat room are telling him to stop, "Cool it a bit, you shot at least 50 times this hour," Jason writes. But he doesn't reply and keeps on shooting.

Finally I get my dinner—lentil soup from my friend at Baba Pita across the street—and sit next to the bed by the back wall of the gallery. The paintballs are hitting the wall and exploding one after another, paint flying everywhere. I look straight at the webcam and—typing into the chat room—say, "Hey, Columbus, I am having din-ner and your paintballs are falling into it." He types back, "Ouch, sorry about that," and he stops shooting. He tells me his name is Luke. I see this as evidence of the power of communicat-ing human being to human being, rather than making a demand, since that makes people stick to their guns.

I feel like my interaction with Luke is a real victory—a victory I don't have much time to savor, though, because soon something strange starts happening to the gun. It begins firing nonstop, the trigger doesn't even go back into position before it fires again. I can see it moving, as if pulled by a ghost. The paintballs are pouring out of the plastic case like some demented gumball machine. There's no way I can refill it fast enough. I call and ask Jason what's hap-pening. He tells me that hackers have found a way to turn the gun into a machine gun, firing nonstop automatically.

And suddenly the chat room comments are coming fast and furious, more quickly than I can field. They are no longer philo-sophical, analytical and flirtatious like before; they are increasingly aggressive, obnoxious and sexual.

How do you feel about Jews?
Are there any girls here?
Golden shower for Wafaa.

Who are these people? Before this project, I had never been in a chat room. I wanted to use the internet to reach people outside the gallery and established art worlds, and I wanted to democratize the process of viewing and interacting with my work. But I didn't know how brutal the anonymous internet culture could be.

Did you enjoy it when the bombs fell on Baghdad?
I had an erection and was eating a cheeseburger.
Shoot that fucker.
We need a bin Laden cutout to aim at.
I cap this muthafucka.

The young woman from Yale had said she thought my project was only reaching anti-war leftists who already agree with me—well, this is proving her wrong.

```
Make that chair spin!
FIRE!!!!
fuckin' Iraqis
```

There are a few supportive comments:

```
Peace to you and your people, Wafaa.
This guy has heart.
Don't shoot him, he's a fucking human being!!
```

But the hatred and racism are coming faster and faster. Just reading them, I feel like I'm being physically attacked. It's amazing what anonymity will bring out in people.

```
Come out and get shot little man.
Those are cum shots on the glass...fuck and kill.
Baba ghannoush
Waterboard him...make him talk.
I'm gonna waffle his balls.
THERE HE IS!!!! SHOOT HIM!!!!
Allahu Akbar
```

I call Jason again, sweat pouring down my face, rubbing my forehead, pulling at my beard. "There's good news and there's bad news," he tells me. "The good news is you hit the front page of Digg.com. The bad news is you're going to get hit really hard and it may last for a few days, so you have to ride the storm."

I hadn't even known what Digg.com was before this. It's a site where millions of viewers flag—"Digg"—and rank news stories; the more people who Digg a story, the higher it moves up in rankings and the more people will see it. So many people "Digged" the story in the *Chicago Tribune* that it was now spreading across cyberspace like wildfire. They warn me in the chat room:

```
You just hit digg. Get ready to crash
You just hit digg, protect your nads!!!
```

Jason bans the hacker who has made the gun automatic. But now someone else is doing it. They've posted a script that anyone can put in their browser and suddenly possess an automatic weapon. We can't ban everyone. Jason writes a script to prevent any one computer from firing consecutive multiple shots. But the hackers are one step ahead: they have launched "botnets," networked computers in various locations programmed to keep firing.

Jason stays up into the early morning hours trying to combat the bots. He finally writes a script to screen out the bots from firing the gun, so he can get some sleep.

"If someone is technically savvy at 14 or 15 years old, bored as hell, they'll do that kind of thing," Jason later said. "I was one of those kids. I grew up, but there's a perpetual culture out there."

```
Dude get a decent server so we can play some Waffa ball!
Too bad we can't waterboard him.
This is how Paris's cell should be set up but with semen
instead of paint.
Anyone stupid enough to set this whole thing up deserves
to be shot, in the nuts.
BOOM HEADDSHOTT
```

They want to kill me. I feel a weight on my chest as if someone's sitting on it. I can't breathe.

```
Shoot him again for jesus.
Send him to guantanamo.
Stone this infidel.
Ohshit its that guy that's on the run with bin laden.
Can you jump around a little.
Lyndie England where are you?
I'm touching myself.
It's a trap! Mossad put bullets in your gun.
I'm going jihad on your ass.
```

I leave the room to catch my breath, monitoring the chat from another computer out of their sight. They are furious that they can't see me.

```
Where is the target subject?
```

```
I want to blast him again
I want to shoot falafel balls at him
Where is that fag Iraqi?
Where's the towelhead?
```

I'm losing it. Every sound and every small movement of the gun feels like an attack on my already taut nerves. I have to get away.

"I'm going to get a glass of wine and lay down," I tell the camera in a shaky voice. Then I leave the field of battle and lie down on my bed in front of the gun for some rest. But I can't lie down for long. I hate being a victim. Why do these people have so much hatred, so much anger at a culture they probably know nothing about? I decide to take things into my own hands, to fool them. I disconnect the compressed-air canister that powers the gun. The paintballs stop coming out, but I can still hear the trigger constantly firing, and the gun swishing as it moves back and forth.

The gun is disconnected, but they don't know it. There is so much yellow everywhere, they can't tell whether they're actually firing or not. I decide to act for them, to give them the show they want and let them think they beat the stupid Iraqi.

I move around the room, pretending to be dodging and ducking and flinching in fear as the gun keeps popping. I speak into the video camera for tomorrow's YouTube clip. "Digg.com, this is very disturbing, very disturbing," I say. I ramble for a few minutes, my eyes darting right and left. "Very disturbing, very disturbing. Digg.com, this is very disturbing." I'm sure I am giving an Oscar-worthy performance and that once I post it on YouTube, it will change their minds to see the level of terror on my face.

```
Holy crap, I just saw him run across the room. He gen-
uinely looked frightened. I hope he doesn't get hurt at some
point.
```

A guy named Eric in San Diego who has been on the site for hours is calling the project a fake. "This whole site is a lie," he writes. "Hide behind your lie. This is emotional blackmail and intellectual lie." He suspects the gun isn't firing; he says he fired at a clean spot on the wall and saw no splotch.

These words upset me. The project is not a fake. It's not a lie. I had no choice but to disconnect the gun. These people want to kill me. There was no way I could keep refilling the paintballs. I had no choice. But the site is real, the project is real, it's real, it's real!

"This whole thing is a sham," writes Eric. "You are all being duped! Hey Waffa, prove you are real and stand up. Stand up, ya faker."

I want to prove him wrong, but I refuse to give in to his manipulative demands. I challenge him to visit me, to spend a day with me in this room. I tell him that someone like him has never been in a situation like this before. He claims he has. From San Diego, maybe he's in the military. "I will sit there with you. 24 hours, real, no shield, loaded gun. 24 hours, you, me, no shields, loaded gun," he says. He keeps repeating this mantra, plus the strange leitmotif "Ad hominem."

"You keep repeating yourself, are you a machine?" someone asks Eric.

"You want to see how real I am? Put me in there with Wafaa and see how real I am. Ad hominem. Call me a machine. Wafaa is the machine. This is fake."

Another chat-room denizen gives Eric FlatFile Galleries' phone number. He calls the gallery, missing me at first but then we talk. He posts that I'm a "decent guy to talk to...he does seem to sound Iraqi...has the correct accent." He wants to accept my invitation and come to the gallery, but the more he talks, the more I realize he's a macho guy who just wants to get shot at for a day. And that's not what this is about. So I rescind my offer, but he's determined. He keeps badgering me and threatening to buy tickets to come to Chicago.

I can't spend all my time arguing with him. Criticism and vitriol—along with a few supportive comments—are being fired at me from all sides.

72 virgins await him.
It's a scam to get donations, probably to buy IED.
Hook his nuts up to a car battery.
Replace the gun with a knife so we can behead him.
Does this guy have a pilot's license?
Kill him!

They are angry I'm not replying to them, they're trying to provoke me to chat. But with comments like these, what's the point? The trigger's still snapping like crazy, and there's no end in sight. I wanted to generate dialogue, but this isn't dialogue, this is ignorant abuse!

I try to read—Stephen Hawking's *A Brief History of Time*, from Jason. But I can't do it. My eyes are drawn to the gun, the click click click of the trigger. I feel its eyes boring into me—the camera on top, the sinister gun barrel . . . click click click. . . .

```
Be very very quiet, I'm hunting waffa.
I think he has survivor guilt.
I don't want to shoot somebody I don't know.
I've always wanted to shoot an iraqi.
```

I try to relax. A glass of wine. I need to have a glass of wine. Where is my wine? I need a glass of ice. Where is my glass? Where is . . . click click click. . . .

```
I wanna have sex with him.
Hey wafaa, sorry about your brother and father.
Stupid cry for attention.
```

Click click click. . . . They want to see me suffer, so I decide to give them what they want. But on my terms—I'm not their clown. I'll act the part of the "stupid Iraqi" so they will think that they've won, that they've defeated me. Then when this is all over I'll be able to reveal how they were the stupid ones, how they fell for my act!

I step in front of the camera and tumble to the ground, face down. I want them to think I've been hit. I was a soccer player, so faking a dramatic fall is no problem—we're always doing that to get the penalty kick. While I'm on the ground I make sure to rub some paint on the side of my head and goggles so it looks like I've been hit. All I can think to myself is: I'm finally having fun! I'm their stupid Iraqi! They're shooting at me, they hate me. They may be having fun, but I'm having more fun!

```
Motherfucking Iraqi, die!
Fire!!!
Shoot him!!!
```

The trigger of the gun keeps wildly clicking. The eye of the camera keeps searching me out. But I have won. I have outsmarted them all. I turn my phone off and lie down to get a little sleep, giddy with exhaustion and the exultation of fooling my tormentors. They came at me with machine guns firing, but they have not defeated me. I have survived—I survived Digg Day.

I fall asleep for a few hours, but before I do, this sense of winning, the power of deception, transports me to a time in my youth....

I T WAS SHORTLY AFTER THE START of the Iran-Iraq war, and I was at my friend's house. His brother and uncle were in the military, and I would often go there to watch TV, study and play ping-pong. We were eating dinner with his sister-in-law and her kids, and the TV broadcast was interrupted with some "important news" about a war crime by Iran.

They showed dark, grainy footage of two trucks, and Iranian soldiers holding what appeared to be an Iraqi soldier, with one hand tied to each truck. Then the trucks drove in opposite directions, ripping him apart. We all stopped eating, overwhelmed with anger.

The next day the whole country was mobilized for war with Iran. There were military trucks on the street corners signing up volunteers, and people were jumping to get on them because they were so angry at what the Iranians had done to this soldier. I didn't learn until I got to the United States that this video of a "war crime" was a fake, reportedly created by *James Bond 007* director Terence Young, who also made the mammoth complimentary biopic of Saddam Hussein, *The Long Days*. Many Iraqis still don't know it was a fake that sent them rushing into battle with Iran.

J7 01:43:06:::70.149.22.163:::next up: 5k zombie machines attack. Proxy supporte
17 01:43:06:::70.149.22.163:::next up: 5k zombie machines attack. Proxy supporte
17 01:43:06:::70.149.22.163:::next up: 5k zombie machines attack. Proxy supporte
17 01:43:06:::70.149.22.163:::next up: 5k zombie machines attack. Proxy supporte
17 01:43:06:::70.149.22.163:::next up: 5k zombie machines attack. Proxy supporte
17 01:43:06:::70.149.22.163:::next up: 5k zombie machines attack. Proxy supporte
J7 01:43:06:::70.149.22.163:::next up: 5k zombie machines attack. Proxy supporte
17 01:43:06:::70.149.22.163:::next up: 5k zombie machines attack. Proxy supporte
17 01:43:06:::70.149.22.163:::next up: 5k zombie machines attack. Proxy supporte
17 01:43:06:::70.149.22.163:::next up: 5k zombie machines attack. Proxy supporte
17 01:43:06:::70.149.22.163:::next up: 5k zombie machines attack. Proxy supporte
17 01:43:06:::70.149.22.163:::next up: 5k zombie machines attack. Proxy supporte
17 01:43:06:::70.149.22.163:::next up: 5k zombie machines attack. Proxy supporte
17 01:43:06:::70.149.22.163:::next up: 5k zombie machines attack. Proxy supporte
17 01:43:06:::70.149.22.163:::next up: 5k zombie machines attack. Proxy supporte
17 01:43:06:::70.149.22.163:::next up: 5k zombie machines attack. Proxy supporte
17 01:43:06:::70.149.22.163:::next up: 5k zombie machines attack. Proxy supporte
17 01:43:06:::70.149.22.163:::next up: 5k zombie machines attack. Proxy supporte
17 01:43:06:::70.149.22.163:::next up: 5k zombie machines attack. Proxy supporte
17 01:43:06:::70.149.22.163:::next up: 5k zombie machines attack. Proxy supporte
17 01:43:06:::70 149 22 163:::next up: 5k zombie machines attack. Proxy supporte

DAY 16

WHEN I OPEN MY EYES a few hours later and turn on my phone, there are a series of frantic messages from Shawn in New York. It seems that when I disappeared from the room, rumors spread in the chat room that I had been hit in the temple and taken to the hospital. (Others speculated that I was in the bathroom, or out partying, or at McDonald's, or planting IEDs.)

I post the video on YouTube showing how "very disturbed" I was by Digg.com.[4] Then I make a statement in the chat room conceding that they've won, content that I've actually won the moral victory. One of

4 At the time, I thought I was in control, but watching the documentary video months later I can see that I was manic, on the edge, completely strung out. It's difficult to watch the footage from that day. I look like a caricature of a TV anchorman, spouting one fevered monologue after another, eyes glazed and constantly staring at the ominous clicking gun.

the Diggers charitably replies that it's a draw. I browse through the Digg.com blog—even with all the prejudice and ignorance I've faced in post-9/11 America, the racism and cold flippancy there are shocking.

Jason had chimed in to defend me: "The Digg effect is causing the paintball gun to sound like a machine gun and maybe causing Wafaa to break down before the server will. What you are missing via the internet is the Sound and Human aspect. I hope he is sane tomorrow. This is both the pinnacle and devastation of his work. Should make for an interesting YouTube video."

Perhaps this one summed it up: "Some say they are trying to stop the shooting, a lot say they are having a party shooting him, most are just watching. That, my friend, is America. Nuff said."

They're still firing nonstop, and I decide to "bite the bullet" and reconnect the compressed air. The gun goes through a bag of 200 paintballs in 15 minutes.

I've run out of the original paintballs I was using; these cheaper ones smell even worse. My breathing problems are becoming more serious, I'm panting even when I'm just sitting still. The burst of energy I got from "surviving" Digg.com is already draining away. I'm twitching and exhausted.

But something amazing is happening online. People are writing scripts to turn the gun left, to keep it from shooting me. "Keep turning LEFT save the guy" is being posted over and over. They're trying to protect me. It gives me a rush of hope. My voice trembles with gratitude as I talk to the webcam. I wipe away tears as I look into the camera and thank them. After all the cruelty hurled at me yesterday, this kindness is a life preserver.

THE UNITED STATES' DEADLY BOMBING CAMPAIGN and international diplomatic attempts had failed to force Saddam to withdraw from Kuwait, and on February 23, 1991, the United States launched its ground war.

It was over in 100 hours.

Saddam agreed to pull out of Kuwait, and Iraqi troops began their retreat, leaving burning oil fields in their wake. Saddam's invasion had been a complete failure by any definition, though he would insist on referring to the war as a victory.

On February 26, defeated Iraqi soldiers were returning from Kuwait toward Basra. As this ragged, exhausted parade of weather-worn and war-torn vehicles made its way slowly through the desert, U.S. warplanes bombed them relentlessly, swooping over them in arcs to drop round after round of munitions on their helpless targets. U.S. officials rationalized that these were Saddam's loyal forces, and that they had defied orders to leave all military equipment behind. In reality, they were mostly conscripts with little allegiance to the dictator who had just put them through hell, along with Kuwaiti war prisoners and displaced Palestinian refugees. Most of the soldiers were from the Popular Army—the army made up of older men above military age, teenagers and even disabled people who could not fight in the regular army. People had been literally kidnapped off the street at arbitrary checkpoints and forced to join the Popular Army—often shipped to the front lines without even a chance to say goodbye to their families. They were hardly Saddam loyalists. Locked in a massive traffic jam on this lone ribbon of highway, which a U.S. soldier compared to spring break traffic in Daytona Beach, they had no escape from the bombing. A U.S. commander referred to it as a "turkey shoot." It came to be known as the Highway of Death.

Up to 100,000 people were killed or critically wounded by shrapnel or burned to death as they sat immobilized or tried desperately to flee their vehicles on foot. Though U.S. officials later tried to minimize the death toll and rationalize the causes of one of the worst atrocities of the Gulf War, in Iraq there was no doubt as to the scope of the carnage. The remains of thousands of burned and bombed-out cars, trucks, buses and tanks were left on the highway and a coastal offshoot road toward Basra—a real-life sculpture of death and decay; a chilling reminder of senseless aggression and destruction.

My cousin—my aunt Mahdiyya's son Abbas—never returned from the Highway of Death. It hurt Mahdiyya especially because after her son had deserted the army, she dragged him to the bus garage where military trucks were waiting and forced him to go back to war. Most

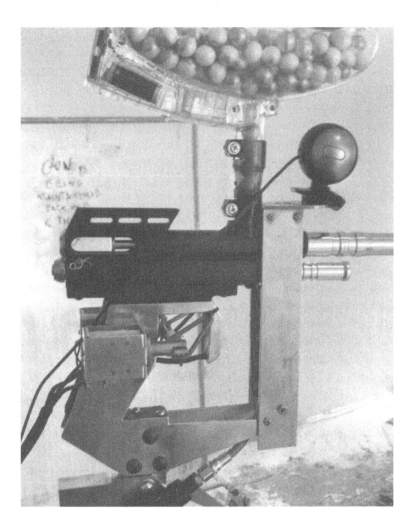

mothers would shelter their deserter sons at that time, but Mahdiyya and her son had a very rocky relationship and for reasons that are hard for me to fully understand, she forced him to go back. Mahdiyya's husband, a member of the Popular Army, was also trapped on the Highway of Death, though he survived, hanging onto the rails of a crowded military truck. He couldn't understand why other people on the truck were just letting go and dropping off; he didn't realize they were being hit by shrapnel and killed.

Mahdiyya later died of lung cancer. We believe that like so many Iraqis, she got cancer from the depleted uranium munitions used by the United States during Desert Storm—and which are being used again during the current war. At any rate, I'm sure the cancer hit her harder because she was weakened by the tragedy of losing her only son.

DAY 16 (LATER THAT DAY)

THE FLOOR IS RIDDLED WITH LESIONS where the yellow slime has eaten away the white paint; bare spots of sheetrock are showing through like leprous sores. Aaron—who runs the gallery along with Susan—is very disturbed by the physical damage to the gallery, as well as the threatening and violent nature of the comments on Digg.com. He suggests the project should end early. But I will have none of it. The project must go on. I pray that it won't come to a standoff between me and the gallery.

And I have other problems to deal with. I got a call from the store that has been supplying us with paintballs. My credit card is maxed out. "I don't have access to my other accounts," I tell the camera. In reality, I don't have any other accounts! I make a plea for donations on YouTube. My roommate Luis and an anti-war artist, Fred, each buy me a bag of paintballs. A bag has 200 paintballs—that could last for a morning or less than half an hour, depending on how many people are firing.

A woman in Florida who has been monitoring my well-being constantly, to the point of obsession, calls to warn me about paint dripping into the electrical outlet and power strip. She is the only chat room participant to whom I've given my direct phone number. I don't know much about her, but I feel a strong connection and sense of comfort from having someone in the chat room almost all the time who isn't hunting me but rather watching over me. I don't know if she is retired or what she does for a living, but she is literally online with the project all the time except when she's sleeping.

I try to scrape the paint off the power strip, and half-heartedly cover the outlet and strip with a piece of cardboard.

The shots are still coming fast and furious. In the video I complain about the "onslaughter," unwittingly combining the words "onslaught" and "slaughter."

I sit in front of the camera messily eating a sandwich, staring warily at the gun as I stuff pieces of food into my mouth and chew violently. Watching the video later, I realize that I look like a caged animal, cornered and aware he's being watched. You can see how nervous I am by my constant blinking. I've heard the CIA used to record how many times Saddam blinked during his speeches for clues to his mental state.

As I tell the camera about my problems—the high traffic threatening to freeze the site, my fear that the gallery might shut down the exhibit, my financial crunch—I gesture wildly. You can tell when Iraqis are getting upset because, like Italians, we start talking with our hands.

I need a break. I feel like I might have a real breakdown if I don't get a little peace and quiet. My mind and body are locked in battle, a common theme throughout my life. My mind is stubborn, determined, strong; it will never give up. But my body is fragile. There has to be some compromise. Today, the compromise is that I will leave the gun for a little while, though it hurts me to do it. I feel intensely guilty, since in Iraq there is no break from the conflict zone. But it is a compromise to make to ensure I achieve the larger goal of surviving the project.

I head down into the basement, my path lit only by the light on the video camera. Like a true Iraqi, I won't go anywhere without a blanket. I lie down on a pillow I find there and some plastic that's used to wrap artwork for transport. I draw a ragged breath, feeling like a 50-pound weight is sitting on my chest. The pillow is decorated with random words—ironically, the word "Energetic" is imprinted right next to my head. I take another breath and close my eyes, dozing and daydreaming for about half an hour. A short rest, but a refreshing one.

Later that day Luis surprises me with one of my favorite comfort foods, a Polish sausage from Jim's, a little 24-hour stand on Maxwell Street. The succulent meat and onions revive me.

FEBRUARY 27, 1991. Kuwait is "liberated," in the words of President George H.W. Bush. Saddam's troops have withdrawn. The war is over, but what was it all for?

The truth was, we fought this war for nothing. Immediately after the humiliating defeat and the horror of the Highway of Death, Saddam was telling people to celebrate the victory—what victory? For him, I suppose, the victory was that he was still in power.

No words can describe the roiling anger of the Iraqi people at this point—having once again, just a few years after the end of the Iran-Iraq war, seen ourselves sent to slaughter, sacrificed for nothing other than our leader's tremendous ego and arrogance.

During the month and a half of bombing by the United States, Iraqis had become increasingly vocal in their opposition to Saddam. I took a bus from Kufa to Najaf, and for the first time I could remember people were talking openly about their hatred of Saddam. It was a momentous tipping point—their fury had overcome their fear. In Nafaj someone smeared the city's biggest Saddam mural with excrement—an audacious act which would have been unheard of weeks before. I also made my own attack on a Saddam mural. I cracked open a light bulb and filled it with red paint, then taped it back together, like an egg. I went to the closest public square, looked around to make sure no one was watching, and hurled it at the mural. My projectile hit its mark with a satisfying smacking sound, and red paint dripped down Saddam's face. At that moment a security light came on, and I saw a police officer nearby. I ran like there was no tomorrow, and I managed to get away—thanks to the narrow winding streets of old Kufa.

Then on March 3, on the main square in Basra, in the south, a soldier turned his tank on a huge mural of Saddam and blasted a shell straight at it—a slap in the face of our great leader. It was like setting fire to dry wood. A massive uprising started in Basra and quickly spread across the south of Iraq, unleashing a wave of brutality against the Ba'ath Party. A week later the Kurds launched their rebellion in the north.

My family returned to Kufa during the uprising—now Najaf was the more dangerous place to be.

In Kufa, word circulated that people would meet at the market to march on local Ba'athists. We knew it was going to be a bloodbath. My mother forbade any of us to leave the house—she stood in the doorway and threatened to kill herself if we tried to join the throng. I peeked out at the ensuing mayhem from the window. People were running through the streets waving swords, shouting deliriously. They spread out from the market and started attacking the police stations, Ba'athist homes and Ba'ath Party offices. They freed prisoners from the jail and looted Ba'ath offices and houses. Many Ba'athists took refuge in the large party headquarters building in the "July 17" neighborhood of Kufa. They locked the doors and stationed themselves on the roof, so they could fire at the approaching mob. But some former soldiers had purloined a military tank in Najaf and driven it all the way to Kufa. On the second round of fire from the tank, most of the Ba'athists surrendered and the rest were captured. We heard that one prominent Ba'athist was held by the arms while someone sliced his body down the middle with a sword. Others were dragged to their death behind trucks driving through the streets of Kufa as Shia onlookers cheered. One man was accosted on the Kufa Bridge. His tormentors forced him to drink gasoline and then shot him to death.

I was wholeheartedly opposed to all this chaos and brutality. I thought there must be another way—detain the Ba'athists and organize trials. The sadistic violence was illogical, but it's not surprising that logic would not prevail in such a situation. The Shia had suffered greatly at the hands of the Ba'athists, seeing their fathers or brothers executed, and this was their chance to get revenge. It was not only revenge against the regime but also personal revenge. Men would go to the home of a Ba'athist who had executed one of their relatives, ask his family to leave, then kill him and set his house on fire.

When things calmed down a few days later, I ventured out into the city to assess the damage. There were bodies in Ba'ath uniforms lying in the streets—their own families were afraid to claim them, and stray dogs had begun to eat the corpses. Finally local religious

leaders said this desecration of the bodies was wrong, and families of the slain crept out to collect the mangled bodies and bury them. The city had descended into a frightening state of lawlessness, with no government services and no security; crime and the settling of old grudges were rampant. I knew the brutality was only going to generate more brutality, and I was right.

The uprising against Saddam was often described as a religious uprising—some called it an intifada. Intellectuals called it a popular uprising, aimed at getting rid of the government. The resistance didn't attack the military—it was all about Saddam. In fact, after the war ended you would see military conscripts walking back from the south in just their underwear, having stripped off their uniforms. There were apocalyptic parades of them stumbling along wearing only white briefs, filthy undershirts, Kalashnikovs and military boots. No one bothered them—that outfit was a sign they weren't going to fight any more, for Saddam or the resistance. They just wanted to go home.

I NEVER WOULD HAVE PEGGED a Tom Hanks character to be my alter ego. But watching the movie *Cast Away* a few months after leaving the gallery, I was chilled to see the parallels between his character, a FedEx executive stranded on a tropical island after a plane crash, and me in my paintball gallery. Tom Hanks' character becomes so desperate for companionship that he develops a deep friendship with a volleyball that also survived the crash. He paints a face on the ball with his own blood, attaches a shock of dry grass as hair and calls it Wilson, after the brand name emblazoned on the ball. He argues constantly with Wilson in an irascible one-way dialogue. When he loses Wilson after tossing him away in a fit of rage, he is devastated.

I felt as though I were watching my relationship with the gun. I despised it, I cursed it, I never wanted to see or hear it again. But in that situation of isolation and stress, it was my steady companion, constantly alive and in motion. When it was silent, I felt lonely and abandoned.

My similarities with Tom Hanks on the island don't end there. After he manages to make fire rubbing a stick on wood, he becomes

manic, giddy, drunk on his own success, dancing around the beach with a blazing palm frond, singing "Come on, Baby, light my fire." All this despite the fact that he is still, by any logical assessment, doomed. That's how I felt when I triumphed, or had the illusion that I triumphed, over Digg.com by halting the gun and putting on a show for them. In times of extreme desperation, in the face of adversity, sometimes the only thing that saves us is our own irrational capacity for pride and egotism, a faith in ourselves that has perhaps no logical basis but pulls us through nonetheless.

M Y FRIEND QASIM VISITED ME at aunt Razeeqah's house. He had his keffiyah wrapped around his head and his AK-47 slung over his back—he looked like a mujahid. I was amazed how quickly he had transformed from an intellectual artist to a religious warrior. He looked at my work and asked me why I spent so much time painting in such dire circumstances. This isn't a time for art, he said, this is a time of war. I said it is never a time for war, but it is always a time for art.

At the height of the uprising, rebel Shias or Kurds controlled 14 of the country's 18 provinces and were closing in on Baghdad. The rebels thought they could count on U.S. support to depose Saddam—president George H.W. Bush had seemed to promise as much in February. But he famously broke his promise, and the United States stood by and allowed Saddam to crush the opposition.

The U.S. ban on Saddam's use of his air force, which theoretically quelled his military might, did not forbid him from using helicopters, and he mobilized them, along with tanks and other artillery, to fight back viciously against the rebels. Saddam's helicopters targeted civilians on the ground, even women and children deemed guilty just because they lived in Shia areas. In the sky above them we would see U.S. planes, crisscrossing each other in the sky, making X's with their smoke. We could only see it as our supposed allies playing in the heavens while people were being slaughtered below. I remember watching those planes and wishing I could become a missile and slam murderously into their steel flanks. In Kufa,

Ba'ath officials knew who had participated in the sectarian slaughter, and they went door to door, dragging Shias out and executing them. It was said that painted on some of their tanks was the slogan "After today, no more Shias."

There was a local family named the Bait Hindi who had become wealthy running a public bathhouse and a popular juice shop. The government had persecuted them because of their sons' membership in the Dawa Party. During the uprising, they hung a large banner on their shop proclaiming, "This is a victory for the Hindi Family," and they liberated some of their relatives from the Najaf prison. But once the government was back in control, Saddam's forces surrounded their mansion with tanks and shelled it, killing some of them immediately and arresting and executing the others.

Frustrated at having been kept inside by our mother at the start of the uprising, Safaa was determined to participate. He wisely went to Najaf, where he was less likely to be recognized, and stood guard for the rebel forces in the dry Sea of Najaf. Once the uprising was squelched Saddam's soldiers began going house to house in Kufa, looking for young men who were likely involved and hauling them away. Safaa was at my grandparents' house, and when the soldiers came to their door my grandmother pleaded with them to spare him, saying he was not involved in the uprising since he worked at a government factory making munitions. However she unwittingly mispronounced the word for munitions, saying it in a way that meant Safaa worked at a factory where they tore people's clothes off. The bewildered soldiers asked her to repeat herself several times, finally breaking into uproarious laughter and letting her be. Safaa was safe.

I remember standing outside my grandfather's house with Aunt Mahdiyya as we listened to Saddam's bombs dropping on Karbala in the distance.

Mahdiyya told me people had seen the image of Imam Abbas, the legendary grandson of the prophet Mohammad, appearing on the battlefield to protect us from Saddam. She said that as long as Abbas was with us, we would be safe.

My aunt truly believed in these legends and their lasting power. She said Najaf and Karbala would never fall and the government would never triumph as long as Imam Abbas's spirit was standing guard. But even as she spoke the bombing got louder. I told her Imam Abbas must be getting tired.

As much as I loved Mahdiyya I couldn't help mocking her stead-fast faith in these myths and fables. In any culture the dispossessed and powerless will turn to religion and legend, because what else do they have to believe in? They need these stories of heroism and su-perhuman saviors to give them hope.

As the military advanced toward Najaf and Kufa, my family fled again, this time to Al-Huriyya, a country town outside Kufa. They traveled on foot, my brother Alaa and my aunt Razeeqah carrying my ailing grandfather in a wheelbarrow. We had heard that in Karbala, anyone captured at home was executed.

My cousin Wabil and his brother stayed in Najaf to fight Saddam's forces. His brother was killed, and Wabil carried his body to the dry Sea of Najaf to bury him. Wabil's mother and other brother in Najaf were arrested and disappeared. Nobody ever heard from them again—they probably ended up in one of the mass graves that were discovered later. The government forces would say they were ar-resting people and taking them to prison in Baghdad, but in real-ity many of them were brought to the desert, executed and thrown in mass graves.

I decided to take my chances and stay in Kufa for a little while longer. Soon Saddam's bombs were raining down on the city. Imam Abbas was nowhere to be seen.

DAY 17

I ORDER A PIZZA. It takes three hours to come, and it's the worst pizza I've ever had. I call the Domino's branch and give them a piece of my mind. "It's good to complain," I tell the camera self-righteously. "It's good to assert your rights as a customer." I'm seeking a sense of empowerment wherever I can find it.

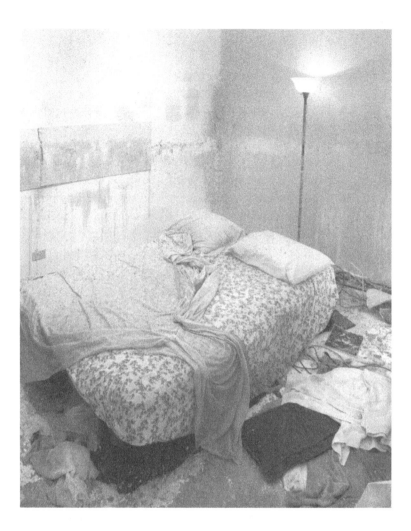

My internal conflict is getting worse. I didn't anticipate how difficult this self-imposed confinement would be. In the past I have been in detestable situations, but I could always blame others and outside factors. This time it's different, I am responsible for this. Over and over I ask myself the same persistent questions—why am I doing this, and is it worthwhile? Even though I know the answers, I have to keep struggling to convince myself.

DAY 18

MY LOGISTICAL SUPPORT SYSTEM IS FAILING. When I call my friends for help, they don't pick up the phone anymore. I understand. People have their own lives, I'm becoming a burden on them. They can't put their lives on hold. It takes several hours to drive out to buy the paintballs and air canisters—that's a lot to ask. But I can't leave the gallery, what can I do? I tell the YouTube video, "If anyone can come by I'd greatly appreciate it, and there are some supplies I need."

Since no one has brought me food today, I pillage the gallery's kitchen for some sustenance. I find chocolate chip cookies and cream cheese—I dip the cookies in the cream cheese. A new delicacy.

DAY 19

I DESPERATELY NEED SOME FRESH AIR in the room. I decide a tree will help, and a former student brings a potted, peppy-looking little tree. I give it some vitamin-enhanced water and let it sit outside the paintball area for a while to gather its strength. It reminds me of the way we would feed and pamper a sheep before slaughtering it in Iraq. As soon as I move the tree into the room, the shooters go crazy.

For some reason most of the shooters are international—from Austria, Quebec, Italy, France, the UK. I didn't anticipate the project would reach so many people overseas; it's another testimony to the internet's power to break the boundaries of geography. And most of the international participants are from the "have" countries rather than the "have-nots," exactly the people I want to reach, those in comfort zones of their own.

Soon the little tree's leaves are speckled with yellow, or shot off and impaled in an ooze of paint on the back wall. The wall right behind the tree becomes so saturated that the drywall is soaked and crumbling. That could cause serious structural damage, so I hastily staple some cardboard across the wall. Soon the cardboard looks

like an abstract artwork itself, splattered, pocked and tattered by the paintballs, so I replace it with wood panels.

A graduate student named Lara from the Art Institute comes by with fresh socks for me and a tin of homemade muffins. Every time a woman visits me, the online peanut gallery has a ball. This time they ask, "How was her muffin?" I've learned yet another piece of American sexual slang.

T HE UPRISING WAS THE ULTIMATE INSULT to Saddam—for a man of such tremendous ego and arrogance, having his own people rebel against him was intolerable.

He obliterated Karbala, the historic Shia holy city. Shias from across the south streamed to Karbala to try to defend it, but they were helpless in the face of Saddam's fury. The city was so full of rebel fighters, the only way Saddam could conquer it was to bomb it to rubble, and he did, meticulously, block by block. Then he moved on to Najaf. Helicopters flew over Najaf dropping leaflets saying the city would be bombed with chemical weapons, and many people fled before the destruction.

Soon his wrath descended on Kufa. As the beautiful, ancient city was being destroyed around us, I took refuge in a partially constructed concrete building, huddled there with other local families, hoping with each shuddering explosion that the structure would protect us. After several nights the bombing stopped, probably to let people leave—Saddam wanted to clear out the area so there would be less resistance. I grabbed Safaa's bike and pedaled out of town toward the village of Al-Huriyya, where my parents and siblings were staying. I rode past farms, where people yelled out to ask me what was happening. I told them Najaf had likely fallen to Saddam's forces.

Later, mass graves were found around Najaf and Karbala; hundreds or even thousands of Iraqis were killed or disappeared without a trace during the uprising. Saddam's officers turned the al-Salaam Hotel (which means "peace," ironically) in Najaf into a military outpost, run by his son-in-law Hussein Kamel. They kept up a steady drumbeat of executions.

When I fled Kufa I accidentally left a painting in Aunt Razeeqah's house of Saddam driving a shovel into the heart of a soldier. I hoped my family would find it when they returned and destroy it, since if a soldier found it first they could use it against me and my family as evidence of mutinous thoughts.

I found my family in Al-Huriyya living with other families in an abandoned schoolhouse, having gone days with virtually no food or water. They were burning the desks to keep warm and cook the little food they had brought with them. My seven-year-old brother and sister, the twins Ahmed and Asraa, would creep out to beg for food at the farmhouses off the main street. People gave them bread, which they'd hide under their shirts; then they'd run all the way back to the schoolhouse to feed us.

Saddam's soldiers were still advancing toward Al-Huriyya, and I knew I had to leave. The government was still looking for me, and if they found me in Al-Huriyya, things would be that much worse for my family because they would be collectively punished for my transgressions. Though my family didn't want me to leave, I had to go for their own sake. My mother broke into tears when I told her I would head for Iran. I wanted to keep it a secret from the kids. I got up in the morning, kissed my mom and slipped out the door. When I visited them in Syria many years later, Ahmed described that morning to me. He said he woke up and I told him I was going to get them breakfast. He said he knew it was a lie, because there was nowhere to get breakfast. After that I didn't see them for years; I didn't even recognize Ahmed when I saw him again. The fact that I never got to see him and Asraa grow up still makes my heart ache.

DAY 20

I REALIZE I'VE LOST FEAR of the gun. I'm accustomed to the sound at this point. This is a dangerous development, because when you get cavalier and careless is when you get hurt. I decide I need to shake things up. I think it is safer in the long run to regain my terror of the gun. And I feel ready for a new challenge. Plus the plexiglas

has become so coated with paint that viewers can't see through it, they don't even know if I'm in the room or not. So I get rid of all the plexiglas shields, and I move the computer from the desk to the coffee table in front of the bed.

Now I will just spend my time staying below the line of fire—in bed, or sitting on the floor. I perfect a duck walk that keeps me below the danger zone. But soon the computer and keyboard are freely splashed with paint, and the monitor dies. It's no small thing to sacrifice my own computer equipment, especially with my credit card maxed out. But I realize this is another way my experience simulates, on some level, that of my family and others in Iraq. They have no way to protect the things they need and cherish.

I SET OUT ACROSS THE WAR-TORN, DESOLATE LANDSCAPE toward Iran, and soon fell in with a group of walkers whom I recognized as being involved in the uprising. One of them was a good friend from childhood. But they were religious people from the Dawa Party. As Shias, they would stop and pray three times a day (Sunnis pray five times a day). While they were praying I would relax and read the book I had brought with me, which happened to be *Lady Chatterley's Lover*, translated into Arabic. I had left with only shoes and the clothes on my back, not even a bag, and this dog-eared book. I have to admit that I don't remember much about the story.

When religious fundamentalists know someone isn't a believer, they try to push your buttons. My walking companions would constantly turn the conversation to God to see what I would say. If I didn't believe in God, they demanded, how did I think I had been created?

Being with them reinforced my belief that there was not just one correct religion, or that not everyone is going to hell except Muslims. And the language of organized religion is so mundane—you have hell or you have heaven; in Islam you have the fire or you have paradise, this beautiful garden. Those are such human, earth-like images. You would think God could think of something more creative than that.

I was in fact a spiritual person, and still am; every night I prayed, not to "God," per se, but to a force I called God for lack of any other name. I would say, "Thank you for giving me the power to believe in myself and the drive to achieve what I believe in."

But such vague spirituality was pure blasphemy to this group. My friend eventually told me I was not welcome to travel with them if I didn't pray. That wasn't an option, so he wished me luck and gave me a 25-dinar note, one of the ones with a horse on it, printed before Saddam put his own image on the bill. (We used to joke that they replaced the horse with a donkey.)

So I changed directions and headed south. I made it to the city of Al Diwaniyah, about 100 miles south of Baghdad, shortly before the regime started bombing it. I got on a bus headed out of town. Soon we came to a checkpoint—checkpoints had been set up by rebels throughout the region. They usually wouldn't let you through if you were from Baghdad, because they figured you could be one of Saddam's people. They could tell from your identity card, and even if you had a fake identity card, your Baghdad accent would give you away. My student ID from Baghdad University was invaluable—since studying made me exempt from military service, I wouldn't be pegged as one of Saddam's men.

But the rebels also often wouldn't let you through if you were from the Najaf region, because they figured if you were from the Shia heartland you should be home fighting for the resistance, not fleeing.

Luckily for me this checkpoint was manned by a friend from college, Kamel. I saw he was missing a leg, and pointed to it with a questioning look. He brushed my unspoken question off and tried to persuade me to stay with him back in Diwaniyah. The idea of a bed and some temporary stability was very tempting. But Saddam was bombing Diwaniyah relentlessly and I knew his troops would soon take the city. And he would eventually seal off the borders. The quicker I got to the border, the better my chances of getting out of the country. So I continued on.

Soon the bus hit another checkpoint, and this time they recognized me as a Kufa Shia and wouldn't let me pass. The man told me, "Don't be a coward, go back and fight."

So I stepped off the bus and started trekking back toward

Diwaniyah, alone, vulnerable to any type of bandits, rebels or government forces. Someone yelled out at me from the flatbed of a passing truck—it was my artist friend from college, Qasim! He waved helplessly as the truck sped away. I kept walking on to Diwaniyah, and asked around until I found Kamel's home. He welcomed me with open arms and made me a wonderful dinner with fresh-baked bread. I was able to sleep for the first time in days.

Meanwhile Qasim sent a letter to my family describing his brief encounter with me and apologizing for not being able to help me out of that perilous situation. For the next year, my family assumed I was dead. That was probably actually a good thing when government investigators came to interrogate them about my whereabouts. They dragged my brothers out one by one to grill them about me. Luckily they really did not know what had happened to me, and their stories were consistent. I think the family was also saved by my father's public display of despair when Qasim's letter was delivered to his carpentry shop. He broke down crying and went running to my mother—she and a neighbor also started weeping. It created enough of a spectacle that I think the government soon lost interest and backed off.

With my belly still full from Kamel's generous meal, I set out the next morning on foot. I soon came to a checkpoint outside the town of Sumawa, manned by Shia rebels who did not want to let me through. I invoked my father's prominent and respected tribe and told them I had relatives in Sumawa who could vouch for me. Two of my young male relatives were summoned and escorted me through the checkpoint. I knew my friend Mudhaffar, a poet and classmate at the university, lived in Sumawa, so I began asking people on the street about him. I didn't want to stay with my relatives for fear of endangering them, especially since they lived near the border of Sumawa and Diwaniyah where Saddam's troops were advancing. My questions about Mudhaffar drew sheepish and suspicious looks; people would shrug blankly or turn away without answering. I was finally directed to his house by an older man. He was surprised and pleased to see me, inviting me in and cooking me a rich meal to rival Kamel's. I told him about the

strange reactions I had gotten while looking for him. He wasn't surprised. Not long ago during the heat of the uprising, his Ba'athist uncle had been dragged to his death by the townspeople. In the morning I asked Mudhaffar if he wanted to leave the city with me, but he declined. So I walked toward the center of Sumawa. On the way, I saw people gathered around a bus, and from inside the bus came the sounds of a woman screaming. It was strange that no one was going onto the bus to investigate or help her. When I got closer I asked what was going on and learned that the woman on the bus had fled from another city with her family, and she was at that moment giving birth. I walked on, and a few minutes later heard a shout of "Allahu akbar" rising from the crowd. The baby was born—new life entering the world in a time of such chaos and death.

When I got to the city center, I ran into relatives from Kufa who were military deserters and also wanted to reach the border. We ended up sticking together for the rest of the trip. They had heard about a dirt road that led all the way to a refugee camp in Safwan near the Kuwaiti border. The dirt road would give us a way to bypass all the checkpoints on the highway. We found the dirt road, which was blocked by a checkpoint manned by French soldiers who were part of the Allied Forces. They couldn't guarantee the road would take us where we wanted to go, but they said we were welcome to pass. We sat down by the side of the road to try to hitch a ride. Word about the dirt road was spreading, and soon a crowd had joined us. Then a semi-truck outfitted to haul cement drove up. The French soldiers told the driver that the road was dangerous and littered with unexploded munitions. They said the driver could pass the checkpoint and risk it if he wanted, but only if he took the civilians waiting there with him. As soon as he agreed the crowd clambered into the flatbed. I was a little slow, and the only spot left was a large basket attached to the top of the truck's cab to fit extra cement. I hopped up there and settled in for the ride.

Perched on top of that truck, hurtling fast down the rutted road, a beautiful rain beating lightly on my face, all the fear and exhaustion and filth of the journey were washed off me like an old skin. At that moment I began to have hope. I felt freedom was possible.

During the ride, I was mentally rehearsing what I would say in English to the American soldiers once we got to the border. Thinking of the refugee camp waiting for us—a mirage of comfort and relief in my mind—I came up with the sentence "I want to take a shower, I'm hungry and I'm thirsty." More than anything I just wanted to wash away all the grime and sand of three grueling days trekking through the desert.

Though this road bypassed the "Highway of Death," it was also littered with the burnt shells of cars and trucks hit by U.S. bombs during that strafing. The closer we came to Safwan, the more of them we saw. I tried not to think about the grisly scenes that must have unfolded inside each vehicle, concentrating on my own plan for the refugee camp.

When we got close to Safwan, we were stopped at another checkpoint manned by American and Kuwaiti soldiers. They forced everyone to get off the truck and started checking IDs. I had my student ID, which again probably saved my life. Because of it I was deemed not one of Saddam's men and allowed to get back on the truck. Some people were detained and taken away by the soldiers. My relatives and I had all gotten through, and we thought the end of our journey was near, but when we arrived in the city we were confused to find not a tent in sight, no refugee camp, only a long line of hungry Iraqis waiting for food distributed by the Americans. Apparently the existence of the camp was a myth.

Dejected, I got in line for food.

Some boys in line with me were frantically licking and rubbing their wrists and arms. The American soldiers would stamp your wrist when you got food, and needing more to feed their famished families, these boys were trying to get seconds. The MREs ("meals ready to eat") came in brown packets, along with water in plastic bags. Even as hungry as I was, the MRE, dry cheese and ham, was inedible to me. Maybe Americans were used to it, but I had never seen that kind of food before. After a few bites I threw it away. Maybe the hungry boys picked it up.

In Safwan my relatives and I met up with an older man traveling with his grandsons. We could glimpse the tents of a refugee camp

on the other side of the border—that was where we wanted to be. We were desperate to get out of Iraq.

But when we got to the border, the Kuwaiti guards laughed and told us to turn back or they would shoot us. They said the camp wasn't for Iraqis, but rather other ethnic groups—Egyptians, Palestinians, various Asians—whom Kuwait wanted to expel. In their eyes we were the ones who had just invaded their country, and they wanted nothing to do with us. It was raining and getting dark, we were out in the middle of nowhere with no shelter. So we turned off the road, away from the checkpoint, and crossed into Kuwait on foot in the dark.

Despite the guards' warnings, we crept slowly around the back of the Kuwaiti refugee camp, every step a great effort, the cold, exhausting minutes blending into a blur of half-crazed determination. We went from tent to tent asking for refuge, but there was no room and little sympathy for our plight. So we trudged back through the wet, cold darkness to an abandoned gas station nearby. The broken-down building was littered with stinking human excrement and trash. I had become seriously ill during the trip; my body was wracked with fever and chills and my stomach was heaving. The stench of this place made me dizzy. But it was raining and cold, we needed shelter and there was no other choice. We used pieces of soggy cardboard to push the excrement off to the side and cleared a space to sleep. I folded my filthy pants as a pillow and closed my eyes. I was thinking at that moment that if my mother could see me, she would be heartbroken. Sleep enveloped me like a warm, downy blanket, temporarily transporting me away from that hell.

But I didn't get to sleep long.

We were abruptly awakened by the shouts of soldiers shining flashlights in our eyes. I thought they were Iraqis at first, but soon realized they were Kuwaitis and felt a momentary flash of relief. The relief was short-lived. Before we could even explain ourselves, they beat us with braided cables, screaming at us the whole time. People at the refugee camp had told them about us. The soldiers tied our hands behind our backs, roughly dragged us out of the building and dumped us in the back of a truck. They took us to an underground shelter and proceeded to interrogate us, bleary-eyed, terror-stricken

and discombobulated as we were. They thought we were spies for Saddam, and they were ready to execute us. The older man in our group started crying like a baby, pleading for his life, asking if he could just show them something. One officer took pity on him and agreed. The man pulled some papers out of his pocket—death certificates for his sons—the fathers of the kids traveling with him. That must have awakened the soldiers' sympathies, and helped convince them we weren't spies. After conferring among themselves they announced they would spare us and take us back to the camp the next day. They kept their word, allotting us cots in the flimsy tents. We collapsed onto them gratefully, ignoring the suspicious stares of our new neighbors.

I went to the Red Crescent tent in the camp and asked to see a doctor or get some medicine to ease the sickness I had developed while traveling. But the Kuwaiti Red Crescent workers coldly refused. They hated Iraqis for invading their country, not to mention the long-standing animosity between the two cultures, and they did not want us in the camp. When they saw I was Iraqi, they smirked and indicated I would get no help from them.

Despite their threats the Kuwaitis couldn't keep the Iraqis out of that camp; it would have been like sticking a finger in a dyke. More and more Iraqis arrived each day. And the more Iraqis came, the more problems arose. Everyone was suspicious; you didn't know who was a Saddam loyalist. We were housed in cheap plastic camping tents. Saddam had sent some of his officers into these camps to act as spies. When they spotted someone they wanted to assassinate, they simply set the tent on fire. If someone arrived who nobody knew, he'd likely be murdered because people would suppose he was one of Saddam's men. It was chaos, and it became a slaughterhouse. In the face of such spiraling violence and mayhem, the Kuwaitis closed the border, and U.S. troops who were supervising the area turned the Safwan Hotel on the Iraq side into a refugee camp.

Even with such uncertainty and danger in our country and in our refugee camp, one day melted into another and we realized life had to go on. Feeling healthier and stronger than when I had arrived, I turned my attention to making my present situation more bearable and planning for the future.

One of my friends in the camp, the older man who had crossed the border with me, knew how to make bread on an overturned pan shaped like a wok. So a few of us started a "bakery" to raise some money.

During the Kuwait invasion Iraqi soldiers had dug underground bunkers as a base for their operations. The old man's grandsons and I periodically crept into these now abandoned bunkers, looking for pots and pans and other cooking implements. The troops had left so suddenly, their personal items were still scattered around as if the soldiers had suddenly been vaporized. I found a big ammunition box which I emptied out, planning to use it as a cabinet in my tent. But as I lugged it back to the camp, one of the Kuwaiti guards blocked my path and confiscated the box. Why would I carry this big heavy box, unwisely attracting the guards' attention? It made no sense, but I always wanted to create a home, even in the most unlikely places.

We baked our bread in the Kuwaiti camp, then crept back into Iraq to sell it to refugees in the Safwan Hotel, skulking among the burned-out hulks of vehicles from the Highway of Death. The ground was littered with unexploded munitions. Sometimes we'd see a kid playing with one and he'd be thrown up in the air and blown to pieces. After a few such horrific incidents, the American soldiers started a campaign to get people to report unexploded land mines, and they would systematically remove them. Making that trip back and forth across the border so many times, it's a miracle we never stepped on the mines. With the money we earned from the bakery, my companions would buy cigarettes and extra food to supplement the American MREs, crackers and canned tuna fish given to us at the camp. But I never smoked a cigarette, and I saved most of my money so I could be prepared for whatever lay ahead of me.

Unbeknownst to the Americans, however, the basement of their refugee camp in the Safwan Hotel was also an interrogation and execution chamber run by the Iraqi Shia rebels. The rebels were so paranoid—with good reason—about Saddam's spies that any new unknown person who arrived was suspected of being a spy. These suspicious people would be dragged to the basement and

questioned. If they didn't convince the rebels of their loyalty to the uprising, they would often be executed—hacked to death, their body parts buried, burned or hidden in piles of trash. One day when I was there selling bread I overheard rebels talking about a new arrival who spoke fluent English, was clean-shaven and chatted with the Americans—surely a spy. Perhaps guided by a subconscious hunch I sought the man out, only to find he was a college friend of mine—a writer and translator. I vouched for him with the rebels, and indeed saved his life. Eventually the Americans were alerted to the grisly goings-on in the hotel basement and shut down the clandestine interrogation and execution chamber.

The rebels, however, continued to carry out executions in the camp in Kuwait, and time in the camp stretched on—I was there for 45 days in all. It truly felt like hell—violence and mayhem on the ground, black clouds from the burning oil wells billowing above us, making our throats perpetually raw. At least those diabolical inky clouds gave us a little relief from the sun.

As if conditions in the camp weren't bad enough, Saddam's troops were still advancing toward us, trying to stamp out every last vestige of the uprising. Then we got the news that the American soldiers—the only thing between us and Saddam—were leaving. We Iraqis were terrified.

There were about 25,000 people all together between the camp in Kuwait and the one in Safwan. Under pressure to protect Iraqi Shias, Iran agreed to take some refugees. A relative of mine, a prominent religious Shia, was allowed to go to Iran. He could have convinced the Iranian government to take me too, but since I wasn't religious, he left me behind. It was one of numerous times that I was hurt by my refusal to even pretend that I believed in their God. But advantageous as it might have been, I could not bring myself to lie about my spirituality.

The Iraqis in the camp were desperate that the Americans not abandon us. So we took action—we lay down in the streets by the hundreds to literally block their passage. We lay there for four days. Foreign journalists swarmed in, but most of the Iraqis did not want their photos taken. I remember an American journalist with long hair who was so terribly frustrated, trying to explain to us that he

wanted to help us by getting our story out. I admired his attitude and passion—it was because of him that I grew my hair long for a time.

Finally we heard on the radio that the United States had struck a deal with Saudi Arabia to take us. We celebrated, dancing in the street. The U.S. soldiers descended on the refugee camp and transported us across the border back into Iraq, to the area around the Safwan Hotel, for processing. They brusquely yelled at us to get in line. I was trying to keep my place near the front, and the surging crowd pushed me up against the soldiers. In response, one of them hit me roughly in the head with the butt of his rifle.

"Don't hit me," I told him, "We're not animals." I was so furious, I walked off and went into the Safwan Hotel to mull things over—I figured if I was going to be abused, I didn't want any part of it. But an American officer who had seen it all happen came looking for me in the hotel and held out a ticket for me to get on the plane leaving Iraq. I stubbornly refused his gesture. But he kept waving the ticket at me, trying to convince me to take it. People were staring at us, wondering why I would refuse a chance to leave this hell. Finally the officer grabbed me by the hand and I went with him, still annoyed, but relieved.

We weren't taken to the plane right away; we were brought to a holding area set up by the Americans for one night. That night I actually felt safe and slept well. Then I was awakened by the scent of coffee and a strange smell I didn't recognize. I walked around trying to find the source of it, until I came upon an American soldier burning something in an oil barrel. I asked him what he was burning, in my thickly accented broken English. He cast me a vicious glance, obviously disgusted and annoyed at having to do this work. "I'm burning your shit."

DAY 21

IN MY PAINTBALL PRISON, I seem to be filling quite a range of roles for different people. Symbol of the anti-war movement; lightning rod for hatred and racism; subject of intellectual discussion; di-

version for the bored; company for the lonely. And catalyst for flirting, heartfelt confessions and existential philosophical discussions. People debate the meaning of life, tearfully bare their souls or recount the minutiae of their daily lives while I am getting shot at. I can only conclude that social isolation has reached such proportions in this culture that when given a platform for dialogue—however unusual—people will grasp at the opportunity to connect with each other.

I got one man on the chat room telling me how drunk he was. He was upset because his friends had abandoned him at a bar. So he signed on and started complaining to me. When I asked if he was all right, he told me to "fuck on." I said, "Don't you mean 'fuck off'?" and he started cursing me.

Another described how he "lost everything," a lovely home, family, church congregation and 30 years as a Sunday school teacher, when the assistant pastor made up a story about him being unfaithful to his wife. It was a lie, though in retrospect it would not have been a bad idea, he said. He "left with a suitcase and never looked back . . . cried a lot, drank a lot, cussed a lot" and most of the time refrained from taking out his bitterness on innocent bystanders.

That tale sparked various discussions about God and the Bible among chat room participants who for the moment seemed oblivious to my presence. They debated the big bang, gay marriage, Amway, Scientology, Genesis. One atheist confessed that after her "crazy sister-in-law" went home she would tell her kids that grandpa is not really watching them from the sky.

Another user posted a continuous stream of passages from the Bible, at such length and relentlessness that others thought it was a bot. People asked him to cut it out, but he just ignored them. Finally I asked him to leave, using his IP address, "181." And he was gone. Later he revealed he was still in the chat room, watching this "stupid game," as he called it, keeping his Scripture to himself.

Another visitor transcribed whole Seinfeld episodes into the chat room—perhaps his version of a holy text.

Drunkenness and substance abuse seem to be a popular theme. Someone tried to sell me on the merits of LSD as a remedy for post-traumatic stress disorder.

Another drunk man from Texas demanded I tell him when to take shots—not on the gun, but of liquor. "You got any liquor there Waffle?" he asked. He needed to stay drunk or he'd remember how terrible his life is, he told me, as he downed a vodka and lemon drink—yellow!—in my honor. He informed me he ate a half pound of crawfish. A few minutes later, he was back with an update—he'd thrown the crawfish up.

W E FLEW TO SAUDI ARABIA in a military jet, on benches facing each other. Many of us were terrified of flying. I asked another man what it was like to fly, and he responded by asking if I'd ever ridden a roller coaster. We used to take girls on dates to the Medina al-Al'ab (The City of Rides) amusement park in Baghdad. We would use it as an excuse to get girls to cuddle up next to us. Bravely protecting the girls as we careened through the racing twists and turns of the ride, we felt like kings of the world.

As the plane accelerated down the runway and took flight, people gripped each other's arms in terror, kids cried and grown men passed out, while others tried to act strong as the color drained from their faces. I just thought about all those roller coaster rides. However this time there wasn't a girl next to me, only a U.S. soldier. I didn't hug him, but I was so ecstatic to be leaving that I drew him a picture of George Washington copied from a dollar bill. I wonder if he still has it.

Rumor had it we would stay in a four-star hotel in Saudi Arabia, then we could choose whatever country we wanted to live in.

As it turned out, there were no four-star hotels.

Once we landed in Saudi Arabia they loaded us on military trucks that headed deeper and deeper into the desert, cutting through sand so fine we all became covered in a layer of white dust that got so thick we could barely recognize each other. We looked like we had grown old all of a sudden. This ferociously inhospitable desert is home to patches of quicksand so voracious a man will quickly be swallowed if he steps into it—the quicksand was often used as a way to dispose of inconvenient dissidents or prisoners.

The trucks rolled to a stop at the newly constructed Rafha refugee

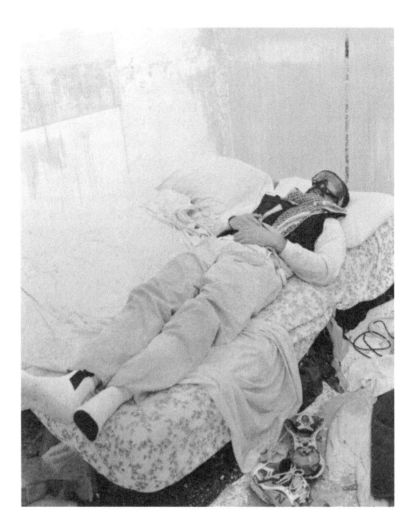

camp in the desert, with neat lines of large canvas tents. The tents were much more spacious than the plastic camping tents in Kuwait, and you could actually stand up in them. After the Kuwait camp with the violence and the tents on fire, constantly afraid of Saddam's spies and thinking I could be shot at any time, this was luxury. I felt safe for the first time in a long, long while.

But the relief of being taken from a war zone to a place of safety evaporated quickly. I was soon hit by the reality that one of my worst

life-long fears had become reality. After all the terrifying stories I had heard of refugee camps and prison camps during the Iran-Iraq war, here I was. Like most people, I have an innate repulsion to imprisonment, the feeling of being trapped or under someone else's control; a refugee camp combines all these feelings. Everything is uncertain and unpredictable; you could be there one more day or 10 more years, and no one can give you any straight answers about your fate. When I finally resigned myself to the fact that I was indeed going to be living in a refugee camp, I made a resolution that I would stay there for only five years. I could use that amount of time to mature artistically and intellectually: a sort of self-imposed training camp. After that, the situation would become unbearable. At the five-year mark, I vowed, I would do whatever it took to leave. Any option would be open.

As if the sense of confinement and uncertainty weren't bad enough, our living conditions deteriorated rapidly.

Within a few days, the American soldiers left and the Saudis were in control. They hadn't wanted us there in the first place—we were mostly Shias and they were conservative Sunnis. They took every opportunity to abuse and exploit us. The more Iraqis came, the more aggressive the Saudi guards got. And we Iraqis, who had already risen up against Saddam, weren't going to submit to anyone now. We would insult the Saudi guards and curse the Saudi king, and the guards would hit back at us.

When the Americans were there, they would clean the communal bathrooms every day. But after they left, no one wanted to clean the bathrooms, and they quickly became filthy. Meanwhile families didn't want their daughters using public bathrooms, since the men's and women's bathroom lines stretched out parallel to each other and waiting in them meant lots of exposure to or potential interaction with the opposite sex. So people started building their own bathrooms in their tents or right outside their tents. Sometimes they would steal the fixtures from the public bathrooms. Twenty thousand people were all building their own makeshift toilets—soon there was a stench of sewage and flies everywhere. I would joke that the Saudis should collect our excrement and turn the camp into a huge organic fertilizer company.

The food situation also went downhill quickly as soon as the Americans left. At first we had wonderful food, even better than average Saudi citizens—a daily spread of fruit, meat, cheese and bread. Food was delivered each morning, and each section within the camp had a communal kitchen where designated cooks would prepare meals for their group. But people wanted to cook their own food. So a system was set up where section leaders would distribute food to each family. But of course people got greedy, and greed led to violence. The Saudi drivers who brought the food started keeping some of it to sell in the nearby cities. And the Iraqi group leaders in charge of distributing the food also started hoarding it to sell back to the drivers and other Saudi employees. Before you knew it, the various people selling and distributing this food at great potential profit were fighting with machetes. When Iraqis started opening their own kabob stands and little restaurants in the camp, it got even worse, because the more food they could stockpile, the more they could profit.

Meanwhile, depressed and with little else to do, people just kept eating. (There was no shortage of food, only a massive amount of corruption in who distributed it and who got the best.) Many people gained so much weight in the camp, they became so obese they could barely walk.

And with the increasing corruption and chaos, the guards became more and more abusive. They imposed arbitrary and petty discipline, keeping us always on edge, angry and suspicious. Sexual abuse and harassment were rampant.

We found most of the guards were very ignorant about the rest of the Arab world. Sometimes I'd walk along the chain-link fence where the soldiers were patrolling outside and talk to them. I told one of them that our situation in the camp was like that of the people in Palestine. Incredibly, he had not heard of the situation in Palestine, so my friend and I explained it to him. He was shocked and said, "Do you think the king of Saudi Arabia knows about this? Because if he did know he would liberate them tomorrow."

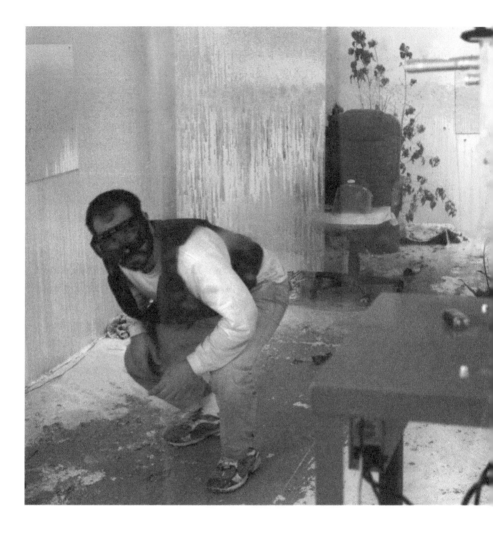

DAY 22

I'M PLEASED WITH HOW THE PROJECT IS GOING and amazed that I am more than two-thirds of the way through, but I'm increasingly concerned about the health problems I've developed. Insomnia, nightmares, paranoia and other post-traumatic stress symptoms, shortness of breath, chest and abdominal pain, strange freckles on my skin, rashes from the fish oil, exhaustion.

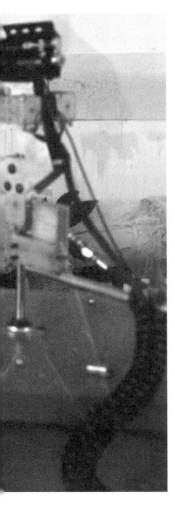

When I face the video camera my eyes are watery and swollen, and I jerk spasmodically as I speak.

A visit from Shawn, who has flown in from New York, gives me needed levity. Our nickname for each other is "Doctor," and today his presence is truly like a tonic. I get another boost from a package sent by high school students I had talked to by phone—a class taught by the wife of my friend and project collaborator Dan Miller. The students send me two Kit Kat candy bars and a stack of books—which unfortunately I know I won't be reading during the project. One is "Amazing Grace" by Jonathan Kozol—about kids like them who live in violence-ridden low-income areas and can identify with my sense of being under fire—literally.

Even a week after the Digg.com drama, chat room participants are still debating whether the project is real. At this point I don't care what they think. "People are doubting, but this is not a publicity stunt, I just want to emphasize the point that we are disconnected from reality," I tell the camera. "I know every one of you faces a difficult choice between shooting and not shooting—I don't want to interfere with that choice—I think every one of us faces that decision in some form in our lives."

Some in the chat room compare me to David Blaine, the illusionist and stunt artist known for suspending himself in a plexiglas case above London and freezing himself in a block of ice, among other things. But I am not seeking publicity or challenging the limits of human endurance just for the sake of doing so. And I did not design this project to challenge credulity or create the appearance of illusion.

I tell the doubters that I am doing this project because I need to feel closer to my family back home, and that it really doesn't matter to me if they believe it's real or not.

I need to change the sheets. Slowly moving around the bed, bent nearly double to avoid the gun, it reminds me once again how the most mundane of tasks becomes a major undertaking in a conflict zone.

Safaa has told me over the phone how he takes his kids to school each day despite the worsening violence. Every morning neighbors and friends call each other to get updates on the latest outbreaks of fighting and tension; every day they plot a new route to school to take the path of least risk. The same strategy must go into a trip to work or to buy food. Every seemingly mundane move takes on the significance of a military maneuver, with your very survival at stake. Going to the market used to be a social group activity, an enjoyable part of the day. Now family members take turns going to the market; they will never go in groups because of the potential for a suicide bombing—better to only have one person killed. Venturing out for everyday activities like this, there is always the chance you won't come back.

DAY 23

A NOTHER WEDDING.
The bride and groom are intrigued by the paintball project, and even though it was not on the radar screen when they booked their wedding at FlatFile, they are glad to have it as the backdrop to their nuptials.

The evening is like a piece of performance art in and of itself. Two separate worlds, with the open doorway providing a window between the two. Blonde women in black minidresses and clean-shaven men looking stiff in their suits amble back and forth across the open doorway, drinks held tightly in hand—from my vantage point they are carrying out a strange modern ballet. Most look into my gallery nonchalantly as they pass, then do a double take and look again. Friends are summoned. Some beckon me over to talk. One tipsy woman can't believe I have blue eyes, coming from the Middle East.

The responses I observe as I recline sleeplessly on the bed are like a microcosm of U.S. reactions to the war, or confrontation with an "other" in general: some curious, engaged and warm, reading my artist's statement on the wall and waving to me. A little girl calls to me gleefully until an adult pulls her away. Some glance furtively but seem not to want to see me, not wanting this strange scene to interfere with the moment at hand. Others are totally oblivious to what is going on.

The couple has asked me to disconnect the gun. In the ensuing silence, I begin to break down. Overcome by a wave of emotions I had been able to suppress during the usual chaos of dodging paintballs, I start to cry as I point the video camera at my face and describe my quickly deteriorating mental state, including nightmares and classic post-traumatic stress symptoms. I am having trouble separating reality from paranoia and memory, and I am bouncing from glee to despair minute by minute. Even though I am on the final stretch of the project, I am suddenly afraid I won't be able to go on. My friend Alicia Chester and her boyfriend throw me a lifeline, arriving with spicy panang chicken curry and encouraging words. Alicia gives me the caring but stern advice that if I need to stop the project to save my mental health I should do so; otherwise I should finish what I started and remember that it was my creation and therefore I am still in control. This works like a bit of reverse psychology; her admonition that maybe I should stop to save my health gives me renewed determination to persevere.

After they leave I am cornered by a tipsy wedding guest who has never heard of paintballs before and repeatedly asks me to explain the meaning of the project. "This is a paintball, just don't squeeze it," I say as I place a ball in his hand, irritated but probably lucky for the distraction from my malaise. Describing the project and the situation in Iraq ad nauseam to visitors has become a mental drain and an annoyance, but I have to remind myself that this platform for engagement was exactly why I created the project. This man and his wife express sympathetic if vague and flaky thoughts on Iraq and the project. "I hear it, I sense it, I feel it. The destruction, the pain, the fear," the man says. "I feel a

distance that comes with uninvolvement." Then his wife, who is slipping in and out of her leopard-print shoes as we talk, excuses them on account of her sore feet and wishes me well. Still in a slap-happy state of exhaustion, I briefly rock out to the electronic dance music from the wedding, moving my head and shoulders as if I am in a nightclub.

IN IRAQ, WEDDINGS ARE HUGE COMMUNITY EVENTS—the whole town is invited, not just the friends and family. You have one celebration in the bride's community and one in the groom's. At the bride's celebration, all the women and kids gather in a house and celebrate, then they get in cars and vans and buses, driving through the town honking, chanting and singing, sharing the moment with everyone.

When the Kufa Bridge was bombed by American soldiers during Operation Desert Storm, there was a wedding bus on it. Shrapnel and human flesh from the bus were strewn about the area. Afterwards there were two holes in the bridge from two separate missiles; one hole was much smaller, since it had hit the bus first.

That image came to my mind when I heard about the May 2004 bombing by U.S. planes of a wedding party in the desert town of Mogr el-Deeb, near the Syrian border. The attack killed the bride and groom and at least 43 other people, including Hussein al-Ali, the popular wedding singer who was performing for the women in their tent. U.S. officials maintained the target was a safe house for insurgents; a general claimed there was nothing found at the scene which would indicate a wedding. But journalists described finding fragments from the silk pillows the men were reclining on and broken pieces of musical instruments; and they matched some of the bodies with the people in the wedding procession video, taken by a man who was also killed. One guest told reporters she hid, bleeding, in a bomb crater after fleeing the scene, and then a U.S. soldier found her, kicking her to see if she was still alive.

That's what happens when you live in a war zone. People cannot be confined in their homes forever—life goes on. You want to defy the war and assure yourself that you are still alive. Yet you take a risk with every step. You are never safe, even on your wedding day.

AFTER I HAD BEEN THERE THREE MONTHS, summer came to the refugee camp, and the heat drove people crazy. It was 120 degrees in the shade. You had to get up and out of the tent by 6 a.m., or else you'd be baked alive. To this day whenever I look to move

into a new home I have to make sure the bedroom isn't facing east—I never again want to experience the cruelty of the morning sun.

The population of the camp had swollen to more than 33,000. The majority of the residents were Shias from the south like me—including various cousins, distant relatives and former classmates of mine. And a Shia man from Nasiriyah who would later work for the U.S. military as an interpreter and be credited with pulling Saddam from the spider hole where he was hiding in December 2003.

Qasim's brother Ali was in the same camp as I was. Ali got a letter from Qasim sent through the Red Cross, saying he had ended up in the nearby military camp known as Artewiya, and to my surprise, my brother Alaa was there as well. Artewiya had been set up as a camp for Iraqi soldiers captured by Americans during the war. I was confused, because my brother wasn't in the military at that point—he was on the front lines during the Iran-Iraq war, then deserted when called back for the Kuwait invasion. But in order to get out of the country, Iraqis had been dressing in military uniforms and turning themselves in to U.S. soldiers—that's what my brother had done. We heard the "military camp" was even worse than our camp, even more corrupt and abusive. I realized I needed to get my brother over to the civilian camp. There was a rule that a parent could bring a child to that camp, so I forged an identity card for my brother showing he was the son of an older woman in our camp. We put in a request for his transfer, and soon I was informed that he would arrive any day. My brother is a very loud and joyous person, even in times of stress. He likes to announce his presence, he loves to sing and shout. Early one morning I was awakened by the faint strains of a song in a familiar voice. At first it seemed like a dream, but it got louder and louder, and when I stumbled to peer out of the tent I saw my brother approaching me, dressed in the military camp's yellow jumpsuit. Even though I had known he would be arriving soon, I couldn't believe my eyes. I wanted to run to him, but I was too weak in the knees from excitement to move, I just stood there waiting for him to reach me. He threw himself in my arms and we embraced each other in the early morning sun with tears of joy and disbelief in our eyes. Soon other people crowded around and joined in a group embrace.

Our camp was getting more and more dangerous. There were various factions among the Iraqis, all brutally enforcing their own sectarian agendas. Though most of the camp residents were Shias, there were also Sunnis and some Christians and Kurds. Then there were the religious fundamentalists, Saddam's spies and the militant dissidents who had it in for Saddam's spies and any Iraqi seen as collaborating with the Saudis. Not to mention long-standing personal and tribal feuds that were given free rein in this lawless society.

That year or so in the camp was the most depressing and terrifying time of my life. You could never feel safe—every night there were tents set on fire and people disappeared. The guards would kidnap kids or young men with no family and rape them. As single men without families, my brother and I were likely targets. The guards had Iraqi informers in the camp who would show them where the single people lived. At night I'd lie in bed listening to the guards' trucks rumbling by, praying they wouldn't stop at our tent. We'd hear them stop somewhere nearby and then we'd hear a man scream as they beat him. And then silence. If I peeked out of the tent, I could see the truck's headlights leaving the camp and heading toward the Iraqi border. The next day people would ask why the man was taken, and the soldiers would say he committed a crime or someone filed a report against him. Several times people from the camp followed the trucks after the guards had kidnapped a man, and they saw the guards hand him over to Iraqi soldiers at the border in exchange for liquor or a little money.

My brother and I would always say good night to each other knowing we might not see each other the next day.

A GAIN, MY MIND TURNS TO HAJI.
I knew him only as a young boy, but still I have a wealth of memories, both firsthand and constructed through the tales of family members once I was in the United States.

The Bilal family owned a large tract of land in the ancient dry sea abutting the famous Najaf cemetery. When our relatives had refused to give our immediate family our rightful share of the land,

Haji confronted a top man in the tribe and convinced him to turn over the land. That was Haji. He was tough and fearless, much more so than I or my other brothers were. He walked with a swagger and literally had a gun on his hip at all times. During the embargo my family's neighborhood became very rough; it made the south side of Chicago look like a picnic. Even before the war, you would see people shot and slaughtered there on a regular basis. You had to be tough to survive there, and Haji was one of the toughest.

Though I detest machismo and male bravado, I had to admire Haji's toughness. His was not an aggressive, flamboyant show of strength, but an iron fearlessness and refusal to back down. If he believed in something, he would stand up for it no matter what. I feel I have this quality intellectually and artistically, but Haji translated his strength into a physical manifestation and a bravery very different from mine and that of my other brothers.

It wasn't until the fall of 2004 when I traveled to Syria and met my mother and brother Ahmed there, that I finally found out what had actually happened to Haji.

U.S. troops were advancing toward Kufa, so the Mahdi Army[5] set up an improvised checkpoint on the other side of the river to stop them. Moqtada al-Sadr's people came to my family's house and put pressure on Haji to man this checkpoint at the Kufa Bridge. My mother and brother Ahmed said there was no way he could leave the house. But there was a lot of pressure on him; he was close with al-Sadr's men, and he didn't want to appear weak. When I had talked to him on the phone in the previous months he was using words I could tell would lead to no good, talking about the "invaders," the United States. Of course, many Iraqis view the Americans as invaders, but the way Haji said it, the vitriol and opaque hatred in his voice, convinced me he was involved with the insurgents and was being drawn into their black-and-white mentality. I told him to stay away from al-Sadr's people, but of course he didn't listen.

5 The Shia militia founded by young cleric Moqtada al-Sadr shortly after the U.S. invasion in 2003; it launched a violent uprising in spring 2004 and has engaged in ongoing bloody conflict with coalition forces.

That fateful day my mother and Ahmed stood in the door blocking him, but Haji pulled his AK-47 on them and said, "If you don't move out of my way, I'm going to shoot you." Later that night, around 2 a.m., they were jolted awake by the sound of an explosion near the bridge. Explosions were common, of course, but Ahmed said this time he knew it was Haji. Soon some friends came to the house and asked Ahmed to step outside. They told him Haji was dead. He didn't want to shock my mother and father, so he told them Haji was injured and in the hospital.

Haji's friends said they were all at the checkpoint, and when they saw a U.S. unmanned drone fly over taking pictures, they knew a bomb would be coming. So they ran, except for Haji—he was so defiant. He wanted to show he wasn't afraid of anything. Sure enough an American helicopter flew over and dropped explosives on the checkpoint, blowing everything to pieces. Some of the shrapnel pierced Haji's heart. The family retrieved his body and took it to the washhouse, the same one where the kids used to spy on the women washing their dead from the Iran-Iraq war. Ahmed laid the body on a marble slab to wash it, and his hand slipped near the spot where Haji's heart was. His hand went right through Haji's chest and came out the other side. The people around him gasped.

When I returned from visiting my brother Alaa in Detroit after learning of Haji's death, for days I had a strange feeling that Haji was in my room at night. When I lay down to sleep I could sense him there, sometimes so strongly that I would start talking to him. I told him, "The world is yours now, you could go anywhere, so why are you here?" I felt like he was trying to relieve himself of the guilt his spirit was carrying at seeing all the people who loved him in agony; I think he chose me because I was the only one not angry at him for going out to man the checkpoint. I told him, "If you died fighting for something you believe in, you should be happy." I don't know if I really meant it or I was just trying to justify his death and make myself feel better.

Ever since we were little, Haji had been my father's favorite. He could get away with anything. None of the other kids could tease him or bother him, or my father would let us have it.

After Haji died, my father wouldn't eat. He dropped from 250 pounds to a skeleton of a man, so light that Ahmed could easily carry

him. It was a slow, painful process. As they say in our culture, the grief ate him alive. And his slow wasting away was a daily reminder to my family of my brother's death, so they could never put it behind them.

I only talked to my father three times after I left Iraq.

The first time I called to tell him I was alive, right after I got to New Mexico. The call had to go through an operator, and he hung up right away because he was afraid of the government. So I called back and said, "Dad, this is Bazzoun," his nickname for me, which means Cat. No one would know that except a member of the family, so he accepted the phone call.

But after he got over his relief at knowing I was alive, his bitterness returned.

He said, "I don't want to talk to you, you are not our son."

He wasn't officially disowning me, he just wanted to hurt me. I think he resented me for leaving Iraq and for our lack of contact for all those years, even though it was his erratic cruelty that had kept me from calling him. He said the words icily, as if twisting a knife in my chest. I didn't talk to him again for almost 15 years, about a year before Haji died.

Then after Haji's death, my brother Alaa told me my father wanted to talk to me. He sounded very broken, he didn't sound like my father at all. He asked me to come to Iraq. He said he wanted to see me before he died. I said, "Dad, don't talk like this, we need you there, we need you to be part of the family." In spite of all the effort I had spent throughout my life fleeing my father, at this moment the thought of losing him, of never seeing him again, plunged me into sadness.

But he had made up his mind to die. Two months after Haji's death, my father, his body shrunken to half its former size, had kidney failure and died in the Kufa hospital. I was photographing my friend's wedding when I got the call. It was my brother Alaa, crying so hard he couldn't talk, and I knew what had happened. I handed the camera to my friend and left. I got on a train to Detroit. It was like déjà vu when my brother picked me up at the same curb where we had met after Haji's death, just a few months earlier.

We opened Alaa's house to people to come grieve with us,

something we hadn't done after Haji's death. And now I could see the power of those rituals I had scorned in my youth. After Haji died, I had to relive the story every time I accepted condolences from a friend or Iraqi acquaintance. The in-home memorial we hosted for my father and the mutual mourning let everyone deal with it together and helped us move on.

During those days I spent a lot of time thinking about my father not in relation to myself, but as his own person, as an Iraqi, as a man. I realized that buried under that layer of cruelty he was a very sentimental person. During times of tragedy—like the deaths of his parents, of his brother Salim, and of Haji—he abandoned his cruelty and became childlike: vulnerable and loving, grieving with everyone else, going constantly to the cemetery and weeping. And in times of stress he rose up in defense of his family with fierce bravery, as when he defended Safaa against the murder charges and confronted the would-be revenge killers. And then that familial devotion and passion would melt away into annoyance and contempt as everyday life enveloped him once again.

For the first time ever, I began to understand my father as a victim of society, besieged by all the expectations and roles placed on a man and a father in a traditional society. People see Arab culture as a patriarchal system that oppresses women, which it is, but men are also oppressed—they oppress themselves with the rigid expectations and roles they must fill or else be shunned. In this vise-like social grip, my father repressed all his frustrations and shattered dreams and humiliations, ending up with nothing but the cruel and crazy outbursts.

I think my father also suffered some form of clinical schizophrenia, and rather than addressing it he reverted to lashing out as a means of self-defense.

When I got back to Chicago I allowed myself to really cry for my dad. I said, "I'm sorry, Dad, we didn't understand you." My tears took me to my bed and I fell asleep crying. As with Haji, my father came to me in a dream and I made peace with him. Before, my dad had often invaded my nightmares, destroying something or chasing me. Not anymore. I felt the power of forgiveness as I let my anger at my father melt away.

Day 24

I LAY IN BED looking at the old, twisted broken lamp which I have kept in the gallery as a target for shooters ever since Matt the Marine brought me the new lamp. Seeing the still-functioning new lamp shining next to the mangled carcass of the old lamp, I drift into a rumination on the meaning of hope, which Matt's lamp symbolizes for me.

Hope.

It's a short word with a long list of meanings.

It comes up about 300 times in the chat log—an average of 10 times a day.

Some of the "hopes" expressed are cruel, angry, the polar opposite of the intrinsic meaning one would want to see in the world:

"I hope your mother dies of vaginal cancer."
"I hope it hits you in the head."
"I sure hope i can get 'im in the nutsack."
"I hope you die in the next 9/11, you deserve it."
"I hope Cindy Sheehan commits suicide."
"American pigs, I honestly hope you all die!"
"I hope you never sleep again."
"I hope this guy gets shot the day he finishes this."

Some "hopes" are pedestrian or indecipherable:

"I hope the museum revokes his grant."
"Waf ya chat tech sucks, hope you didn't pay him!"
"He better hope Fox News doesn't pick up this story."
"Hope you're recycling."
"Cheered, had hope, got disappointed."
"Wafaa, hope your dick is forever green."
"Hope you got a volume discount on paintballs."
"Hope u sleep with a thick carpet."
"I hope you enjoyed your brief glimpse of Waffle."
"Hope someone builds an ark for this bible flood."

There are honest questions:

"What do you hope to convey with this installation?"

"I don't understand what you're doing, but I hope it helps the PTSD."

Many expressions of support and sympathy:

"I hope someone is there that will give you a hug!"

"wb hope u know im not shooting :)"

"Brilliant concept - I hope you wear thick clothes."

"I hope the situation gets better in Iraq."

"hope u survive this without getting traumatized."

"Hey, I hope I don't hurt you."

"Hope your lungs will recover."

"Wafaa hope your family is facing less bullets."

"Thinking of you, hoping you are well and with hope."

"Good for you, Wafaa. Keep hope alive!"

"Please don't lose hope, Wafaa. You've got a lot of supporters here :)"

And hopes for change, sometimes delivered in somewhat broken English, perhaps by foreign participants or just from bleary-eyed, clumsy-fingered people hunched over keyboards late at night:

"I hope in the people to overcome our differences."

"I hope you change your current government."

"Good night, Wafaa. Hope you can fix the system." (meaning most likely the server, though it could have larger meaning as well)

"I hope this art helps to repair their reality."

"I hope for your sake they find peace soon."

"Everyone I hope we all find peace within."

This exchange had one hope after another:

"Good luck ... I hope you find meaning in this."

"I really hope all Americans aren't racist mofos."

"Dude, I feel bad for you. I hope you don't get hit."

"I really hope people stop shooting you. Its wrong."

A visitor I "hope" I never meet in person:

"Where is that assfuck? If he calls this captivity, he better hope he never goes to jail...Christ why are people so unbelievably gay? You are stupid. I hope you're gone when I return... I hope you homos don't stay up too late it's a school night."

One person said:
"It seems a bit hopeless."

But many discussions give me hope, reassure me this has all been for a purpose. Seeing how many people invoke hope in the chat room, I am convinced that it is not just empty rhetoric or my lofty idealism. Despite all that's wrong in the world, people do have hope. I feel lucky to have given them a platform to share it.

"I hope. I depend on that ultimately...
we have to change the system
so that children grow up as good people
I know it is too ideal to happen
but the more we try, the better it will get
and I believe that at this moment...
don't give up hope
don't give in...
I hope that I can learn a bit from you
and maybe we made you think a bit, too."

I HAD A JOB in the camp picking up trash and spraying chemicals in the toilets every morning. A sympathetic older Saudi man drove the truck with a tank of chemicals; I would ride along and hop out to spray the toilets and collect the trash. I used the meager pay to buy art supplies, the driver would pick them up for me when he visited the city. I asked him for oil colors but he kept coming back with pastels, colored pencils or magic marker instead—it was all the same to him. Finally he got me the oil colors. I painted on canvas cut from the sides of tents, attached to stray pieces of plywood as

makeshift stretchers. As it had during the Gulf War and during the uprising in Iraq, painting helped me stay sane in the refugee camp. I painted mostly images of war and destruction, the horrific scenes seared in my memory, translated into abstract forms. One piece that I managed to take with me to the United States shows a line of forlorn figures—a funeral procession—trudging into the Najaf cemetery. You would not be able to guess the context without an explanation, but the muted colors and faceless figures convey an air of sadness and solemn ceremony. Another, which I considered a significant artistic breakthrough, shows a tumultuously colorful group of figures carrying a prone body above their heads. I remember being so pleased with the way that piece came out that, as soon as I finished it, I took a long walk around the camp engulfed in my satisfaction and my plans for future paintings.

But many times, my work would just be destroyed by the sandstorms that whipped through the camp. You could see them coming from miles away like a billowing wall of dust, a terrifying beige tsunami. We'd all dive into the tents and cover ourselves with blankets, wrapping our keffiyahs tightly around our faces, hoping we could survive it. As the storm arrived it became pitch black, the air was full of grit and even the scalding sunlight was completely blocked out. A roaring sound muted all other noises, and for those minutes or hours you were trapped alone in a cocoon, eyes and mouth tightly shut, breathing shallowly. People sometimes died—elderly people, little kids or people with asthma—suffocated from inhaling too much sand or from heart attacks triggered by the stress. When we reemerged after the storm, everything was coated in sand like a layer of moss, almost like a long-moldering shipwreck. After each sandstorm, the Saudis, who wanted to empty the camps, would bring air-conditioned buses and offer to take people back to Iraq. And people would always go, even though it meant they would probably be killed.

I was sick of having my work destroyed by the sandstorms, the paint coated with globs of sand or the canvas torn by the force of the wind. So as the summer waned I decided to build an adobe hut. I had seen it done before, during my time as a young guard

at the Saudi border—the observation towers I had sat in reading and scanning the border were made of mud bricks.

So I set to work.

Whenever I had free time I mixed water with the sandy clay to make bricks, storing them in a pile next to our tent. Finding water was a problem. But the kitchens in the camp had a place where the water would run off, so I started collecting that water and soon I had kids helping me. People thought I was crazy. They didn't think the mixture would harden, but it did. And they didn't want to think we would be there much longer—but we were. Every day I'd make a few bricks, and some friends would help, especially if I gave them cigarettes. When I had enough bricks, we started stacking them up into sturdy, stout walls. When they were as tall as a regular room, with blocks cut out for windows and a door, we made a roof from the plastic trash bags I got from my job collecting trash. I laid them out on the sand and fused them together with heat from a candle. I covered the window in clear plastic. "Let the sand storm come," I said to myself, "This place is sealed!"

By the time the hut was done, winter had set in, a dry, bone-chilling cold in the desert. My brother Alaa and I moved out of the tent and into the hut. At night sometimes it was so cold my muscles

would cramp painfully. I'd have to wake my brother to ask him to rub my back.

We had a kerosene heater in the hut during the day, but we turned it off at night for fear of carbon monoxide poisoning. We built a little shower next to the house with plastic bags protecting the adobe walls. We would heat water with the kerosene heater and go in there to bathe.

Now that the winter freeze had come and there was still no sign of release from the camp, the people who had thought I was crazy to build the house were asking how they could make their own. Soon people were making bricks all over the camp. The Saudis were amazed at how we turned the camp into a village. We even built a marketplace, and people started to plant gardens. Perhaps we had accepted the fact that we might be there a long, long time, and instead of dog-eat-dog chaos, some of us were beginning to live together harmoniously as a community. There were several other experienced artists in the camp, and I designated my adobe house as an art studio. During the day the other artists and I would paint in there, and kids would come to watch and learn from us. In the evenings it transformed into a literary salon—a venue for poetry reading and intellectual discussion—of philosophy, history, literature, politics—discourses that helped us keep our dignity, intellectual spark and humanity while we were treated like animals by the uneducated guards. I spent so many long hours reading by dim candle light in that adobe house that my eyesight was ruined.

One day our group of painters decided to build an adobe wall to display our artwork.

But all our industry, art and intellectualism was infuriating the fundamentalist religious Iraqis who also lived in the camp. They labeled us communists. They said if we built the art wall, they would burn the ground underneath us. One day when I was painting a group of them stormed in and demanded that I paint a portrait of Muhammad Bakr al-Hakim, one of the most important living Shia religious leaders at the time.

I didn't think I had a choice—if I refused I was sure they'd attack or kill me. So I painted the portrait on a piece of canvas from a tent, nailed to a piece of plywood from the public restrooms that people

had torn apart. The religious leaders came back for the portrait and snapped it out of my hands while the paint was still wet, then one of them held it above his head and paraded around the camp with his followers chanting "Allahu Akbar." It was a moment of humility for me. I had no escape plan from this situation, I felt cornered and I knew this was a battle worth conceding for the greater goal of surviving and leaving the camp. Even so, being forced to prostitute my artistic talents for them left an aftertaste of defeat in my mouth.

We were surrounded by oppression on all sides—on one hand the Saudi guards, and on the other the religious Iraqis. And across the border in Iraq, there was still the specter of Saddam.

DAY 25

IT IS MEMORIAL DAY, and the gun is shooting nonstop. I wonder if it has something to do with the military significance of this holiday, but then I remember that many of the shooters are international—from Canada, Italy, England, Denmark, Thailand. The cesspool of yellow paint disgusts me, but it is impossible to clean it up with new shots being fired so rapidly. I describe it as a "male dump site." The project has taken on an aspect of sexual metaphor to me—I can relate to how women sometimes feel used and abused by sex. This testosterone-driven male impulse to fire, to ejaculate, to aggressively leave their slimy and pungent mark on a space or being before disappearing without a word.

The gun is a metallic penis, the shots a series of quick angry orgasms. I see the gun as a symbolic and physical extension of the male aggressive drive to dominate, a reflection that disturbs me to my inner soul. I could never have guessed how strongly I would loathe the paintball residue—the slimy liquid around me and the sexual connotations it has evoked. Throughout my life I have confronted men who wanted to be in control. But this time I can't fight them, I have to submit to their aggression, hoping the interaction will awaken their consciousness on some level.

I N THE SPRING OF 1992, after I'd been there a full year, there was
an uprising in the camp.

The abuse, rape and even murder by the Saudi guards had be-
come unbearable, practically every day people were disappearing. I
didn't hear any talk of the uprising in advance, but I could tell peo-
ple were reaching a fever pitch of anger and agitation. One night I
heard the usual shouting and commotion that meant the guards were
procuring a victim. But then, instead of the sound of an Iraqi man
screaming as he was beaten, I heard Iraqi women making the joyful
keening sound we refer to as "Halahil." And an Iraqi male voice
thankfully yelled, "Allahu Akbar." People started running out of their
tents to figure out what was going on. I later found out that a group
of women had ambushed the guards when they came to take away
this man who had been charged with some wrongdoing. Apparently
they startled the guards so much they were able to grab the guards'
guns and turn the tables, holding them hostage in the tent. Soon a
crowd of other refugees joined them, holding the guards captive.
The tent was surrounded by the time I got there. Meanwhile the
Saudis had blocked all the entrances and exits to the camp with their
bodies and trucks. It was a standoff that seemed like it could erupt
into a small war.

With the Saudis thus occupied, the Iraqi fundamentalists took
the opportunity to attack their enemies, including tribal leaders who
didn't agree with them. Tents were set afire.

People were afraid the Saudi military might launch a full-scale
assault on the camp and slaughter everyone. But we were up for the
fight. We could not go on living with this level of abuse and fear.

The refugees formed an impromptu negotiating committee
and told the Saudis that if any soldiers entered the camp, the
hostages would be killed. The committee came up with three de-
mands: that no Saudi military was to be allowed into the camp—
they could only patrol outside; that the camp administration must
be completely overhauled; and that a United Nations office must
be opened.

During the standoff, the Iraqis wouldn't let any Saudi trucks bringing food or water into the camp. We worked together to conserve what supplies we had. After a week our water and food stores were dangerously low, people were getting sick and weak, but we were determined to hold out until our demands were met. The Saudis could see that soon they'd have a major disaster on their hands. So they gave in, and to our joyful astonishment, all three demands were met. The guards no longer entered the camp, except in extreme cases, such as to investigate a murder. It felt like we Iraqis had founded an autonomous zone right there in Saudi Arabia. And a United Nations office manned by an Egyptian representative was set up in a trailer in the camp—finally, a lifeline to the outside world. We could send and receive letters through the UN office, and there was some oversight of the conditions.

Soon after the uprising, the Saudis moved us to a new camp, with cinder block walls encircling tents. Though we got a new UN office in the new camp, one of the other conditions of the uprising was ignored. Saudi guards were again patrolling the camp. In the old camp the improvised bathrooms and other structures people had built all over the place made it harder for the soldiers to control the population—kind of like the winding narrow streets of Najaf, where dissidents could disappear from Saddam. The new camp's orderly cinder block walls and central group bathrooms with functional plumbing made for more comfortable conditions, but also made it easier for the guards to control us.

One high-ranking, U.S.-educated Saudi officer stationed at the camp took a real interest in those of us who were artists. He provided us with supplies and invited us to paint in an air-conditioned trailer. In exchange, we would do commissioned pieces for him—landscapes and portraits of his family. Though we weren't supposed to leave the camp he managed to take a few of us to Rafha, the first real city I had been in for almost two years. I went to the barber—the warm water caressing my scalp and the barber's fingers working through my hair to get out all the sand was a sublime experience, and I wished it would never end. With the money I earned from cleaning toilets I bought a camera, which I smuggled back into the

camp. I started secretly shooting photos and gave the film to my driver friend to develop.

The officer's support meant a lot—just having an educated and sympathetic Saudi to talk to amongst all the hatred and ignorance was invaluable. But other Iraqis were furious at our relationship with him; they saw us as Saudi collaborators and traitors. Meanwhile, the fundamentalist Iraqis decried our artwork as an affront to God. I realized sadly that I would have to give up painting in the trailer and chatting with the officer or I risked being killed.

DAY 27

YESTERDAY, DISCOUNT PAINTBALL RAN OUT of yellow paintballs. A local manufacturer had agreed to supply me for the remainder of the project, even though they don't normally sell to individuals. But half an hour after I had been gratefully thanking them for their offer, I was told they had to rescind it. They blamed a recent corporate merger and stressed that the decision had nothing to do with the politics of the project. We worked out a deal for Mark, the sympathetic owner of Discount Paintball, to buy from them and resell the paintballs to me.

Meanwhile I am experiencing technical difficulties. Both computers in the gallery space are acting up—I pound angrily on the keyboard and vow to never use a computer again once this project is over.

Then I get two deliveries that soothe my frustration. I open the first box—it is a lovely green peace lily from a couple, Malin and Jason, who lived in Chicago before moving to the South. Malin had been one of my classmates at the Art Institute. She put her artistic career on hold to start a family, and she later told me that my project inspired her and gave her renewed energy to pursue art again. The peace lily brings tears to my eyes, and I wrap my arms around the plant protectively as I vow, "I will not let anyone shoot this plant." Then I get another box—it's another peace lily, this one bigger and with delicate white flowers—also

from Malin and Jason. (A mix-up by the delivery company resulted in not one but two lilies.) An enclosed note mentions that peace lilies are supposed to be good at "cleaning themselves."

ANOTHER SUMMER DRAGGED BY. Plagued by the relentless heat and the growing sense that we might be here forever, some people committed suicide.

We began to hate the rest of the Arab world, because we were suffering so horribly here and none of the Arab nations were coming to our aid. It felt as if the rest of the world didn't know or care that we existed. Since we were mostly Shias in the camps, we were seen as rebels destroying our own country. No other Arab country wanted such dangerous and ungrateful residents.

My chemical-spraying route included the mobile homes housing the Saudi guards and the Saudi command center on a hill above the camp. One day we heard a rumor that a delegation from the Swedish embassy was at the command center. No one could leave the camp, but my driver friend agreed to bring me up to the center, under the guise of spraying chemicals. I brought my art to show the delegation; I was desperately hoping I could connect with the Swedes and convince them to get me out of there. They took a cursory look at my art and me with guardedly sad, sympathetic expressions, but told me there was nothing they could do. I stepped out of the command center feeling the world collapsing around me—I had pinned so much hope on this brief encounter. We had felt hidden for so long; now I had come face to face with representatives of the outside world, yet still they refused to rescue me from this hell.

I regularly paid the Saudi driver to fax my letters to many different embassies, especially the U.S. embassy. With the help of my translator friend—the one whose life I had saved in the Safwan Hotel— I wrote a page in English describing my education and artistic talents and my desperate need to leave the camp. It seemed like shouting into a void—I never got any response, but I wouldn't give up.

Saudi Arabia had been pressuring the United States to help clear

out the camps since they were first established; the Americans had created them during the uprising, and it was supposed to be a temporary situation. Finally, in 1992 the United States agreed to take in some refugees, and an American delegation came to the camp to conduct interviews.

Rumors flew about what they were looking for, who they would choose. Not everyone would get an interview—there was a pre-selected list of people. My name was on that list, and I wondered if it was thanks to my faxes, though more likely it had to do with the influence of my translator friend, who was one of a small number of translators and doctors who had already left the camp for the United States.

As the interviews approached, we were all excited and anxious— it felt like the nervousness of a first date, a job interview and college entrance exams all rolled into one and then multiplied fifty-fold. The interviews were held in a mobile home, and though it was air-conditioned, my palms sweated as I waited for my name to be called. I had been rehearsing my answers, and I had brought a sheaf of art work—paintings, drawings and photos. A British newspaper that had somehow found its way into the camp had a story about a cousin of mine who had refused to leave Kufa during the uprising and instead mounted a gun on his roof and hunched there shooting at Saddam's troops until he was finally killed. (This cousin, Falah Bilal, was renowned in our family for his toughness. My younger brother Haji would later be called "the new Falah Bilal.") I brought the newspaper along, too. I figured the article would help prove my family and I were dissidents against the regime, and hence in mortal danger if we returned to Iraq.

Finally I was called in to face a group of bland, relatively friendly American interviewers, immigration agents dressed in civilian clothes.

They first asked if my life would be in danger if I returned to Iraq.

After that, there were two things they wanted to determine— had I participated in violence or killed anyone, and had I ever been a member of the Communist Party. They also asked if I had any family in the camp. When I told them about my brother, whose name wasn't on the list, they scheduled an interview for him in two days.

I left the interview feeling confident that I had made a good impression and ecstatic that my brother would get a chance, too.

But I was also nervous because I felt my brother's and my own fate now depended on having our stories straight. Even though I had told them the truth, you never know how two people will remember things differently. So for the next two days my brother and I practiced for his interview around the clock. I told him all the questions they would ask and what my answers had been. I quizzed him with the questions in different order. We hardly slept. They had asked me if I had any tattoos. I didn't, but my brother had a tattoo of his name on his arm, a common practice in the military during the Iran-Iraq war, so the body can be identified. In retrospect, this tattoo probably would not have posed a problem, but I was paranoid about any obstacles and I told him the tattoo could hurt our chances.

"Don't worry, it will be gone," he said. The night before the interview he found one of our cousins who was in the camp, and they heated a spoon until it was red hot and pressed it into his arm. I didn't have the guts to watch, but he didn't even scream. When he went to the interview, it was all bandaged up. They made him open the bandage. A nasty wound, but no tattoo. He still has the scar.

A few weeks later, the guards posted the names of those accepted for immigration to the United States. People moved in a stampede from all sides of the camp toward the UN trailer where the lists were posted. Even before we got to the list, people began yelling out to us that my brother and I were on it. We would be free! We were leaving the camp! I was exuberant, but at the same time a sadness came over me because I knew many of my friends and relatives would not be so lucky. Once I left, I would most likely never see them again.

In preparation for our departure we gave away our tents, our utensils, everything but the clothes on our backs and our blankets— no Iraqi would leave without a blanket, because you never know where you might end up next. We were leaving our world behind forever, but at least we'd have that little piece of home and security with us. Our last night in the camp, my brother and I didn't sleep at

all. We made tea for a steady stream of visitors who came to bid us farewell. Many tears were shed.

A photo from that night—September 11, 1992—shows my brother and me and a few friends sitting on a blanket on the floor of a yellow canvas tent, a plate of oranges in front of us, with looks of tense anxiety and sadness on our faces. I have gathered my art supplies and a few books in front of me for the trip. Nearby sits the oil can I used as a palette, smeared with colorful swaths of paint.

Another photo taken the next day shows me, my brother Alaa and my cousin Mansoor linking arms, staring defiantly at the camera, the barren, parched, endlessly flat desert we were about to leave forever stretching out behind us. We are next to a soccer field; women in black chadors cluster around the goalpost. I'm wearing a crisp white Barcelona Olympics T-shirt, neatly tucked into blue jeans; men in the background are dressed in white robes and turbans.

We were excited, but also afraid of the unknown. Thanks to Saddam's propaganda, most of our mental images of the United States were negative ones—homelessness, AIDS, cancer, people abandoned by the government and left dying on the streets. Nevertheless, we knew what we would find couldn't be any harder than what we had already been through.

My brother and I were extremely lucky to be in one of the first groups to get out of the camp. After we left, there were more uprisings. Thirteen people were killed in a riot in March 1993, with residents demanding that Saudi Arabia open its borders to Iraqis fleeing the country. Little-seen footage shot by a Swedish documentary crew shows men buried up to their necks in the sand with their mouths sewn shut in protest, a desperate cry for attention and aid from a world who had forgotten them.[6]

DAY 28

THE VIRTUAL HUMAN SHIELD IS IN FULL FORCE.
An Art Institute graduate I have never met before, Beverly Wilson, came across the website during the heavy shooting on Memorial Day weekend. She figured out that by constantly clicking the gun left, she could keep it away from me, as long as her clicks outnumbered the aggressive shooters aiming at me. Through the chat room she organized more people to protect me. They are calling themselves the Virtual Human Shield, and they've even drawn up schedules to cover me around the clock, though I think Beverly puts in the most hours by far. When she isn't busy left-clicking she also visits me in the gallery, one time bringing me fresh socks because she saw I was wearing some ratty, unmatched ones.

I see the Virtual Human Shield as a form of the cyber political resistance, which has become increasingly common worldwide, from the online organizing of the 1999 anti–World Trade Organization protest in Seattle to the Zapatistas' online solidarity movement, to the practice of intentionally crashing multinational corporations' servers.

6 By 1997 the United States and other countries had stopped accepting refugees from the camp, and when the United States invaded Iraq in 2003 there were still more than 5,000 Iraqis there, living in better conditions than we had, but plagued by hopelessness, restlessness and depression. After Saddam's fall many Shias were repatriated to Iraq, but by the end of 2007 there were still hundreds of Iraqis in the Rafha camp, apparently still afraid or unable to return to their country. An order was given for the camp to be emptied, with a plan for Iraq to provide financial incentives and social support for the residents to reintegrate into Iraq.

Breaking geographic barriers and uniting people around the globe, the internet opens new frontiers for fighting oppression and injustice.

I've talked extensively with Ben and Sylvia about these topics.

We agree that while Domestic Tension draws out the misanthropic and brutal elements of cyberculture and human nature, it also highlights the ways in which the internet has become a forum of community resistance and empowerment.

I categorize the paintball project participants in three general groups: peace seekers who direct the gun away from me, identifying with me and with the project's impact on my physical being; aggressors who operate in a predatory, hunting mode, likely mirroring their own internal conflict and violence; and the simply curious, who are intrigued by the idea of pressing a button in Australia or China and seeing a paintball gun fire in Chicago. Among these are the computer geeks and paintball fanatics. I want the project to force each viewer to confront their own motives, their own internal conflict about shooting me.

An internet-based project was also tailor-made to reach the vast pool of the bored and isolated young people glued to their computers. With the world at their fingertips, figuratively and literally, this significant and growing demographic runs the risk of becoming too lethargic to enter into what past generations have experienced as the everyday value of human interaction. Saturated with images, stories and immediate gratification available to them 24/7, it takes something extra—extra violence, extra novelty, extra shock value—to capture the attention of this group, either in the "real world" or on the internet.

I am worried that this young generation—the one making up the front lines of the U.S. military—has become desensitized to violence. And even more disturbing than the desensitization is the lack of connection to the consequences of one's actions. This characterizes the way the U.S. military comports itself around the world; my brother Ahmed told me how American tanks would just run over cars in their path without even pausing, for no reason, and as if nothing had happened.

Also unnerving is the popularity of websites showcasing home videos of cruel, humiliating and violent acts. Sylvia thinks interest

in my project was fed by "this culture of wanting to see people being humiliated," but Ben has a more positive view. He calls it crowd-centric democracy, where everyone has equal power to voice their opinions and ideas.

THE FIRST STEP ON OUR JOURNEY out of the camp was boarding a bus that would bring us to a holding area run by the Saudis. We lined up and held out our IDs for inspection, one by one, and here an unexpected tragedy unfolded as many of the refugees were pulled out of line.

In Arabic people usually have four names—your first name, then your father's name, then your grandfather's name, and then your family name. (My full name is Wafaa Gize Kadhim Bilal—meaning "Faithful; Invader; One who is patient; Heavy rain.") Now we found out that if any one of your names was spelled wrong on that list, or if your posted name did not match your identity card exactly, you were not going to be allowed to leave after all.

These people had gone through all the mental, emotional and physical preparations to leave the camp—giving away all their belongings, saying their tearful goodbyes, sifting through the fear, excitement and elation about the new life to come—and now they were being sent back. The drama unfolded in front of a throng of people pressing around to watch and bid us all goodbye—a crowd of witnesses to these moments of absolute heartbreak and dejection. Alaa and I were fortunate in that our documents all matched up, and we were allowed to board, but watching the others in their pain was excruciating. I later heard there were a few suicides back in the camp, after people had come so close to freedom and then lost all hope.

The holding area, where we stayed for about three days, was comfortable. We were housed in nicely furnished, air-conditioned trailers, ate delicious food, and even went in to the city to shop.

Finally we were put on buses to the airport; we were a mass of bubbling human emotion—anxiety, exhilaration, nostalgia for the land we were leaving behind and jittery excitement about our new

lives. Once we got to the airport, the flight was interminably delayed. We joked that TWA stood for "Tomorrow We Arrive."

A few people were so afraid of flying, they balked at the last minute and refused to board, even after all they'd been through. This created quite a stir, since the luggage was already loaded, so if they didn't get on, all the luggage would have to be removed and resorted. Finally the stragglers agreed to get on the plane. I wonder how much of their fear was actually of flying, and how much they were afraid of the new life that lay ahead of them.

As for me, I was both terrified and excited. Excited because I had friends in the United States who told me it was a beautiful place, but terrified that I wouldn't find opportunities there and that some of the disturbing propaganda we'd been fed would turn out to be true. In the back of my mind were nagging worries that I would face hatred and racism—after all, the United States had just invaded my country—or that I would end up jobless and destitute, like the homeless American woman abandoning her child in a park which Saddam had smugly broadcast on Iraqi TV. Except for what I spent on art supplies, I had saved up all the money I could in the camp, hoping it could tide me over in whatever lay ahead. Other camp residents had mocked me and called me stingy when I refused to splurge on cigarettes or extra food, but I knew there might come a time that I would need every last cent.

When the plane took off, everyone started smoking. The haze of smoke laced with nervous perspiration was so thick that we could hardly see our fellow passengers. Kids were crying and women were coughing. The smoke even filtered into the pilot's quarters—he made an announcement asking us to please cool it. Some men drank beer after beer on the plane. In the camp, nonreligious people always found ways to get alcohol, smuggling it in or making their own wine from fermenting fruit, or even drinking aftershave. But buying real beers and drinking them gleefully and openly was a great luxury.

Just as we were getting comfortable with flying, the pilot made an announcement that mechanical problems with the plane were necessitating an emergency landing in Paris. I could not believe it. After all we had been through, the most powerful Arab and Western countries in the world had sent us a defective plane.

We were stuck in a glass enclosure in the Paris airport for what seemed like an eternity, other travelers staring at us curiously. Without any food or water, we got increasingly thirsty, hungry and restless until finally we were told that the plane was repaired and we could reboard.

DAY 29

IT'S 3:30 IN THE MORNING. I wander out to the bathroom, feeling like I'm walking in a moon suit or entrapped in someone else's body. I've gained so much weight—20 pounds in 30 days—from lack of exercise, depression and stress-induced overeating. I strip to stare at myself in the bathroom mirror, obsessively filming up and down my body; a side view, a frontal view, a view from the back—mug shots of the distortion and abuse wrought on my once proud physique. (This video is not for YouTube, but part of the documentation that will help me later on as I try to make sense of everything that happened in that room.) My face is pale and bloated, speckled with the strange dark freckles that have suddenly appeared over the last few days. Drooping bags hang under my listless, bloodshot eyes. I've been an athlete all my life and take pride in staying fit—it's painful to see myself this way. I put the camera under my swollen belly and point the lens straight up, seeking the most unflattering angle possible, cruelly pushing the flesh up in a mound, a rippling landscape below a jungle of wiry black hair.

Now I feel no anxiety or sadness or fear, or even anticipation at the project's imminent conclusion. Just a vast and colorless apathy, my interest piqued only by this masochistic display for the camera, my intellect and emotions so exhausted that I seek refuge in the realm of superficial vanity.

I have always avoided becoming overweight; even as a child eating from the collective pot at family meals, I would make my own plate with a controlled portion. Though in our culture big bellies were viewed as a sign of health and wealth, I associated corpulence with power, corruption and indulgence. But in the paintball project,

146

food became one of my only sources of comfort and release, a kind of negotiating chip between my mind and body, an indulgence I granted myself to convince my body not to rebel against all the abuse.

Nonetheless, the physical result of this "negotiation" disgusts me.

"All right, talk to you later," I tell the camera irritably.

O UR FLIGHT FINALLY TOOK OFF from Paris, and we headed across the Atlantic to our new lives in America. I stared out the window at the fluffy white clouds passing slowly by, then the luminous sunset, then the velvety dark of night: a homogenous and gentle aerial landscape obscuring the thousands of miles we were traveling. There was no ceremony to mark the slipping away of the whole region I had called home for the first quarter century of my life.

Only clouds and more clouds and the hum of the plane's motors, plus the alternately raucous or subdued conversation of my fellow travelers.

We touched down at JFK International Airport in the early morning, descending through a gorgeous sunrise painted amber, purple, deep blue and blazing pink, like a celestial welcome mat rolled out just for us. My brother and I wandered around the airport in a jet-lagged fog, buying our first American meal at McDonald's. Or rather, my brother bought his first meal—even though I was younger, I was in charge of the money and I couldn't imagine spending $5, the equivalent of about 20 Saudi riyal, for a meal. In the camp I'd make about 25 riyal a day for spraying the toilets and collecting the trash. If this was the way money flowed through your fingers in the United States, I thought, it was going to be a hard life.

We were supposed to get on a plane to New Mexico with a social worker, but for some reason that plane never came. After waiting all day, our escort was ready to take us to a hotel. I had almost everything of importance in my briefcase—my camera, photo negatives, sketches by kids from the camp. After a customs officer marked my passport, I turned around to collect my belongings and found that my briefcase was gone. I got the sinking feeling that all the bad propaganda we'd been fed about America was true.

The night in a hotel revived me, and the next morning I woke up filled with energy and expectations. Someone had already turned the TV on, so the very first thing I heard as I opened my eyes were the words "Good Morning America," the talk show.

That afternoon as our plane lifted off the runway we saw the sprawling mass of New York City. The landscape could not have been more different from the Saudi desert, where you would see dry emptiness for miles and miles. For the next four hours we knew the United States was unfolding below us, but we could only imagine what new lands we might in the future be able to explore because a soft impenetrable blanket of clouds blocked our vision. By the time we descended into Albuquerque, night had fallen. The sky was black but so clear you could see every city light, like pots of gold shining in the darkness. It wasn't until the next morning that we saw the Sandia Mountains rising above us, melting into the clouds. We had

never seen anything like it. My brother and I debated where the mountains ended and the clouds began.

A Catholic relief organization called Catholic Social Services set us up with jobs and an apartment and promised us financial support for three months. My brother and I and our two traveling companions—a doctor from the camp and a translator friend—the one who would eventually bring me the news about Haji's death—were set up in a studio apartment on Espanola Street. Our first night in the apartment we heard gunshots shattering the cool night outside. It was one of those seedy apartment complexes in a poor neighborhood, resembling a motel, with doors opening onto the parking lot. We peeked out the curtains and saw a group of young men standing around casually holding guns. "We left the camp for this?" my brother asked.

I didn't want to waste any time before starting my new art career and education. So our first morning in Albuquerque, I convinced the translator and my brother to accompany me to the University of New Mexico to find out about their art program. We didn't know exactly where the campus was; we just started walking and asking for directions along the way.

The low-slung adobe houses and desert brambles were not so different from the scenery I'd left behind. The afternoon sunshine on the adobe walls reminded me of a day back in Iraq when I had accompanied my father to visit the graves of his parents in the Najaf cemetery. Walking out of the cemetery, the rosy light fell gently on the crumbling walls of neighboring buildings, an image of home that is burned into my mind as if by the sun's own rays. With this flashback came a pang of nostalgia, reminding me how much a stranger I would always be now that I had left home, and that I might never find that same warmth in the sun or in my heart.

Before I left the camp I had photographed all the paintings I was leaving behind. Though I lost many of the negatives in the stolen briefcase, luckily I had a few more in my suitcase. On the way to the university I had prints developed at a drug store.

We found the university, and after earnestly presenting ourselves to various secretaries and departments we secured an audience with an adviser in the art department. I showed him my prints. He looked

at them respectfully and said he could see me studying art at the university, but first I had to master the language.

That evening we went to the home of another translator friend who had arrived some time before us. He lived with an artist who also became a good friend—Diana Huntress, who had taken up Sufi Islam and would later call herself my American mother. She heard our story about the gun-toting men in our apartment complex, explained that we were in one of the city's worst neighborhoods—probably the cheapest rent the relief organization could find—and promised to help us find a better spot.

Despite New Mexico's natural beauty, I was disillusioned with Albuquerque for my first few weeks. After the bustle and intellectual and artistic vibrancy of Baghdad, it felt like a sleepy little backwater, but Diana convinced me to give it a chance. She introduced me to the art scenes in Santa Fe and Taos—I was glad to see such interest in art there, but I wasn't impressed with the content. I was young and highly idealistic, and fervently believed that all art should have profound meaning.

After a few weeks we moved out of the Espanola Street apartment and into a five-bedroom house on Madera Street, in a much nicer part of town. We got food stamps from the government; I felt so ashamed to use them that I would go to the poor neighborhoods to do my shopping so I wouldn't stand out like a sore thumb as I used my food stamp card. The meager economic support we got from the Catholic organization and the government—which I am very grateful for—was nothing compared to the way I knew European governments supported Iraqi exiles like my friend Qasim, who had ended up in Turko, Finland. Day-to-day survival was rough. But in retrospect I'm glad I was forced to make a living on my own almost from day one because I believed in giving back to my new society, not just taking from it, and I think work gives your life meaning and value.

The Catholic organization got my brother and me jobs working 10 hours a day at a jewelry factory called Shube's—its logo was a shoe with a bee on top of it—making $4.25 an hour. Most of the other workers were undocumented Mexican immigrants. While

I was there, immigration agents raided the place after a woman who had been fired called and tipped them off. I quickly learned that culture and ethnicity in the United States is far from homogenous, especially in the Southwest, where the land had once been Mexico and is now again being settled by Mexican immigrants. My brother, who also worked at Shube's, actually learned more Spanish than English; he instinctively identified with the immigrant workers.

I was disgusted with the monotonous work and the obvious exploitation of workers at Shube's, but I took solace in the fact that I was earning money to buy art supplies. My job consisted of shooting molten wax into molds—rote work that took little mental effort, so I listened to talk radio to learn English while I worked. One of my primary English teachers was Rush Limbaugh.

After six months, I was due for a 25-cent raise at Shube's. I knew I was one of the quickest workers there, and I demanded a dollar an hour raise. The supervisor told me to forget it. So I walked out, deciding that having no job was better than that job.

I looked through the paper and after a while I found work making cabinets for $7 an hour, using some of the carpentry skills I had learned while working with my father. Meanwhile I enrolled in night classes at a community college called the Technical Vocational Institute (TVI) to study English and other subjects including art history, all for free. There were many immigrant students at TVI, and the community made a profound difference in our lives. Years later I ran into one of my fellow students, a Russian woman, in the Albuquerque airport. "I'm a doctor," she told me, with some awe in her voice, when I asked what she was doing. "I'm a college professor," I told her. We were both so proud of what we had achieved—having last seen each other sitting in a night class trying to understand basic English. That moment symbolized my ardent belief that when you give people opportunities and education, they will seize them.

While studying at TVI, I could picture all these opportunities spread out before me, but I needed the key to open the doors, and that key was the English language—There was no co-conspirator on a motorbike arriving to give me exam answers here! I learned

to understand English quickly, but it was intensely frustrating not to be able to respond when people talked to me.

I struggled along with the vocabulary of a young child. When I exchanged glances with a cute co-worker at Shube's, or when someone approached me at the café where I used to drink coffee and read, I would become tongue-tied, with a torrent of ready Arabic words dammed up by my inability to translate them into English.

My language problems became a novelty for my new group of American friends. At a dinner party thrown by a young woman I was dating, I decided to ask a friend about her car, a Volvo. "Maya, how is your vulva?" I asked, overenunciating slowly. The question hung in midair for a moment, and then everyone started laughing— except me, still clueless. "Are you the first owner?" I proceeded gamely. Then, "How many miles does it have on it?" My girlfriend squeezed my hand, stifling a giggle, as the others nearly fell off their chairs.

When my English was finally good enough, I enrolled at the University of New Mexico, majoring in art. My older brother Alaa and I still lived together. When we were at the camp my brother had promised me that if we ever got out, he would make sure I was able to study art. And he kept his promise. Once classes started at the university I quit working, and my brother supported me financially, proud to see me pursuing my dream.

It hadn't been difficult to stand out as an artist at the University of Baghdad, but it seemed like everyone in New Mexico was an artist. There was much more competition. While I wasn't risking my life for my art, facing surveillance and censorship, there were new social and artistic challenges. Without an oppressive authoritarian government to rebel against in my artwork, I had to find new ways to challenge limits and make a name for myself.

A young artist's career is a matter of claiming a place for oneself, of saying, "I am here." Having gone through that phase, a more mature artist can concentrate on truly developing talent and vision. That's the hard work, as I would find later in my career. During my early years in New Mexico I was mainly concerned with being

provocative, which I know now is actually one of the simplest things to do as long as you aren't afraid of anything.

After Iraq, Kuwait and Saudi Arabia, what could I be afraid of in New Mexico? I couldn't get arrested, I couldn't get prosecuted, I couldn't get executed. It was easy.

Though I was only a few years older than most of my fellow students, I had lifetimes more experience than they did. Many of them were living away from their parents for the first time, while I had already lived and faced death in three other countries. Most of my fellow students were obsessed with being cool and being accepted. I didn't want to be cool—I wanted to say what was on my mind. For the first time in my life I was free from the oppression of family, society, government and religion. Now I wanted to speak loud and clear about how much I hated government, religion and patriarchal gender roles.

I had a few inspiring role models at the university. One was Patrick Nagatani, a photography professor who became a close friend and mentor. He not only supported and affirmed my work and goals, but opened my mind to other possibilities and approaches without imposing his ideas on me.

However, I also met a lot of resistance among the faculty: many professors didn't want to work with me because of the political nature of my art. I was rejected from advanced painting classes again and again. I got so frustrated that I considered transferring out of the school. But then I became good friends with a printmaking professor, Jose Rodriguez, who convinced me to take his class before quitting. I loved it so much, I decided to stay. I started working for the university as the print lab monitor so I could use the printmaking studio at any time. Often I'd end up there all night; Jose would come in the morning to teach his classes and find me still there, red-eyed but joyfully absorbed in my projects. "Go home and get some sleep!" he'd say.

I loved the way intaglio printmaking allowed me to manipulate layers within the same work. Unlike painting, you aren't locked into an image once you have created it—you can keep altering or adding to the print with new plates. One of my favorite works shows a human figure tumbling through the air toward a mosque. I based

another print on a photograph of my face contorted by a scream, my hands half covering my straining jaws, printed both in ashy black and brilliant green. Another print depicts a slumping, rumpled figure from the back, washed in shades of rust and green. Below you can barely make out a drifting rowboat obscured by black scribbles. In Arabic I scrawled the words meaning, "Alone here, alone there, I always was afraid the boat would capsize . . . but I drowned and the boat stayed afloat. . . . Oh, friend, now the boat is alone . . . sailing."

Eventually my work began to gain recognition. Among other things, my video "Absinthe Drinker" won an award from the New Mexico Museum of Art. This was one of my early experiments with interactive electronic art—a still-emerging form then—and the possibilities intrigued me. I relished the chance to engage the viewers rather than presenting them with a passive experience; I had begun to feel that the potential for saying what I wanted in paintings and drawings was limited, and with this new medium a whole new landscape opened up.

My honors thesis project was my first interactive exhibit, in which two facing chairs were activated by a motion sensor when the viewer walked by. One was a comfortable armchair of plush red velvet, with a dildo sticking out of a hole in the seat. When activated, the dildo moved up and down and a strobe light pulsed. The facing chair was hard and uncomfortable, with spikes protruding from the seat, and when the viewer walked by it a dog would bark. The juxtaposition of the two chairs was meant to represent how forces of repression censor the desire for liberation and pleasure.

In that same exhibition, I showed a handmade box in the shape of a cross, decorated with a beautiful painting of the Holy Trinity. The viewer was encouraged to open the box, where they would find a dildo wrapped in the American flag and nailed to a cross— this was meant to symbolize the hypocrisy and repression that is hidden under the attractive façade of organized religion. The dildo was surrounded by pages from the Bible, which were themselves surrounded by images of the sickness and starvation caused by the embargo in Iraq, a comment on the effects of imposing one culture and religion on another.

The school demanded that these pieces be set apart from the rest of the gallery space by a curtain and behind a door with a warning sign about explicit content. Even so, the work was vandalized by a fellow student, a doctoral candidate in art history, who broke the mechanism that activated the chairs and yanked the flag-draped dildo off the cross. He went straight to two local TV news stations and bragged about how he'd vandalized the work because it was immoral.

Later he came to me and wanted to talk about our differences, but in my view he should have done that before attacking the pieces and now he only wanted to justify what he had done, not have a true dialogue.

Meanwhile my piece The Sorrow of Baghdad was displayed in the same gallery. It was an installation inspired by a gruesome image I had seen at the bombing of the Kufa Bridge. I had come upon the scene to see a woman's body covered in her ragged, bloody shawl. People told me what had happened—the woman was practically blown in half, but the baby she had been holding was miraculously still alive. Someone gently picked up the child and brought it to safety. For my artwork I re-created the scene of the bombing, with concrete rubble, a painting of the woman's face a mess of dripping flesh, incinerated dolls and toys. I burned things in the gallery to create the stench of an explosion, and superimposed an image of my brother Alaa riding a bike against a backdrop of Baghdad. Ghostly white plaster hands floated in the air, holding a replica of a mosque, and nestled inside its dome of mirrors lay a tiny baby's coffin.

Sitting next to this whole scene was a boar dressed as a businessman with a stars-and-stripes tie. A local taxidermist sold me the boar's head after I asked him for a pig—in Iraq calling someone a pig is the worst insult. I had never heard of a boar, but the wild, coarse-haired face captured the mood I was looking for.

The boar held a VCR remote control and cackled maliciously as he watched a video of U.S. politicians grinning with their one-time buddy Saddam—Dick Cheney, Gulf War–era Secretary of State James Baker, Rev. Jesse Jackson, Bob Dole, George H.W. Bush, to the tune of "Taking Care of Business." And then the viewers saw themselves in a mirror emblazoned with the words "You are a witness."

After a flurry of TV news coverage about the broken dildo, many

people sought out the exhibit for a dose of salaciousness, and in so doing, were exposed to my art and my message about war.

After graduating from the University of New Mexico, it was time to move on.

First I joined my brother Alaa in the Detroit suburb of Dearborn, where he had moved from Albuquerque. He and a partner started a jewelry store called Santa Fe to You—specializing in turquoise, silver and other Southwestern jewelry.

Their business was thriving, and I offered to assist their efforts. But then the September 11 attacks happened. Dearborn is home to a large Arab, and specifically Iraqi population—there is a saying that when you're in Dearborn, the United States is one mile in any direction. However, even there, the backlash against Arabs was immediate and palpable. My brother's business plummeted, and he ended up working odd jobs to help make ends meet. Meanwhile I was accepted to the School of the Art Institute in Chicago to pursue my Master of Fine Arts degree.

It was a relief to be in such a diverse and artistically vibrant city; I didn't feel like I faced the same kind of prejudice and conservatism in Chicago as I had in Dearborn. But ripples of racism and fear were still evident. Among other things, police had to be called in to stop an angry chanting mob that was marching toward a mosque in suburban Bridgeview. A homeless man downtown once called me bin Laden, though after I started a conversation with him we ended up becoming friendly acquaintances.

And then the Bush administration started talking about Saddam's supposed weapons of mass destruction and the need for a preemptive attack against Iraq. Like almost anyone with direct knowledge of Iraq, I knew there was no connection between Saddam and Al Qaeda and that Iraq had no advanced nuclear weapons program. I watched with incredulity as the United States geared up for war, filled with dread and disbelief that Iraq was to be subjected to yet another wave of terror and devastation.

This was to be my last day in the gallery, but after pining for the moment when I would walk out a free man, I've decided to extend the project 24 hours more. I dedicate the extra day to everyone who doubted I would make it this long. A few hours of sleep have washed away last night's malaise, and I'm jubilant at my impending success.

The Human Shield is in full force. I count 39 people continuously turning the gun left, protecting me. They're battling about 200 more who want to shoot me, though, causing the gun to jerk spastically back and forth.

A package arrives, yet another graceful white peace lily. The message says simply, "From a grateful left clicker. The world is a better place because of people like you."

I place the lily next to the computer and hide my face behind it, so my visiting roommate and the online viewers can't see my tears of gratitude and joy. "Hope is alive," I proclaim melodramatically.

After my father passed away, I wanted to go to Iraq, no matter what the consequences, to see my mother before something happened to her. I needed closure.

But the situation with al-Sadr and the Mahdi militia was worsening, and it could have been fatal for me to enter the country. Saddam's followers were still active, and they might kill me for my previous opposition to the regime—Kufa is like a small town, where everyone knew me and would know if I returned. And simply coming in to Iraq from the United States would make me a target for al-Sadr's people because they would assume I was a collaborator with the invaders. Beyond that, anyone coming from outside Iraq would be a target for gangs trying to kidnap for ransom. To reach Kufa from Syria, where I would land, I would have to drive through the treacherous "Sunni triangle," including Ramadi, where cars were regularly ambushed and people

kidnapped. So I grudgingly accepted the fact that I couldn't go into Iraq if I wanted to come out alive. Instead, in the fall of 2004 I took three weeks off from teaching and traveled with my brother Alaa's wife and their children to Syria to meet my mother and brother Ahmed. (Alaa did not come, since he had already gone to Iraq in 2003, not long after the invasion, before conditions got so bad. At that time he could travel freely around the city.)

My mother and Ahmed hired a trusted driver who drove them the 16 hours across the desert from Kufa to Damascus. They made the trip safely, arriving before we did, and rented a furnished apartment for all of us.

They met us at the Damascus airport. When I saw my mother across the crowded atrium, my heart started beating so hard I thought it would burst. I pressed my hand on my chest just to calm down. I had to get through security before I could go to them, but my bags didn't arrive and there was some complication with the visa. My sister-in-law started yelling at the guard, and the guard yelled back at me. I finally gave him $20, and after that everything went smoothly. I remember thinking how bad things must be if you could bribe an officer with just $20.

I ran to embrace my mother and brother, so relieved they had survived the dangerous journey. At first it was odd, almost like meeting strangers, since we were all so tense and it had been so long since I had last seen them. But as we talked we relaxed, and I started to remember my mother the way she always had been. That night was the first time in 15 years that I felt I was able to really sleep. And for the next 16 hours straight, I just slept and slept and slept and my mother forbade anyone to wake me.

When I was finally up, my mother made breakfast—going out to buy everything fresh at the market—bread, tea and a kind of sweet cream skimmed from thick pure cow's milk. I was transported back to the old days. Apart from the lingering grief of my father's and Haji's deaths, that time in Syria with them was truly beautiful.

When I looked at my mother's gentle, wrinkled but still lovely face, one thing bothered me—she was missing so many teeth.

Dental care was the last thing on their minds during the embargo and war. So I brought her to a Damascus dentist, and soon she had new teeth. Now I could see the smile of my childhood memories.

Damascus is a spiritual center of Shiism, and many important historical Shia figures are buried in Syria. Being a devout Shia, my mother wanted to visit all their shrines. We went to the major shrines in Damascus, and then we rented a minivan and driver to take my mother to visit the shrines and monuments outside the city. I needed a little time alone at this point, and I went to explore the bookstores of Damascus. I was leafing through dusty tomes in an underground store in the heart of the city when the owner sidled up to me and asked where I was from. I said I was from Iraq, speaking in Arabic, not letting on that I'd come from the United States. Before I knew it I was surrounded by men saying I should go fight for my country, trying to convince me to become a suicide bomber. I was shocked at their brazenness, the fact they were aggressively trying to recruit me within minutes of meeting. Then another man joined them and they switched to English, not realizing I could understand them. They were saying I would be perfect for the job. I realized I had to snap back into the old mind-set, being alert and ready to flee or fight at all times.

Being in Syria was like being back in the old Iraq, the good and the bad. There was the same Ba'ath Party propaganda: different names and pictures—Bashar al-Assad instead of Saddam—but the same tired slogans. (The Ba'ath Party actually began in Damascus, but the Syrian party split with Saddam after Saddam refused a proposition to unite the two countries into one.)

Being in the United States I had gotten over my fear of speaking out, and I wanted to see how people in Syria would react to talking about the government. I made it a point to ask relatively innocuous questions, like "What is life like here these days?" When I asked those questions in a cab, the driver would immediately change the subject. When I started talking that way in the marketplace, the people around me would just disappear.

The trip also gave me the chance to get to know my brother Ahmed again. I hadn't seen him since I sneaked out of the school-

house where the family was hiding outside Kufa during Saddam's attack on the uprising. He was only a little kid then; now he was 24. I kept searching his face for signs of the young Ahmed I knew, the bright little boy so full of ambition and promise. But I couldn't find any. This was a new person, almost a stranger to me.

As I got to know him all over again, I felt sick to see how my father had broken Ahmed's spirit and manipulated his life. Once we were sitting in the back of a public minibus in Damascus, it was hot and crowded, and he started to hyperventilate. I could see he was trying to keep his cool, so I didn't ask him about it until later. That's when I learned the full story behind Alaa and my bailing our father out from gambling debts a few years earlier. We had gotten a call from our family saying Dad owed people a lot of money and they were demanding he pay. They were talking thousands of U.S. dollars; millions of Iraqi dinars. It took Alaa and me a while to get the money together, but eventually we sent it to our family in Iraq.

This was during the embargo, when everyone was suffering, and my father's gambling had left my family bankrupt. So he started borrowing money to play the lottery, telling himself he'd win big and everything would be fine. Of course he didn't win big, and soon people refused to lend to him. So he began to use young Ahmed as a co-signer for loans brokered through the state. What the family hadn't told us in their phone call was that Ahmed was in jail at that moment because my father had used his name. When one of the lenders demanded he repay a big loan, my dad fled to Baghdad, and the police came for Ahmed and put him in the crowded, filthy Kufa jail with hardened criminals. The men were jammed in so tightly that they could hardly sit down. There was no way to wash or shave, and the place was crawling with lice. Ahmed developed an extreme case of claustrophobia there, which was triggered on the minibus in Syria.

That wasn't the only time my father sabotaged Ahmed's life and dreams. Ahmed was a great soccer player, and he was invited to be on the Kufa city team which would travel around the country for

competitions. But my dad pulled a gun on the coach and said if he took Ahmed on the team, he would shoot him.

Another time Ahmed had an opportunity to move to Baghdad to go into business with a neighbor selling wood-fired ovens made of clay. During the embargo these ovens were popular all over the country, because there was little electricity to run modern ones. There was huge demand for clay ovens in Baghdad, but few people making them. The neighbor decided to open a business there and asked Ahmed to be his partner. But my father drew his gun again and said, "You can't take him."

My father's pathology was such that no matter how much he abused the family and complained about having to support us, he wouldn't let us get away from him. Part of the reason he disowned me in our second to last phone call, I'm sure, is that I had dared to abandon him and come to the United States. He was great at playing the victim and garnering sympathy from people; I saw him do it many times.

After Haji and my dad died, Ahmed was left alone in the house with my mom and sank into a depression. He and Haji had been extremely close, sharing all the ups and downs of life. Now his whole world was crumbling. He would go to the Najaf cemetery every day and sit by Haji's grave talking to him. He told me that sometimes he would drift off and lose all track of time until he realized night had fallen—a dangerous time to be in the cemetery since it is a haven for criminals and wild animals.

My trip to Syria made me realize what it would be like if I did go back to Iraq. The motherland of my nostalgic memories doesn't exist any longer, and it chills me to think how many people won't be there to greet me—my brother, my father, my uncle and aunt, my grandparents, various cousins, so many friends who have been killed or displaced during the wars.

DAY 31

THIS IS IT.

Ben and Sylvia are helping me set up a live audio stream for the last few hours. Before, I had intentionally cloaked the project in silence, to enhance the remote and virtual atmosphere; now the people who have fired all these shots and communicated with me only through harried chat room exchanges will finally hear the blasts of the gun and the sound of my voice.

My computer monitor died a few days ago from the fish oil seeping into it, so I'm working from my laptop now. We've put it in a cardboard box to protect it from the paintballs. With Ben sitting hunched behind the box setting up the audio, I joke, "Ben Chang has programmed all the computers in the world, now he's moved on to programming cardboard boxes."

As 5 o'clock approaches, the gallery fills up with visitors and media. I answer chat room questions out loud to the backbeat of the nonstop gunshots.

Seven more minutes.

I raise my fist in a victory salute.

Six more minutes.

"Thank you, Ben, thank you, Sylvia, thank you, Dan, thank you, Jason, thank you, Dimitris."

Five more minutes.

"Thank you, Human Shield."

Four more minutes.

Never has a minute seemed so long!

Three more minutes.

A paintball explodes in the air and splatters me.

The last 15 seconds the crowd counts down with me like it's New Year's Eve: 15, 14, 13, 12, 11, 10, 9. . . .

Five o'clock.

I duck-walk below the line of fire and disconnect the gun. I keep a calm demeanor, but I'm dizzy with euphoria.

"We silenced one gun today and I hope we will silence all guns in the future," I say, peeling off my goggles and popping out my ear plugs for the last time.

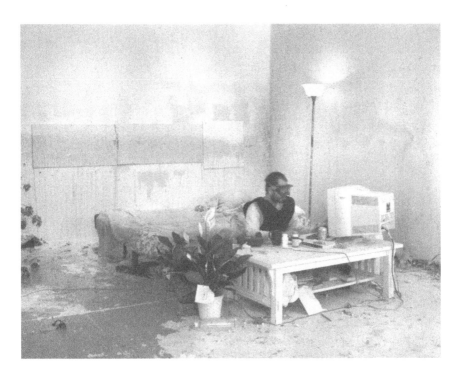

I feel like I'm having an out of body experience, like I'm coming out of a cocoon, my life transforming on the spot. Even in my exhaustion, I am suddenly light and free.

One of the TV cameras broke down right at the last minute; they want me to reenact the scene. Not a chance, I make a beeline for the gallery's front door and step out onto the wet, steaming asphalt. The elevated train rumbles by right above me. I lift my face to the sky, the sun is shining and yet a misty light rain falls on me like a benediction. The TV anchorwoman is hovering impatiently inside the door, wanting footage of me but refusing to get her hair wet. However, I'm in my own world.

Freedom.

"I promise you I won't cry," I say, my voice cracking like a teenager. "But it's great to be alive."

Soon I'm walking down Division Street near my neighborhood to meet Ben and Sylvia for beer and ribs. Buses wheeze and snort

on the busy street, cars honk and people in sidewalk cafes chatter and call out to friends. But I'm floating through a dream world, surrounded by a beautiful, surreal silence. The trees have never been so green, the air has never felt so fresh, the streets of Chicago have never looked so clean.

I turn the camera on myself for one last shot, an uncontrollable smile bursting through.

POSTSCRIPT

IN THE DAYS FOLLOWING THE PAINTBALL PROJECT, I realized I had exited FlatFile Galleries a changed man, forever altered by the physical, emotional, artistic and social intensity of an experience that seemed like a wrinkle in time far longer than just a month. My body felt permanently impacted and aged as if by years rather than weeks of such stress. And I had gained a wealth of wisdom, insight and ultimately inspiration disproportionate to the mere 31 days spent in the gallery. Concurrently I also felt a significantly increased sense of responsibility and urgency to keep this momentum going. Though a huge weight of guilt—survivor's guilt, guilt at living in the comfort zone while my family and so many others were living under fire—had been removed from my shoulders by the project, I felt a new ability and hence duty to push myself to the limit to focus attention, foster understanding and promote dialogue about the conflict, and war in general, in innovative and provocative ways.

And I didn't have long to wait.

I barely had time to clean up the paintball project and catch up on errands before I was off to my next adventure, constructing an Iraqi farmhouse on the lush grounds of the Montalvo Arts Center in Saratoga, California. I had accepted an invitation to be part of Montalvo's "Iraq: Reframe!" residency program and designed my proposal months earlier, though Domestic Tension gave me new ideas for how to carry out my plan.

Whereas in Domestic Tension I had put myself in a position symbolically akin to that of an Iraqi living under fire, with the "Iraqi House" I wanted to invite members of the local community to help

164

build and live in an Iraqi farmhouse, connected via live webcam to a real Iraqi home. I wanted Americans to actually get a taste of everyday Iraqi home life and culture, and also to experience how precarious this existence is in a conflict zone.

As soon as I arrived in Montalvo I set straight to work building the house, using the same technique that I'd used to build my adobe hut in the Saudi refugee camp. We had acquired piles of earth and dirt from the surrounding area, mostly from construction sites. Using

golf carts, hoses and concrete mixers, two assistants and I along with a small but loyal group of local volunteers began making row upon row of adobe bricks, creating a glorious mucky workshop on the otherwise pristinely manicured lawn. We mixed the dirt with water and shaped it into uniform rectangular bricks that were lined up to dry in the sun, then hauled up the hill and methodically stacked and mortared into walls. One of the assistants, a young photographer named Terekah Najuwan, had grown up in Sudan, helping her family make huts with the same method.

In Saudi Arabia I had faced a water shortage, the jeers of doubters and the dangerous displeasure of religious Iraqis when constructing my adobe house. As it turned out I actually faced greater obstacles constructing a similar house at Montalvo, an upscale artist colony where I was an invited guest. I found out my project had to meet building codes including earthquake resistance. So we added steel rebar to the house, a big undertaking that added many extra hours to the project.

The volunteers, assistants and I worked literally from sunup to sundown or later each day, caked in mud, stopping only briefly at midday to wolf down sandwiches. One of the most dedicated volunteers was a dainty, perfectly fit, tanned and blond, obviously well-heeled woman in her 50s or 60s who would wear pertly coordinated pink shorts, sneakers and nail polish—we called her the pink lady. Another regular volunteer was Chris, a tough woman who had recently returned from Iraq where she had been a military contractor. She had also been a private contractor in war-torn Bosnia. She was a hard worker and loved speaking a little Arabic and sharing her wry observations on Iraqi culture with me. Despite her obvious affection for Iraqis, she said the biggest lesson she had learned was never to trust an Iraqi. When it came time to put a window in the house, Chris had the perfect one—a large, peeling but sturdy multi-paneled window that had survived the 1989 earthquake in the Bay Area, even as the rest of her house had been destroyed. She said she never knew what had motivated her to keep the window all this time, and she was touched to be able to give it a new home in an Iraqi house.

As the end of my month-long residency approached, it seemed

impossible we would finish the house in time. We worked late into the night with the help of floodlights, except on evenings when weddings on the grounds forced us to cut our work short. At the end of the long days I would drag myself up the hill to my spare but comfortable apartment, aching and too tired to do anything more than wolf down a few slices of pizza and collapse into bed.

Before the paintball project, I had largely recovered from the post-traumatic stress symptoms and sleeping problems caused by my experiences during the war and in the refugee camps. But during that month of Domestic Tension they came back with a vengeance, and to this day I still cannot get a natural night's sleep without bolting awake, feeling anxiety or fear, my mind running and running.

Even with the physical exertion at Montalvo I was still plagued by these sleeping problems, meaning I spent that month in a state of complete exhaustion—I quickly burned off the weight I had gained during Domestic Tension, and then some. Again, I found myself in the battle of mind versus body, my stubborn mind driving my suffering body perhaps well beyond what was healthy or wise.

The house was finished just in the nick of time, but then city officials said it would be illegal for people to live in it, even with the rebar we'd added, shooting down a major part of my plan. (Northern California has especially strict building codes because of the earthquake risk. A moderate earthquake, magnitude 5.6, shook the Bay Area in October 2007. The Iraqi house survived the test without a flaw. But that wasn't enough to convince the building inspectors.)

I left Montalvo in late August, just in time to start teaching my classes at the School of the Art Institute, planning to come back later to see the live webcam installed and ultimately to stage the grand finale of the project—no one knew except the residency administrators, but my plan was to blow the Iraqi House up. The idea was that after community members had become emotionally and physically invested while building the house, it would then be destroyed in an instant, the hours of hard work and memories reduced to rubble just as Iraqi houses are every day.

Unfortunately none of this came to pass. The Montalvo staff dragged their feet on giving me the resources to install a webcam and lay the groundwork for the explosion. Though I had described my plans months earlier and received full support, as it turned out Montalvo's leadership did not want me to destroy the house. I was given various excuses, including cost, liability and feasibility, but all my attempts to address their concerns or find solutions were met with silence or shifting stories.

When I went back to Montalvo for the official unveiling of the project in November 2007, it seemed the center had finally agreed with my revised plans to blow the house up on the anniversary of the start of the Iraq war in March 2008. I told this to the assembled crowd. Shortly after making the announcement I made eye contact with Chris, the military contractor. She looked crestfallen and betrayed. She left without saying goodbye, and I haven't heard from her since. I think my plan to destroy the house to which she had devoted so much work—and her window—confirmed her belief that no Iraqi could be trusted.

Soon after the opening, Montalvo again began waffling about the plans for the house, and it continued to languish without a webcam or clear purpose. As the Iraq war anniversary approached they made it clear I could not blow up the house, despite all the research I had done on safe and inexpensive demolition services. I came up with an alternate plan to ignite the structure in a spectacular but ultimately harmless blaze of gunpowder, similar to the celebrated work of Chinese artist Cai Guo-Qiang. I got an initially enthusiastic response, but was not surprised a few days later when permission was withdrawn.

Ultimately the house had no grand finale, and it was unceremoniously dismantled brick by brick. A deadline was finally set for its demise because another wedding was planned on the grounds, and the bride's mother was adamant that the Iraqi house was not invited.

I consider the whole situation an example of de facto censorship. A provocative and potentially deeply engaging collective experience was aborted in the interest of playing it safe. I was deeply disappointed with the experience, though it did give me renewed appreciation for FlatFile owner Susan Aurinko's unflagging support throughout Domestic Tension.

I had little time to stew over the fate of the Iraqi house, however, because early 2008 marked the birth of my soon to be famous alter ego, the Virtual Jihadi. It would be the centerpiece of my visiting professorship at Rensselaer Polytechnic Institute (RPI) in Troy, New York, a school with the odd juxtaposition of a radical, political art department and a prominent science/industry focus on military defense. With a large ROTC program and significant funding from the Pentagon, it is the oldest technological research university in the United States. I was invited to be part of RPI's program "Art and Islam: Electronic Representations and Local Communities," and the project I had in mind seemed perfect.

Not long after the United States invaded Iraq, a video game producer named Jesse Petrilla hit the market with "Quest for Saddam," a video game inviting players to shoot down Iraqi soldiers, winding their way through palaces and deserts until they ultimately assassinate Saddam. The game utilizes coarse, jingoistic stereotypes; every Iraqi soldier has Saddam's face, and they all utter the same nonsensical phrase—"Huminumanuma"—that reminds me of the simian sounds attributed to Africans in old racist cartoons. The scenes are sprinkled with obnoxious anti-Arab nuggets, like a poster for "Camel Cola." Saddam himself is a crass stereotype, with thick jowly features and heavy eyebrows. In interviews Petrilla has said he is not political, but he is a founder of the United American Committee, which purports to be a watchdog group fighting the threat of "Islamofascism." Its website is full of alarmist, sensational media alerts and it hosts "Jihad Chat," a chat forum full of vitriolic anti-Muslim, anti-immigrant discussions.

Al Qaeda was not amused by "Quest for Saddam," and it hacked the game for its own purposes, turning it into a hunt for President Bush. Instead of gunning down Iraqi soldiers, the player fights American soldiers, and if you reach the highest level you get a chance to shoot a crudely rendered image of George W. Bush. The game is called "The Night of Bush Capturing." Al Qaeda's media arm made the game available on the internet, complete with mesmerizing Arabic music and a home page featuring the visages of Arab religious leaders and militants.

I decided to add my own spin to this game, as a way to address how ordinary Iraqi civilians like my brother become vulnerable to recruitment by terrorist groups who prey on their bitterness and fear. I decided to cast myself as one of these regular Iraqis who is recruited to be a suicide bomber. With the help of my roommate Luis Mayorga's design prowess and Shawn Lawson's and Ben Chang's video game expertise, I hacked into Al Qaeda's version of the game and inserted myself as the lead character—the Virtual Jihadi. To create an extra layer of pop culture resonance, we outfitted my character in the medieval garb of "Assassin Creed," a popular video game. I created a backstory, illustrated by my friend James Kloiber in a storyboard accompanying the exhibit, based on the real-life death of my brother. James's drawings show how the Virtual Jihadi's brother is killed by American troops, and in his grief and rage he decides to become a suicide bomber intent on killing President Bush.

Things seemed to be going well at RPI as I guest lectured to students and prepared for the opening of Virtual Jihadi on March 5, 2008. I planned to invite guests to play the video game on a large screen, next to a life-size cutout of the Virtual Jihadi.

Then the College Republicans club got wind of the event and posted an outraged missive on their website calling me a "terrorist" and the art department a "safe haven for terrorism."

The afternoon before the opening, I was speaking to a video production class when three school officials with stern looks on their faces interrupted and asked me to step outside. I asked if they could wait until the class was over, but they said no, they couldn't. I followed them into another room for a lengthy interrogation that was a chilling reminder of the times Saddam's men grilled me about my art at the University of Baghdad. One of the interrogators was Laban Coblentz, a former official with the International Atomic Energy Agency and now chief of staff to RPI president Shirley Ann Jackson. They told me Jackson had sent them to investigate whether school money was being used to support terrorist propaganda, and whether the exhibit was "suitable" for an RPI audience. They also informed me that CIA, FBI and Homeland Security officials would be at the event. "They are welcome," I said. The RPI officials said they had hired extra security for my safety.

As the lecture approached I was nervous; the accusations of the College Republicans and the intimidating, overblown response by school officials gave me flashbacks to the feelings of paranoia and repression from my university days in Baghdad. I felt this was a crucial moment. I had to perform well for a crowd of about 300 that included government agents. This might be the only university art lecture they'd ever attend—I had to make it a good one! I entered the lecture hall not knowing if I might get shot or arrested; all the while I was speaking I was trying to engage people and drive home my points while at the same time scanning the audience for any threatening movements.

Luckily the speech went smoothly, and I finished on a warning note.

"Ignorance is not an excuse," I said. "If people want to change the direction of this country, they have to talk. I've seen how we surrendered our power little by little to a dictator in Iraq, to the point that we could not speak to our own brother or sister. I don't want to see this again. I don't want to see what happened in Iraq happen in this beautiful country."

The next day, we got word that Virtual Jihadi had been "suspended" while school officials investigated its intent. But I was assured I was still a welcome guest on campus. At least until a few days later, a Sunday morning, when I headed to my temporary office to do some work but found that the electronic identification card school officials had given me for the duration of my stay didn't work. I got the attention of a security guard inside the glass door. He opened it and told me he was part of an extra security force hired by a special firm because a visitor had done work linked to terrorism. He wasn't supposed to let this guy in, he told me. After some more questions and conversation the guard agreed to let me in, not knowing I was the terror threat in question. "You need to work on your terrorist outfit," the head of the art department later joked. All faculty identification cards had been suspended that day, and as word spread through the art department school officials were bombarded with angry calls, so they revoked the department lockdown and tried to calm people down.

Soon, the exhibit was officially closed. An RPI press release said

the school decided the video game was not fit for the RPI community since it "derived from the product of a terrorist organization" and "suggests the killing of the President of the United States."

I had been censored.

RPI President Jackson—former chair of the Nuclear Regulatory Commission under President Clinton—was besieged by angry art students and professors at a school town hall meeting several days later. She vehemently defended her decision. In response to the argument that Al Qaeda's game is freely available on the internet, she repeatedly compared it to child pornography.

Local artists hastily arranged to have Virtual Jihadi open at Media Sanctuary, a struggling grassroots gallery in downtown Troy. A city commissioner and prominent Republican Party activist, Bob Mirch, was outraged. He called for a protest against the opening and commandeered local TV coverage to denounce this terrorist advocacy in the heart of Troy. Protesters waved deeply disturbing handmade signs and posters, including one showing missiles rocketing toward Iraq. Another featured a bizarre photocopied image of an elephant defecating—with an Iraqi flag pasted below the steaming load.

"I don't know if these people are mental deficients or what the story is, but free speech can only go so far," said the man holding the elephant sign. "It's a time of war."

The protesters interviewed by local broadcast journalists and an independent documentary maker seemed largely unaware of the nature of my exhibit. Some said they were city workers or friends of Mirch. Apparently they had been told an Iraqi terrorist was in Troy, and they were here to let him know he was not welcome. Rushing into the Media Sanctuary for the exhibit, protectively flanked by my friends and supporters, I honestly felt more danger of violence than I had since leaving Saudi Arabia. The head of the art department was equally nervous; we even devised an emergency exit strategy for me if things got too dicey.

News of the exhibit had also spread through the right-wing blogosphere. One blogger, on BelchSpeak, proposed his version of political art, "I have a self-flushing Koran. I want it to be powered by a green source, but I couldn't find one so I salvaged the unspent carbon credits of Wafaa Bilal's dead brother to power it."

The day after the opening, the Media Sanctuary was shut down by the city building department. The stated reason: code violations, namely that the door was only 29 inches wide instead of the mandated 31 inches. City officials said the gallery had been under orders to fix up the violations for months, and the timing had nothing to do with the Virtual Jihadi inside.

The artists and activists of Troy were outraged. A flurry of public debate, protest and letter writing energized the town, continuing even after I returned to Chicago. Locals told me more people came out to protest against the censorship of Virtual Jihadi than had protested the war. Meanwhile, RPI announced a policy to vet future art exhibits for appropriateness, a move that provoked furious outcry and charges of preemptive censorship from the department. In April 2008, the New York Civil Liberties Union filed a lawsuit against the city of Troy for censoring the exhibit. The renewed attention to Media Sanctuary resulted in $30,000 in donations, enough to rehab the whole gallery including the offending door. A local newspaper described the lively buzz of volunteers working to rehab and clean the gallery, under the icy, watchful gaze of the life-size cardboard cutout of the Virtual Jihadi.

As if Virtual Jihadi didn't make enough of a mark on RPI, another of my projects there also caused a stir. Having experienced living under the gun, so to speak, during Domestic Tension, I wanted to personally explore the hot topic of waterboarding and whether that age-old interrogation technique constitutes torture.

I wanted to be waterboarded.

I made this the focus of one of my guest spots at RPI, in professor Igor Vamos's advanced video production class. Igor and I, along with RPI professor and artist Rich Pell, discussed various permutations of the idea, until we settled on an absurd, satirical project called "Dog or Iraqi."

A website, www.dogoriraqi.com, described how I had been recruited by a company called TortureChoice to try out new forms of torture. On the site, viewers could vote who should be waterboarded—me or a cute, wide-eyed pug. The site showed us both gazing up peacefully at a brilliant blue sky, me in a

dishdasha and the dog wearing an American flag around his chubby neck.

The website's blog drew outraged comments from animal lovers furious we would suggest waterboarding a dog. The Humane Society even called RPI's art department threatening legal action. There seemed to be plenty of concern for the dog, but not for me. "You are doing this voluntarily, but the dog isn't," people said. "Well, the dog might have valuable information," I told them. "It's all in the interest of national security." Besides, it isn't torture, or so the U.S. government would say.

After the Virtual Jihadi debacle, staging the culmination of "Dog or Iraqi" at RPI did not seem possible. We—or rather, TortureChoice—searched for other venues, but the idea was too legally and politically complicated for any private venue. I flew out to New York City in late April knowing I (or the dog) would get waterboarded, but still not knowing exactly where or how it would happen.

The scene turned out to be the dusty, dank basement of a private studio in Troy. It looked the part of a torture chamber—lit harshly by a naked bulb, grime everywhere, even a splatter of what looked to be blood on the concrete floor—the residue of a previous art project. The voting between me and the dog was close until the last moment. More than 4,000 votes were cast, and less than 10 separated us. It was actually surprising so many people voted to waterboard the dog; I don't know if that was an attempt to save me, or just a lot of people who didn't like dogs. In the final minutes I "won" the vote—more people decided to waterboard me. It was a private affair, only a few local artists in attendance and two RPI students, both ROTC members planning careers in the military. I was glad it turned out this way, a personal moment rather than a public spectacle, but I wondered, if I put myself through this torture here, with only a few witnesses, confronting my own fears and these political questions in private, will it still have meaning? Of course we also planned to document the event on video to be posted later on the web—since Domestic Tension, I have felt unable to let any momentous occasion pass without footage to preserve it.

The whole situation seemed surreal and somewhat silly until the final moments, when I realized I really was about to get waterboarded. Then I truly felt fear, and an awkward chill descended between me and the two artists—good friends of mine—who were about to inflict extreme and possibly dangerous pain on me. I think the anticipation and actual experience for them was perhaps as traumatizing as it was for me; I can only imagine the effect perpetrating such behaviors has on young U.S. interrogators. To my chagrin I realized my soon-to-be torturers did not know how to waterboard someone. So we watched several instructional videos on YouTube, one a comical and yet highly disturbing satire ending with the subject defecating on himself and the admonition that, "the smell of victory is the smell of excrement."

The two interrogators donned Santa Claus masks and beards which happened to be lying around to obscure their identities— they were taking a significant personal risk by doing something that could possibly result in my injury or death, not to mention the politically explosive subject matter. I quickly changed into the dishdasha and a white skullcap, feeling vaguely like I was in a dream preparing for my own execution. They tied me to a tilted board in the basement, one Santa Claus perching on the flimsy chair that seemed barely able to hold his weight and the edge of the board. They covered my eyes with a tacky Tweety Bird T-shirt and filled a pitcher of water. "Wait!" I said. "Aren't you supposed to put something in my mouth?" I had to direct my own torture! They roughly snatched the skullcap from my head and stuffed it in my mouth, inducing the dreaded gag reflex. I couldn't close my throat. Soon icy water was trickling directly into my lungs. I lurched and twisted frantically and raised two fingers, our agreed-upon sign for mercy, struggling with my hands tightly bound on my chest. They grabbed the cap out of my mouth and I sputtered and wheezed desperately. But it had only been a few seconds. I had panicked, but I had to endure for longer than that. "It's OK," I gasped. "Keep going." The cap went back in my mouth, another deluge of water. Sheer terror. I truly felt I was drowning.

I jabbed two fingers in the air—my two middle fingers this time. They ungagged me and started to untie me frantically; I slid off the board onto the cold concrete spitting and coughing. My vision was

bleary. My hands were tied too tightly to undo quickly, I lay prone, staring helplessly at the video camera documenting the event.

"Anyone who says it's not torture should try it," I said.

I had only lasted a total of about seven seconds, and I had thought I was dying. They say waterboarding often lasts 20 to 30 seconds, and detainees may undergo multiple rounds. As sharp as my fear was in those few seconds of choking, I knew my "interrogators" were friends looking out for my safety. Detainees are waterboarded by aggressive soldiers who very likely have killed before and might not blink at killing again.

The two ROTC students left immediately after the waterboarding, I didn't get a chance to hear their reactions and they apparently didn't want to hear mine. I can only wonder if it made them ponder what a future in the military might mean.

I kept coughing violently the rest of the night, trying to clear the liquid from my lungs. I was in a subdued fog until I got back on a train to New York City the next morning, not at all sad to be leaving Troy.

Domestic Tension and the year of work, controversy and dialogue that followed have given me hope. Though I launched the paintball project largely to give a voice to my Iraqi brothers and sisters, all those cyber interactions—negative and positive—created bonds between me and participants across the globe, but most intensely with people here in the United States. I had crafted the project to tap into American cyberculture and pop culture, and now I feel myself a part of and a product of those cultures, along with that of my homeland. I've had firsthand experience with the best and the worst of American culture and society, and as a result I feel more deeply connected to my adopted country and its people. Most important, I have evidence that Americans will listen and respond to my questions, that we can create dialogue and understanding where none existed before.

And now I ache not only for my fellow Iraqis who are suffering so much, but also for my American compatriots. The United States

176

seems calm now, but most people have no idea of what is coming. More than 100,000 soldiers will soon return home with the post-traumatic stress I know so well, not to mention the mysterious effects of depleted uranium . . . and the ripples of resentment and animosity this war has sent throughout the world will inevitably wash up on U.S. shores.

As I write this, mainstream political dialogue is still focused on the crazy idea that we can somehow still "win" the war in Iraq. For someone like me, a citizen of both countries, what outcome would constitute a victory? When you're talking about war, about so many thousands dead, so many families shattered on both sides, how can anyone claim victory?

At best, we can hope to survive.

And we may think we are surviving this war.

But as I drive through a pounding rain and suddenly panic at the memory of water trickling into my lungs . . . as I bolt upright in bed awakened by nightmares or twist and turn through sleepless nights . . . flailing between worlds of comfort and conflict . . . hope and despair . . . I wonder. . . .

About the Authors

Iraqi born artist Wafaa Bilal travels and lectures extensively to inform audiences about the situation of the Iraqi people and the importance of peaceful conflict resolution. Bilal has exhibited his artwork worldwide, including Baghdad, the Netherlands, Thailand and Croatia; as well as the Museum of Contemporary Photography in Chicago, the Milwaukee Art Museum, Albany Institute of History and Art, the New Mexico Museum of Art and various other U.S. galleries. His residencies have included Montalvo Arts Center in Saratoga, California; Catwalk in Catskill, New York; and Rensselaer Polytechnic Institute in Troy, New York. He is currently an assistant professor at New York University's Tisch School of the Arts. www.wafaabilal.com

Kari Lydersen is a staff writer at the *Washington Post* out of the Midwest bureau and author of *Out of the Sea and Into the Fire: Latin American-US Immigration in the Global Age* (Common Courage, 2005). She is also a youth and college journalism instructor and freelances for various publications about environmental, immigration and other issues. www.karilydersen.com